Ruskin on Turner

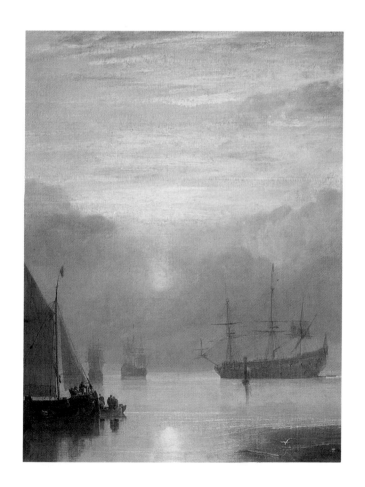

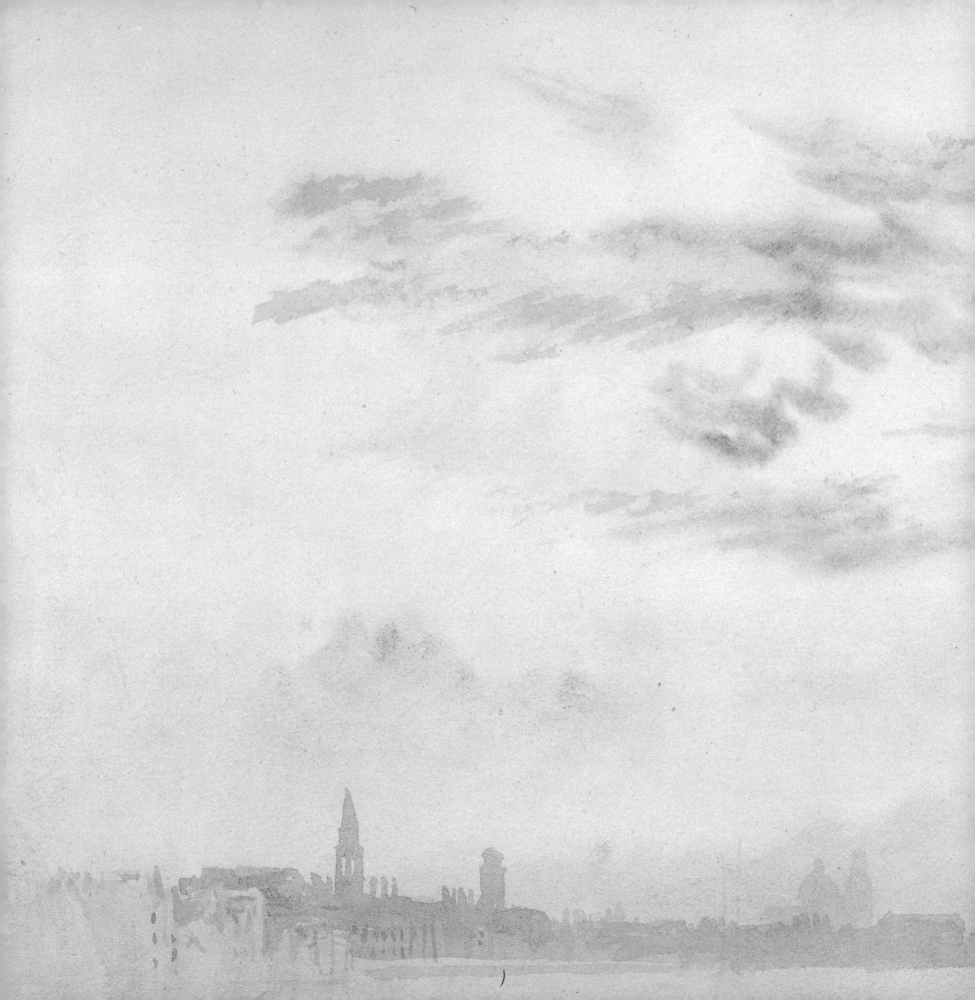

Ruskin on Turner

Dinah Birch

CASSELL

First published 1990 by Cassell Publishers Ltd,
Artillery House, Artillery Row, London SW1P 1RT

An Albion Book

Conceived, designed and produced by The Albion Press Ltd,
P.O. Box 52, Princes Risborough, Aylesbury, Bucks HP17 9PR

British Library Cataloguing in Publication Data

Ruskin, John 1819-1900
Ruskin on Turner.
1. English paintings. Turner, J.M.W. (Joseph Mallord
William) 1775-1851
1. Title II. Birch, Dinah
759.2

ISBN 0-304-31845-0

Designer: Andrew Shoolbred
Editor: Robyn Marsack
Project co-ordinator: Elizabeth Wilkes

Typesetting and colour origination by York House, London
Printed and bound in Hong Kong by
South China Printing Co.

Half-title: Detail from Sun rising through vapour, 1807
Title page: Detail from Looking East from Giudecca, 1819
pp. 6-7: Detail from San Giorgio from Dogana, Venice, 1840
Unless otherwise stated, all illustrations are by J.M.W. Turner

Contents

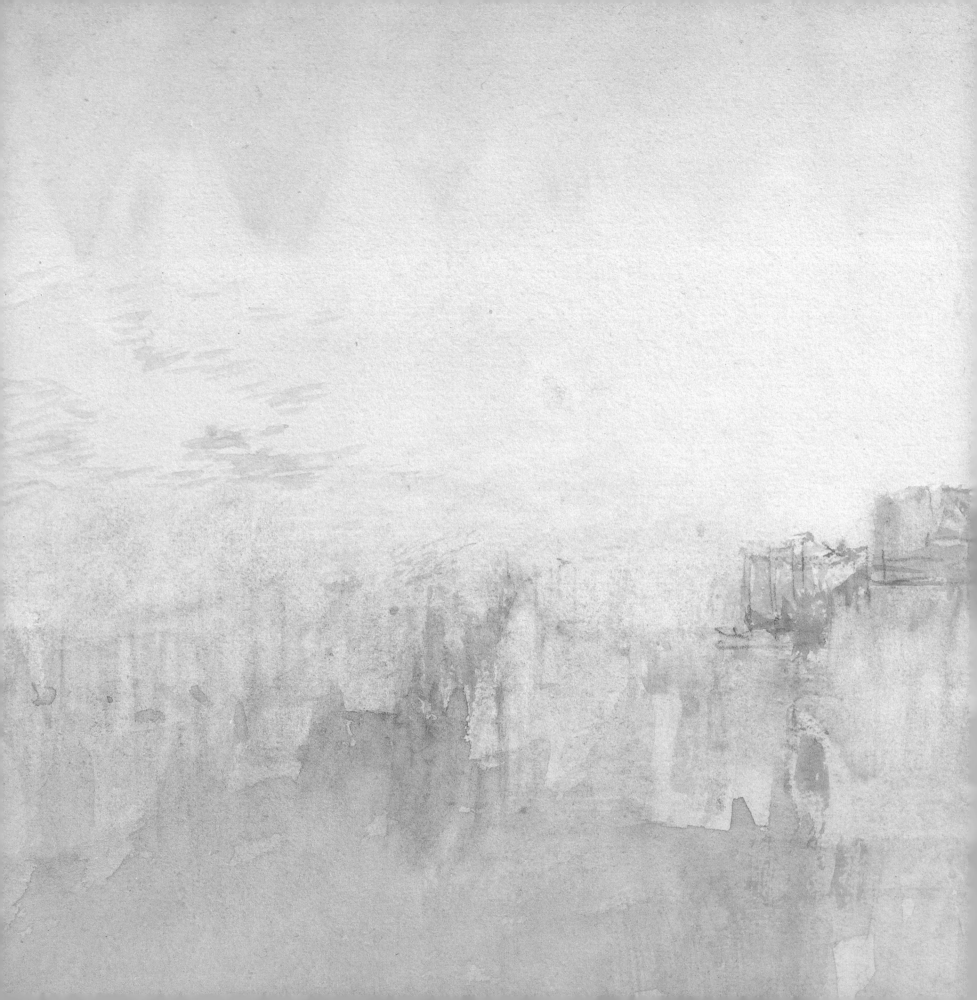

For Sidney Birch

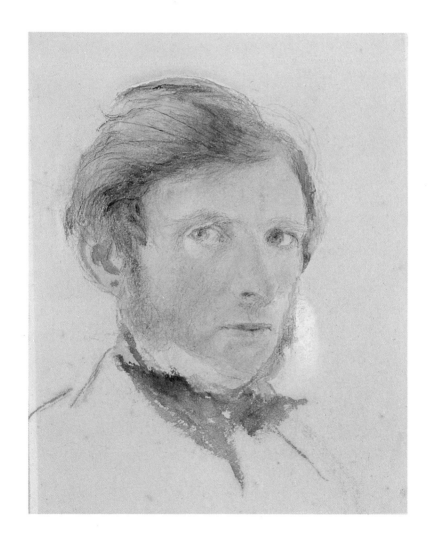

Ruskin: Self-portrait, 1861

Introduction

Turner has now settled his right to be called England's greatest painter. Ruskin should stand beside him as England's greatest critic. They have more than eminence in common. Both were solitary, eccentric men, at odds with the culture that produced them. Both were passionate, sometimes irascible but also generous and immovably loyal. Such loyalty is the defining characteristic of what Ruskin did for Turner. He made an imaginative commitment to Turner's art as an adolescent, and kept faith all his life. Through serving Turner, he claimed that meaning in pictures might be infinite. To this day he remains Turner's stoutest champion, his clearest interpreter and most precise translator. No other bond between artist and critic has been so close and so enduring.

Their names are indissolubly linked. Yet their fame survives in very different ways. This is because Ruskin's prose can be as daunting as Turner's pictures are sumptuous. Almost anyone will have some idea of what Turner's images are like, if only through postcards – a blur of Venetian colour or swirling storm at sea. But Ruskin's name often endures through reputation only. People have a notion of him as a utopian reformer, a great architectural historian, a failed husband, or a crazy don, without having read a word of his writing. The vitality of Turner's paint has an immediate appeal. Ruskin's forbidding volumes cannot compete. One result of this has been that what Ruskin actually said about Turner has often been forgotten. This is an irreplaceable loss. The persistence of Ruskin's searching intellectual engagement with Turner was unparalleled. It offers vicarious access to a world which is strange to most of us, a world in which the accurate tracing of particularity and growth in a painter's vision becomes a new understanding of our own lives.

His view of Turner was neither static nor always celebratory. One thing, however, never varied – his conviction that the beauty of Turner's work was the expression of a thinking mind, and that it is our privilege and obligation to seek out the thought alongside the beauty. Turner was the first ground of Ruskin's teaching, and his response to the paintings became the medium for much more than an interpretation of English landscape art. Ruskin's perceptions of myth and history, of divinity, of politics, of the natural world, find new formulation as he examines the paintings. The critic thinks in words, Turner thinks in paint. But in Ruskin's definition, the painter's thought is as precise, complex, and subtle as anything to be found in print. As Ruskin describes them, Turner's pictures are transformed. We are made to see that they are not simply diverting evocations of the beauties of nature. They are shaped by history, and their aesthetic stature rests on what Turner had to say about human potential, suffering, and responsibility.

This is also how Ruskin saw his own work. His understanding of Turner is so closely bound up with his personal preoccupations that to move between the pictures and the prose is often an unsettling experience. We are not bound to accept all that Ruskin claims for the painter. The conjunction of the two minds has some unexpected results: sometimes Ruskin's own vision overwhelms that of Turner. But

to feel this, even to object to it, is in itself a tribute to what Ruskin has achieved, for it acknowledges the nature of his respect for the painter's work. What Ruskin is asking us to do is to open our eyes and look at the pictures. If what we see leads us to question his analysis, so much the better – as long as our questions are based on what we have seen, and not on what we have assumed.

The most revolutionary aspect of Ruskin's reading of the pictures is his readiness to concede precedence to the intelligence of the eye. This kind of looking is a strenuous undertaking. It can never be a matter of the passive acceptance of images. To understand the concept of vision so literally is as strange now as when the first volume of *Modern Painters* appeared in 1843. Perhaps it is still stranger, for we are used to attaching a different kind of importance to what we see. The power of representation as it is now conceived is that of the camera, an instrument which gives us images with an accuracy and detail that no painter's hand can rival. The photography available to Ruskin was not sophisticated; nevertheless he was perfectly prepared to use it. He valued the exactness of what the camera has to offer. Cameras don't think, but photographers do, and Ruskin found no reason to despise their work. What a painter can offer is not so much superior as incomparable. Every nuance of his image is a product of the human mind, engaging or failing to engage with what it perceives. Line, colour and light are translated into experience and thought – egotistical illusion and evasion in a bad picture, honesty and perception in good work. Thus the picture becomes a text, to be read and understood as we might a poem, or a passage from the Bible. Pictures, even poor pictures, are lessons made visible. But their instruction is not to be had for the asking. We have to work for it.

Ruskin's Turner, then, gives us a body of texts which we are invited to approach with informed intelligence, devotion and openness. What Ruskin promises in return for our exertion is a vision of nature made human. Finally, the compulsion of this vision is joy, for Turner shows us a world in which the human mind might find its home. Yet Ruskin constantly reminds us that such pleasure can never be unmixed. He sees Turner's paintings as an expression of natural truth, so faithful that they almost transcend art, and become facts of nature in themselves. But if our home is in nature, we cannot escape our natural end. Turner relentlessly paints the cruelty of natural forces, with human creatures helpless in their power. Avalanche and lightning, shipwreck, famine, pestilence and fire – Turner left few forms of natural destruction undepicted. Ruskin brooded on him as the great painter of human mortality.

As his reverence for the pictures grew, his sense of their meaning darkened. The impassioned celebration of the first volume of *Modern Painters*, so touching in its confidence and exuberant generosity, becomes something much sadder, if not wiser, in the homage of his later years. The early Christian fervour of his youth, from which his first reverence for Turner had grown, faded into a soberly agnostic middle age. But Ruskin was at last able to reconstruct his Christian faith, ending his days, as Turner did not, in the Christian conviction of a life after death. The process of his coming to believe that our final home is not in nature was a bitter one, and it is this process that marks the most crucial distinction between his vision and that of the painter who inspired him.

For the fact is that despite all that Turner and Ruskin had in common, much divides them. They came of different generations, and different backgrounds. Turner was born in 1775. He was forty-four years old, a middle-aged man at the height of his skill, when his greatest admirer was born in 1819. He was of Ruskin's parents' generation. Like Ruskin's father, Turner was a Romantic. He was an insatiable reader of poetry: Thomson, Akenside, and Rogers were his heroes as a young man; later, it was to be Scott and Byron. He was determined to bring the scale and enterprise of Romantic poetry to the practice of painting. His paintings are accompanied by quotations from poetic works, sometimes written by himself. He projected an epic poem to be given the characteristic title of 'The Fallacies of Hope'. Turner's deference to the spiritual grandeur of nature must be seen as a Romantic phenomenon, one which grew out of a new kind of contact between the intellectual ambitions of poets and painters.

So, too, must Ruskin's, whose enthusiasm for Byron equalled anything that Turner could show, and who constantly substantiates his commentary in the first volume of

Modern Painters with quotation from Wordsworth. It was through Romantic poetry that Ruskin first encountered Turner. On his thirteenth birthday, he was given the 1830 edition of Samuel Rogers's Byronic poem *Italy*, which included vignette engravings by Turner. The book made a lasting impression. But Turner's allegiance to Romantic thought was of a kind that led him to reject Christian certainty. Neither Ruskin's father nor, as a young man, Ruskin himself, shared this disaffection. The members of the Ruskin household, more prosperous and more respectable than anything Turner had experienced as a boy, were regular church-goers, solidly committed to an Evangelical Christian faith of a kind that was utterly foreign to Turner's intellectual world. In the early volumes of *Modern Painters*, Ruskin struggles to make Turner a Christian phenomenon, and a Protestant phenomenon at that. He does this by presenting Turner as an unwearied seeker after truth, humbly serving and interpreting a spiritual power far greater than himself. The paintings become a ministry of a natural world which is in its turn an expression of the divine. Wanting to look at Turner in this light, Ruskin was enabled to see and to describe aspects of the painter's achievement to which others had been blind. But he could only do so at the expense of imperception in other areas. The juxtaposition of Turner's works with what Ruskin has to say about them in the earlier phase of his criticism can make it hard to accept the view of Turner as the assiduous servant of a Christian God. Humility scarcely appears to define the pictures in quite the way that Ruskin claims. Byronic extravagance and defiance, often accompanied by Byronic high spirits, frequently seem to form Turner's aspiration, particularly in the major oil paintings of his middle and later years. The tension between what Ruskin was compelled to find in Turner's work, and what was actually there, may account for some of the restless persuasive drive in these early critical analyses of the pictures. As Ruskin grew older, and began to shed some of the influence of his parents, his view of Turner changed.

Several factors combine to account for this change. Ruskin had come to know Turner personally, though he was never close to the painter. The contact had done nothing to diminish his respect. But Turner seems to have given his young disciple an awkward welcome: not unkind, but not altogether warm either. Ruskin was unable to break down the barriers between them. It was particularly vexing that Turner made no public acknowledgement of Ruskin's impassioned defence of his art, especially as the literary success of *Modern Painters* had enhanced the prices that the pictures could fetch – prices that the Ruskin family now had to pay in order to add to their growing collection. Turner might have resented the eloquence with which Ruskin had appropriated and in some ways misrepresented his deepest purposes. Perhaps he told Ruskin he did. If so, Ruskin would have been hurt. We can't know exactly what passed between the artist and his critic, but we do know that some distance developed between them. The second volume of *Modern Painters*, published in 1846, three years after the first, makes little mention of Turner's painting. A gap of ten years was to follow before the third volume appeared in 1856. In that time, Ruskin passed through the humiliating public failure of his marriage, and published a major three-volume work on Venetian architecture and history, *The Stones of Venice* (1851-3). Both experiences taught him a great deal. The second volume of *Modern Painters*, the book whose enthusiastic reception had confirmed his reputation as one of the most influential writers of his time, turned out to be the last work of his youth.

Turner died in December 1851, naming Ruskin among his executors. Ruskin's responsibility to him was now a more professional matter. He was no longer a zealous youth asserting the claims of a living painter. He was an established critic, judging and recording the work of a dead man. His retrospective view of Turner, in *The Harbours of England* and the later volumes of *Modern Painters*, is quieter and in some ways less engaging than the intense and polemical analysis of the monumental first volume. But it is the expression of a more mature mind, and it recognizes forces in Turner's work that as a young man he had not been able to allow.

In the later 1850s, Ruskin was himself moving away from the Christian faith that he had shared with his parents. He did so gradually and painfully, and he never completely cut the ties with his old beliefs. His new evaluation of Turner was partly a cause, and partly a result, of this shifting religious position. Looking at Turner again had now become a public as well as a personal duty. Ruskin was responsible

for the sorting, arrangement, and preservation of thousands of Turner's drawings, a task that filled the winter months of 1857-8 and gave him an extraordinary opportunity to reconsider the development of Turner's career. He saw that the painter he so revered had been a more various, in some ways a bolder, artist than he had previously been able to imagine. Not all of these new perspectives pleased him. There were drawings which he thought obscene; he supervised their burning. We shall never know how those lost drawings might now be appraised, but it is clear that they must have given Ruskin sobering matter for reflection. Turner had celebrated natural divinity: he had also explored human sensuality. After 1858, Ruskin's view of Turner is increasingly concerned with defining the codes of symbolism in which he believed the painter had formulated a vision of spiritual truth, a vision wider than anything we will find in the interpretations of the 1840s.

Ruskin's earliest defence of the artist had been built on what he insistently called Turner's 'truth to nature'. His claim was simply that the pictures expressed moral truth as it was embodied in the natural world – in mountain, cloud, tree and stream. That was all they did, and it was enough. To comprehend such truth had, after all, proved to be more than his first viewing public could manage. Ruskin's business had been to supply their deficiencies, a mission which had fed his imagination, and that of his readers, to the full. Now that work was no longer sufficient. Turner's 'truth to nature', the particularity that makes up the substance of the first volume of *Modern Painters*, could reach out to universal structures of belief. In order to interpret this new body of truth, Ruskin had fundamentally to revise what he believed about Turner's relations with history and with religion.

Modern scholarship has made it clear that Turner's interest in non-Christian religions was one of the most radical dimensions of his work, linking it with the interest in mythology which characterized the thinking of the younger Romantic poets. This was something that Ruskin was never able to appreciate, for he always saw Turner's religious identity in terms of his own. He had first thought, and often said, that Turner's interest in the classical world was an unfortunate distraction from the real purposes of his art. It seemed to him an academic affectation, hostile to the Christian ideals which had transfigured the benighted civilization of the pagans. But his loss of Christian belief in the late 1850s had driven him to look again at other, older kinds of belief. It was at this time that Ruskin began to develop the concept of ancient mythology, and Greek mythology in particular, as an expression of reverence for spiritual meaning in the natural world. Greek gods and goddesses were not, after all, simply the deceitful figureheads of idolatry. They were the embodiments of a pure reverence for air, cloud, sun, earth and sea. Thus the qualities of the mythology which had so often supplied Turner with subjects for his art no longer seemed alien to what Ruskin had come to believe the painter was attempting. In the 1860s and 1870s, Ruskin developed this argument to the point of claiming that an imaginative understanding of the history of art would reveal Turner to be, in his deepest nature, a Greek rather than a Christian painter. This was an idea that he elaborated most fully in his Oxford lectures of the early 1870s. Continually tracing his own spiritual evolution through his changing interpretations of Turner's pictures, Ruskin came to feel that a profound sympathy with Greek mythology, a religion which had no concept of immortality, enabled Turner's art to express and to transcend the sense of darkness and death that haunted his own imagination.

It is characteristic of Ruskin's thought, which persistently fuses the spiritual with the material, that he should envision these concerns in terms of the painter's practical methods. In his earliest analysis of Turner, he writes chiefly about form. In his later criticism, he turns his attention in a more specific way to what constructs a painter's form: line, colour and light. And it is above all light, the essence of what the eye perceives, that becomes the focus of his attention. Line and colour, the qualities which might seem to make a more vivid impact on the eye, are as Ruskin came to understand them subordinate to light – or, more accurately, they are simply ways of expressing light. Turner is most profoundly himself when the richness and solidity of his colour and form dissolve into what had first struck Ruskin with awe, his 'blazing incomprehensible mist'. Turner makes his pictures out of light. It is from the recognition of this simple fact that Ruskin comes to define him as a great spiritual painter.

The experience of light in the natural world represents

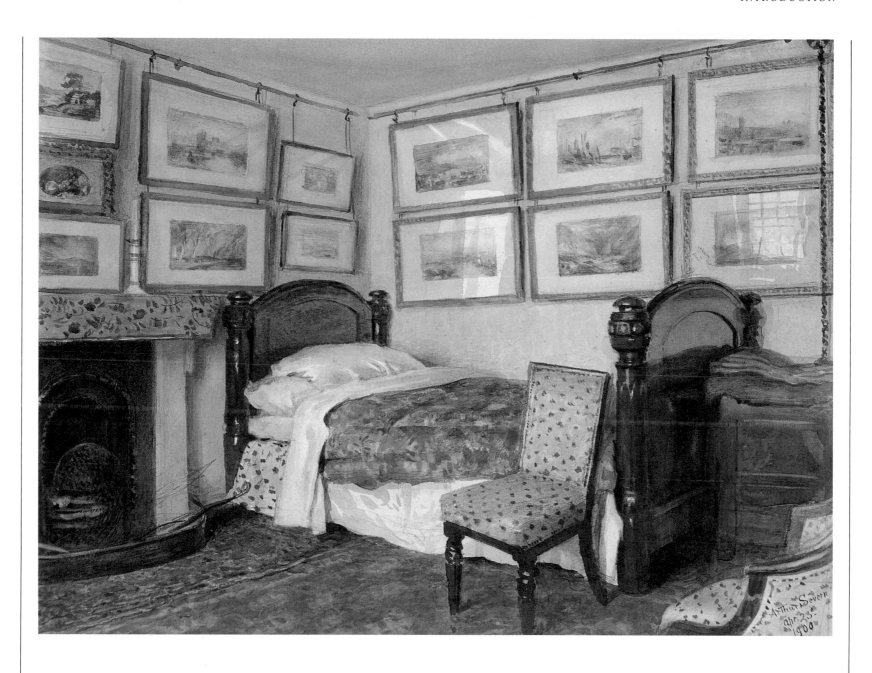

Arthur Severn: View of Ruskin's bedroom, Brantwood, 1900

more than physical perception. Since the earliest recorded history, light has been seen as goodness, life, reason; darkness as evil, death and falsehood. It is on the basis of this fundamental sense of opposition that Ruskin formulates his new understanding of religious tradition. What other religions have in common with Christianity is more important than what separates them. The most important divisions in human experience are the most simple, and the questions to ask are those posed by Turner's brush. Where does the light come from? What does it show? What defeats it?

The sense of perpetual war between light and darkness had anciently been expressed in forms of mythological contest. Turner painted these contests, and Ruskin writes about them – most notably in the final volume of *Modern Painters*, published in 1860. But Turner, like other contemporary poets and scholars pondering the meaning of old traditions in mythology, was interested in the Zoroastrian notion that neither light nor darkness could ever claim a final victory. His explorations of myth, in pictures like *The Garden of the Hesperides* or *Apollo and Python*, share Ruskin's own sense of uncertainty, and threat. The sun contends with powers no weaker than itself: the smoky dragon of the Hesperides, the unslayable python on whose temporarily subdued form Apollo founds his oracular wisdom. What Ruskin has to say about these pictures is more troubled than anything he had previously published about Turner's art.

But it is not only in the overtly mythological pictures that Ruskin sees Turner as a painter of light. Apollo, the god who becomes in Ruskin's view especially Turner's own, is the god of the sun, and the sun is Turner's particular concern as a painter. Sunlight and shadow are the defining points of his visual language, and, like every other aspect of this language, they carry an intellectual meaning. This is why Turner is not greatly interested in portraits, nor in interiors – though he painted both portraits and interiors, for Turner left nothing untried. It is not the enclosed human environment, nor the individual human face, that most concerns him, but the universality of life under the sun. His god, Apollo, may be featureless, as the sun's face is without feature; but what the sun illuminates is infinitely specific, particular, unrepeatable.

Turner had always seemed an impersonal power to Rus-

kin. He was more like an agent of nature than a human artist. The sense of Turner's inaccessibility, intensified by his closed personal life and finally by his death, made it easy for Ruskin to conceive of him as the expression of what was unchanging and absolute. In Ruskin's interpretation, his art acquires an intensity that does not simply express a religious understanding, it becomes in itself of a religious identity. A text from Dante or the Bible, an ancient myth, a rock, a flower, or a watercolour sketch by Turner: all are spoken of in the same spirit of devoted analysis. As Ruskin grows older, it becomes more and more difficult to divide the areas of his concern into discrete sections. The multiple preoccupations and projects of his latter years flow into each other, gathering into a single current of exhortation and exegesis. 'How things bind and blend themselves together', Ruskin mused ruefully in *Praeterita*, a book which is more elegy than autobiography. His remark begins what was to prove the last paragraph he prepared for publication. But the copious work of the twenty years which had gone before, work which was in some sense nothing more than a gigantic demonstration of an observation which is at last made in gentle nostalgia, presented its readers with as much challenge as melancholy. It is audacious and innovatory, scorning the compartments into which we are all too ready to separate the diverse aspects of our knowledge and experience. What Ruskin finally demands is that we should learn the right relations between the things we see.

Perhaps this is the most fundamental association between the work of Turner and Ruskin. Like Ruskin, Turner had consistently refused to confine himself to any one area of interest. No artist before him, and none since, can show such an extraordinary range of subjects, approaches, models and skills. To examine even a limited portion of his work, as much as the walls of the Clore Gallery will hold, is to be bewildered by the diversification of his talent. Like Ruskin, Turner treats history and myth, cities and deserts, plants and animals, the most intricate detail of a building or the grandest sweep of a mountain range. Nothing is too difficult for him to attempt, or too lowly to be of interest. But every aspect of his vision must be seen in relation to every other aspect. Nothing is separate.

Ruskin had emphasized this from the point of view of

composition in many of his early writings on the painter, painstakingly showing that no detail from his pictures, however winning, could be fully effective in isolation from the whole; and that the whole, however majestic, was inoperative if any one detail should be removed. This integrity of perception becomes still more central to the energy of the pictures in Turner's late works, just as it did in Ruskin's final writings. Boundaries dissolve: between earth and sky, sky and sea, sea and sun. Pictures become statements of light – sometimes a simple line of bright cloud, the memory of a sunset; sometimes an infinite, indistinct reflection of an entire city. What was true of individual works was also true of the oeuvre as a whole. Its meaning could only touch its fullest extent if the pictures were seen together. This is the point of Turner's bequest to the nation. England could freely possess his works, if England would undertake to exhibit them as a single entity. The nation's long betrayal of responsibility to this bargain would have been to Turner, as it was to Ruskin, deeply symptomatic of its failure of vision.

For all his insistence on Turner as the universal artist, Ruskin never ceased to regard him as an Englishman. English traditions, English weather, and English landscape had formed his consciousness. In the final volume of *Modern Painters*, Ruskin presents this profoundly national identity as a misfortune rather than a privilege. Ruskin's patriotism, which could be ardent, was always ambiguous. He came to believe that England had denied its most gifted artist as much as it had taught him. Much of the shadow against which Turner's light defined itself seemed a product of the mechanical greed which he saw invading the spirit of the nation. This was a view which was confirmed by the carelessness with which Turner's bequest was treated. He brooded on the negligence with deep bitterness, and it became one of the most persistent sources of his alienation from England's boasted prosperity and wealth.

But the drab illusions of material progress, which had blighted Turner's native landscape with factories and smoke, was not confined to England. Turner had been an eager traveller, and in this too Ruskin was a lifelong disciple. Ruskin's favourite destinations – French rivers, towns, and plains, Alpine peaks, and above all the canals and palaces of Venice – were in part decided by Turner's routes, and the subjects of Turner's drawings. Ruskin always saw these places as they had been expressed in Turner's art. It was inevitable that they should increasingly seem faded and soiled when set beside the shining images he knew so well. The reality of Venice, then as now, cannot quite live up to Turner's shimmering vision. In Ruskin's late middle age, Venice was embarking on a process of erratic industrialization, with results that Ruskin found deeply distressing. But what Ruskin saw as an unstoppable tide of degradation was not simply an urban affair. The sky itself, once so pure, was now grimy with industrial smog over England, and seemed more and more unclean in every country he visisted. The rivers were polluted, the trees felled, even the stainless glaciers of the Alps were littered with the refuse of a new and irreverent generation of tourists. Turner's Europe, like Turner's England, was receding into an irrecoverable past. Turner had painted forms of natural destruction. Now Ruskin, robbed of the grandeur of Romantic apocalypse, was forced to write about a more human kind of ruin.

Turner and Ruskin, for different reasons, saw glory in an elegiac perspective. Turner responded with a truly monumental art, celebrating human vitality in the face of human dissolution. Confidence on this scale was not within Ruskin's grasp. Service, rather than defiance, motivates his work; service devoted first to Turner's pictures, and then, more urgently, to what those pictures had represented. His own drawings and paintings were formed in this spirit of devotion. He made few claims for their merits, describing them simply as records, useful in so far as they were accurate. Nevertheless, these drawings demonstrate as nothing else can what he had learned from Turner: fidelity and precision, a sense of delicacy and boldness in composition, and, more deeply still, a sense of light. They could not have been made without Turner's towering precedent. Yet they have a distinct beauty of their own, a stubborn identity in homage, of a kind which epitomizes the long creative relationship between two men of diverse and dedicated genius.

Ruskin's Turner

The intensity of Ruskin's association with Turner was not founded on close personal friendship. Though the great painter and his most articulate advocate did come to know each other, there was always a sense of restraint between them, and sometimes of coolness. Ruskin conveys something of this ambivalence in his account of his first meeting with Turner, a memory introduced into *Praeterita* almost as an afterthought: 'I have passed without notice what the reader might suppose a principal event of my life . . . ' The reader, Ruskin implies, would be wrong. The first impression recalled in *Praeterita* is both vivid and adulatory, but it is qualified by a lament for the distance between the eager young admirer and his hero. Turner chose not to teach Ruskin. 'Such things are never to be . . . ' It is not likely that we shall ever know quite why this was so, for neither Turner nor Ruskin left a full account of what passed between them. Perhaps, as Ruskin hints in *Praeterita*, Turner disliked the vehemence with which the critic asserted his greatness. Or perhaps the reserve was primarily a matter of divided generations. Turner was closer in age to Ruskin's father, John James Ruskin, than to Ruskin himself, and, despite crucial differences in social class and religious allegiance, he was in many of his values and assumptions closer to that shrewd Scottish wine merchant, with his deeply Romantic passion for art, than to the younger man who wrote about his pictures with such devotion. Much of what Ruskin thought and felt about Turner was in fact closely bound up with his feelings for his father. Turner was the only man that Ruskin venerated more than John James Ruskin. In his youthful commitment to Turner, Ruskin made the first move in what was to be a long and difficult process of disengagement from his father's dominance. All of Ruskin's most impassioned writing about Turner predates the death of John James Ruskin in 1864. Much had happened to change the relation between the merchant and his son before that final separation – including the death of Turner, in 1851. But it was only with the loss of his father that Ruskin was fully able to develop a more measured, perhaps a more detached, view of the painter.

The purchase of Turner's art became a focus of trouble between father and son. As a young man Ruskin had no income of his own, and depended on his father's generosity to own the pictures he coveted. John James Ruskin was torn between the desire to give his son what he wanted, and the need to assert his own equivocal feelings about the importance that the painter had for Ruskin. The Turners first acquired by the family show something of Ruskin's father's taste: they are more social in subject, and perhaps, despite the gathering storm in *Winchelsea*, more cheerful in feeling, than the paintings which came to mean most to Ruskin as his understanding of the painter became both wider and more intimate. They remind us that there were aspects of Turner's art that could play little part in Ruskin's most mature and searching criticism.

In *Praeterita*, Ruskin gives a rueful account of the mixed pleasure and distress that buying Turner's art – and, sometimes, not buying it – brought into the life of his family. The *Splügen*, particularly, a late Swiss watercolour which slipped out of his grasp (see p.22), became an emblem of failure and misunderstanding that went far beyond the importance of

the drawing itself. Ruskin simply calls it 'the best Swiss landscape yet painted by man'. Nowhere, however, does he give a detailed analysis of this grave and disciplined composition. Perhaps it represented too much. In 1878, after his first and most damaging bout of mental illness, friends collected money to present the picture to him. This was a touching gesture, and one that meant much to Ruskin. The *Splügen* thus came to have a sobering significance for him throughout his life: first as an expression of events that divided and united him with the father he deeply revered, then as a reminder of the mental pain that closed in round his later years – and of the loyal friendship and help that was to make that affliction bearable. The sense of Turner's presence became part of that loving support. Ruskin kept his Turners close to him, as continuing sources of intellectual and spiritual nourishment. In Brantwood, the house in the Lake District which became his home when his mother died in 1871, many of them hung round his bed. After Ruskin's own death in 1900, Arthur Severn, one of those who had tended his last years, made a painting of the empty bedroom, with the Turners still crowded on the walls like waiting friends (see p.13).

It is in Ruskin's own creative identity, rather than in direct recollection of Turner, that we find the truest record of what the painter and the critic were able to give each other. What Ruskin wrote about art – not only about Turner's art, but all art – is deeply informed by what Turner had taught him. So, too, is his own work as a painter. It is characteristic of the sense of modesty underwriting Ruskin's apparent arrogance that he never seriously attempted to work in oil on canvas. That, he felt – as he came to feel about his youthful attempts to write poetry to match Byron's – was beyond him. His work is all on paper, most of it painted in watercolour. Ruskin's draughtsmanship and fine sense of colour arises from the concentrated observation that expresses his understanding of Turner as powerfully, and as delightfully, as anything to be found in *Modern Painters*. But they are not simply copies of Turner's methods, for Ruskin had something of his own to say.

The deepest impulse of his imagination was elegiac. Ruskin described and painted buildings, birds, girls, flowers, clouds and stones because he knew he could not possess them, and wanted to remember them as they were. This led him to see, more profoundly than anyone else had, the darker side of Turner's differently motivated work. It is as a painter of transience and mortality, and, finally, of ruin, that Turner emerges from Ruskin's mediating criticism. The vision was unforgettable, for in Turner Ruskin found the means to define the Romantic aspiration to create indelible beauty.

Dad never praised me for anything but saving a halfpenny.
J. M. W. Turner, to a friend

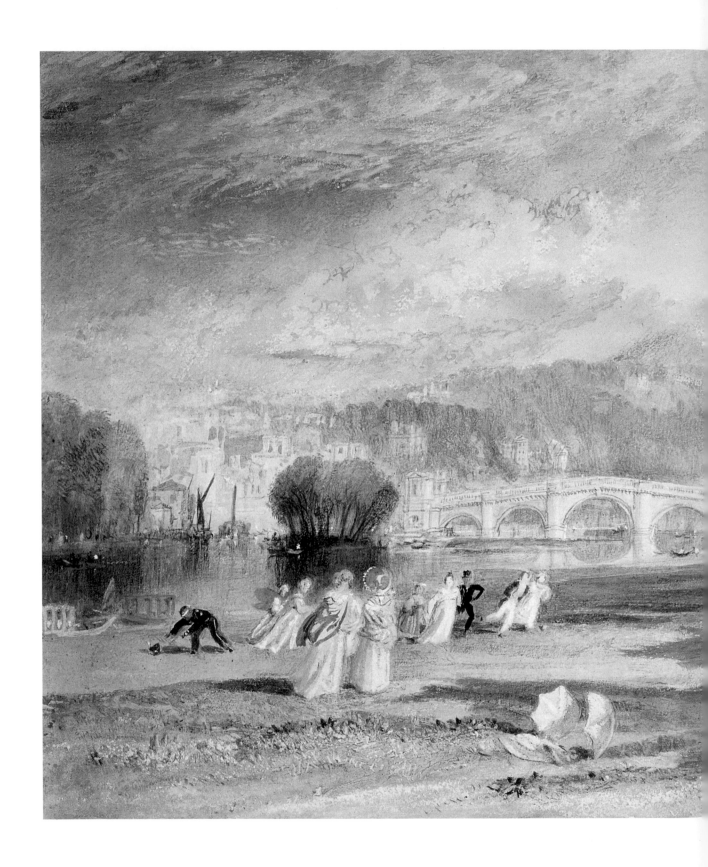

Richmond Hill and Bridge, Surrey,
c.1831

First Turners

MR GODFREY WINDUS was a retired coachmaker, living in a cheerful little villa, with low rooms on the ground floor opening pleasantly into each other, like a sort of grouped conservatory, between his front and back gardens: their walls beset, but not crowded, with Turner drawings of the England series; while in his portfolio-stands, coming there straight from the publishers of the books they illustrated, were the entire series of the illustrations to Scott, to Byron, to the South Coast, and to Finden's Bible.

Nobody, in all England, at that time – and Turner was already sixty – *cared*, in the true sense of the word, for Turner, but the retired coachmaker of Tottenham, and I.

Nor, indeed, could the public ever see the drawings, so as to begin to care for them. Mr Fawkes's were shut up at Farnley, Sir Peregrine Acland's, perishing of damp in his passages, and Mr Windus bought all that were made for engravers as soon as the engraver had done with them. The advantage, however, of seeing them all collected at his house – he gave an open day each week, and to me the run of his rooms at any time – was, to the general student, inestimable, and, for me, the means of writing *Modern Painters*.

It is, I think, noteworthy that, although first attracted to Turner by the mountain truth in Rogers's *Italy*, when I saw the drawings, it was almost wholly the pure artistic quality that fascinated me, whatever the subject; so that I was not in the least hindered by the beauty of Mr Windus's Llanberis or Melrose from being quite happy when my father at last gave me, not for a beginning of Turner collection, but for a specimen of Turner's work, which was all – as it was supposed – I should ever need or aspire to possess, the 'Richmond Bridge, Surrey'.

The triumphant talk between us over it, when we brought it home, consisted, as I remember, greatly in commendation of the quantity of Turnerian subject and character which this single specimen united: 'it had trees, architecture, water, a lovely sky, and a clustered bouquet of brilliant figures.'

And verily the Surrey Richmond remained for at least two years our only Turner possession, and the second we bought, the 'Gosport', which came home when Gordon was staying with us, had still none of the delicate beauty of Turner except in its sky; nor were either my father or I the least offended by the ill-made bonnets of the lady-passengers in the cutter, nor by the helmsman's head being put on the wrong way.

The reader is not to think, because I speak thus frankly of Turner's faults, that I judge them greater, or know them better,

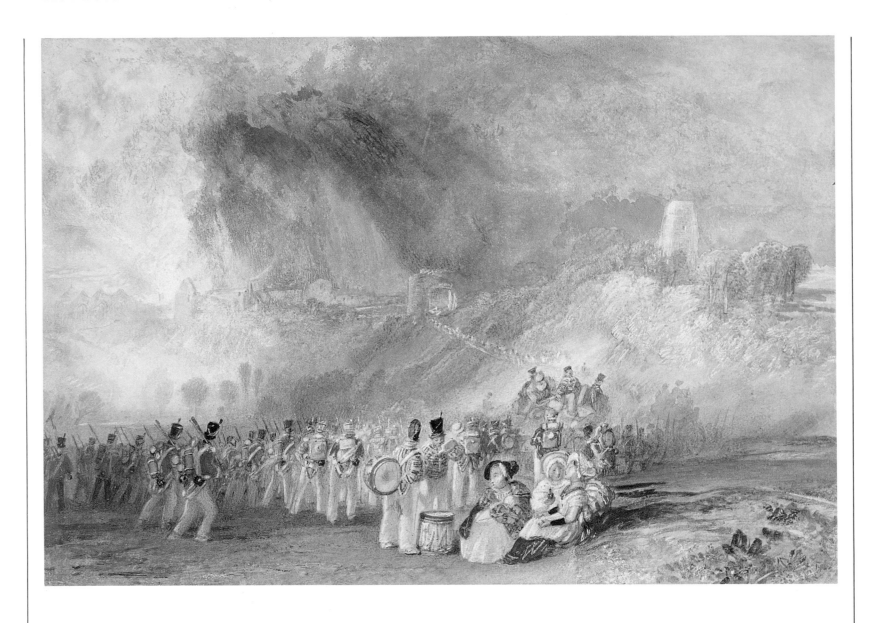

Winchelsea, Sussex, Soldiers on the March, c.1828

now, than I did then. I knew them at this time of getting 'Richmond' and 'Gosport' just as well as other people; but knew also the power shown through these faults, to a degree quite wonderful for a boy; it being my chief recreation, after Greek or trigonometry in the nursery-study, to go down and feast on my 'Gosport'.

And so, after Christmas, I went back to Oxford for the last push, in January 1840, and did very steady work with Gordon, in St Aldate's; the sense that I was coming of age somewhat increasing the feeling of responsibility for one's time. On my twenty-first birthday my father brought me for a present the drawing of Winchelsea – a curious choice, and an unlucky one. The thundrous sky and broken white light of storm round the distant gate and scarcely visible church, were but too true symbols of the time that was coming upon us; but neither he nor I were given to reading omens, or dreading them. I suppose he had been struck by the power of the drawing, and he always liked soldiers. I was disappointed, and saw for the first time clearly that my father's joy in Rubens and Sir Joshua could never become sentient of Turner's microscopic touch. But I was entirely grateful for his purpose, and very thankful to have any new Turner drawing whatsoever; and as at home the 'Gosport', so in St Aldate's the 'Winchelsea', was the chief recreation of my fatigued hours.

Meeting Turner

I have passed without notice what the reader might suppose a principal event of my life – the being introduced to him by Mr Griffith, at Norwood dinner, June 22nd, 1840. The diary says:

> Introduced today to the man who beyond all doubt is the greatest of the age; greatest in every faculty of the imagination, in every branch of scenic knowledge; at once *the* painter and poet of the day, J. M. W. Turner. Everybody had described him to me as coarse, boorish, unintellectual, vulgar. This I knew to be impossible. I found in him a somewhat eccentric, keen-mannered, matter-of-fact, English-minded – gentleman: good-natured evidently, bad-tempered evidently, hating humbug of all sorts, shrewd, perhaps a little selfish, highly intellectual, the powers of the mind not brought out with any delight in their manifestation, or intention of display, but flashing out occasionally in a word or a look.

Pretty close, that, and full, to be seen at a first glimpse, and set down the same evening.

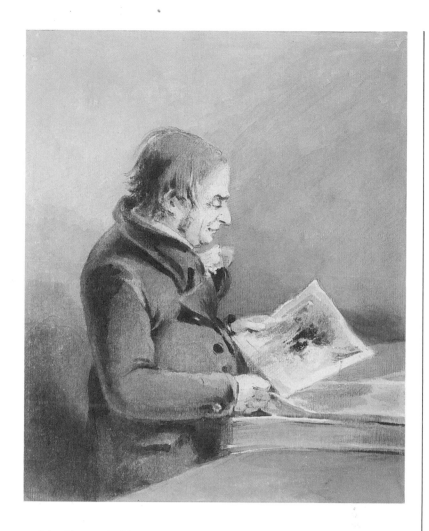

John Thomas Smith: J. M. W. Turner in the British Museum Print Room, c.1825

Curiously, the drawing of Kenilworth was one of those that came out of Mr Griffith's folio after dinner; and I believe I must have talked some folly about it, as being 'a leading one of the England series'; which would displease Turner greatly. There were few things he hated more than hearing people gush about particular drawings. He knew it merely meant that they could not see the others.

Anyhow, he stood silent; the general talk went on as if he had not been there. He wished me goodnight kindly, and I did not see him again till I came back from Rome.

If he had but asked me to come and see him the next day! shown me a pencil sketch, and let me see him lay a wash! He would have saved me ten years of life, and would not have been

21

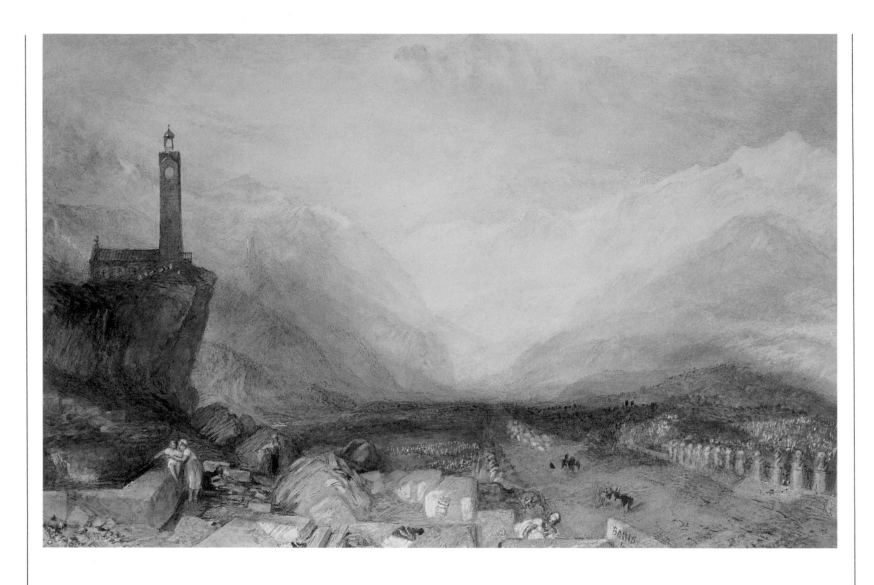

The Splügen Pass, 1842

less happy in the close of his own. One can only say, Such things are never to be; every soul of us has to do its fight with the Untoward, and for itself discover the Unseen.

Buying Turners

And so the year 1842 dawned for me, with many things in its morning cloud. In the early spring of it, a change came over Turner's mind. He wanted to make some drawings to please himself; but also to be paid for making them. He gave Mr Griffith fifteen sketches for choice of subject by any one who would give him a commission. He got commissions for nine, of which my father let me choose at first one, then was coaxed and tricked into letting me have two. Turner got orders, out of all the round world besides, for seven more. With the sketches, four finished drawings were shown for samples of the sort of thing Turner meant to make of them, and for immediate purchase by anybody.

Among them was the 'Splügen', which I had some hope of obtaining by supplication, when my father, who was travelling, came home. I waited dutifully till he should come. In the mean time it was bought, with the loveliest Lake Lucerne, by Mr Munro of Novar.

The thing became to me grave matter for meditation. In a story by Miss Edgeworth, the father would have come home in the nick of time, effaced Mr Munro as he hesitated with the 'Splügen' in his hand, and given the dutiful son that, and another. I found, after meditation, that Miss Edgeworth's way was not the world's, nor Providence's. I perceived then, and conclusively, that if you do a foolish thing, you suffer for it exactly the same, whether you do it piously or not. I knew perfectly well that this drawing was the best Swiss landscape yet painted by man; and that it was entirely proper for *me* to have it, and inexpedient that anybody else should. I ought to have secured it instantly, and begged my father's pardon, tenderly. He would have been angry, and surprised, and grieved; but loved me none the less, found in the end I was right, and been entirely pleased. I should have been very uncomfortable and penitent for a while, but loved my father all the more for having hurt him, and, in the good of the thing itself, finally satisfied and triumphant. As it was, the 'Splügen' was a thorn in both our sides, all our lives. My father was always trying to get it; Mr Munro, aided by dealers, always raising the price on him, till it got up from 80 to 400 guineas. Then we gave it up — with unspeakable wear and tear of best feelings on both sides.

Learning from Turner

Now, if there be any part of landscape in which nature develops her principles of light and shade more clearly than another, it is rock; for the dark sides of fractured stone receive brilliant reflexes from the lighted surfaces, on which the shadows are marked with the most exquisite precision, especially because, owing to the parallelism of cleavage, the surfaces lie usually in directions nearly

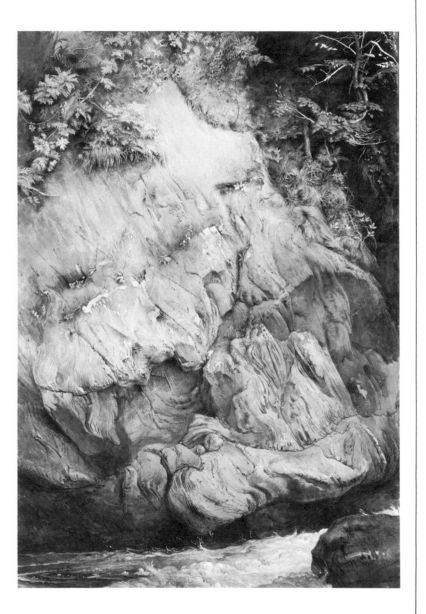

Ruskin: Study of Gneiss Rock, Glenfinlas, 1853

23

parallel. Hence every crack and fissure has its shadow and reflected light separated with the most delicious distinctness, and the organization and solid form of all parts are told with a decision of language, which, to be followed with anything like fidelity, requires the most transparent colour, and the most delicate and scientific drawing. So far are the works of the old landscape painters from rendering this, that it is exceedingly rare to find a single passage in which the shadow can even be distinguished from the dark side – they scarcely seem to know the one to be darker than the other; and the strokes of the brush are not used to explain or express a form known or conceived, but are dashed and daubed about without any aim beyond the covering of the canvas. 'A rock', the old masters appear to say to themselves, 'is a great, irregular, formless, characterless lump; but it must have shade upon it, and any grey marks will do for that shade.'

Ruin

I said that Turner painted the labour of men, their sorrow, and their death. This he did nearly in the same tones of mind which prompted Byron's poem of *Childe Harold*, and the loveliest result of his art, in the central period of it, was an effort to express on a single canvas the meaning of that poem. It may be now seen, by strange coincidence, associated with two others – Caligula's Bridge and the Apollo and Sibyl; the one illustrative of the vanity of human labour, the other of the vanity of human life.[1] He painted these, as I said, in the same tone of mind which formed the *Childe Harold* poem, but with different capacity: Turner's sense of beauty was perfect; deeper, therefore, far than Byron's; only that of Keats and Tennyson being comparable with it. And Turner's love of truth was as stern and patient as Dante's; so that when over these great capacities come the shadows of despair, the wreck is infinitely sterner and more sorrowful. With no sweet home for his childhood – friendless in youth, loveless in manhood – and hopeless in death, Turner was what Dante might have been, without the 'bello ovile', without Casella, without Beatrice, and

1 The Cumæan Sibyl, Deiphobe, was, in her youth, beloved by Apollo; who promising to grant her whatever she would ask, she took up a handful of earth, and asked that she might live as many years as there were grains of dust in her hand. She obtained her petition. Apollo would have granted her perpetual youth in return for her love, but she denied him, and wasted into the long ages – known, at last, only by her voice. J. R.

without Him who gave them all, and took them all away.

I will trace this state of mind farther, in a little while. Meantime, I want you to note only the result upon his work; how, through all the remainder of his life, wherever he looked, he saw ruin.

Ruin, and twilight. What was the distinctive effect of light which he introduced, such as no man had painted before? Brightness, indeed, he gave, as we have seen, because it was true and right; but in this he only perfected what others had attempted. His own favourite light is not Æglé, but Hesperid Æglé. Fading of the last rays of sunset. Faint breathing of the sorrow of night.

And fading of sunset, note also, on ruin. I cannot but wonder that this difference between Turner's work and previous art-conception has not been more observed. None of the great early painters draw ruins, except compulsorily. The shattered buildings introduced by them are shattered artificially, like models. There is no real sense of decay; whereas Turner only momentarily dwells on anything else than ruin. Take up the Liber Studiorum, and observe how this feeling of decay and humiliation gives solemnity to all its simplest subjects; even to his view of daily labour. I have marked its tendency in examining the design of the Mill and Lock, but observe its continuance through the book. There is no exultation in thriving city, or mart, or in happy rural toil, or harvest gathering. Only the grinding at the mill, and patient striving with hard conditions of life. Observe the two disordered and poor farm-yards, cart, and ploughshare, and harrow rotting away: note the pastoral by the brook side, with its neglected stream and haggard trees, and bridge with the broken rail, and decrepit children – fever-struck – one sitting stupidly by the stagnant stream, the other in rags, and with an old man's hat on, and lame, leaning on a stick. Then the 'Hedging and Ditching', with its bleak sky and blighted trees – hacked and bitten, and starved by the clay soil into something between trees and firewood; its meanly-faced, sickly labourers – pollard labourers, like the willow trunk they hew; and the slatternly peasant-woman, with worn cloak and battered bonnet – an English Dryad. Then the water-mill, beyond the fallen steps, overgrown with the thistle: itself a ruin, mud-built at first, now propped on both sides; the planks torn from its cattle-shed; a feeble beam, splintered at the end, set against the dwelling-house from the ruined pier of the water-course; the old mill-stone – useless for many a day – half-buried in slime, at the bottom of the wall; the listless children, listless dog, and the poor gleaner bringing her single sheaf to be ground.

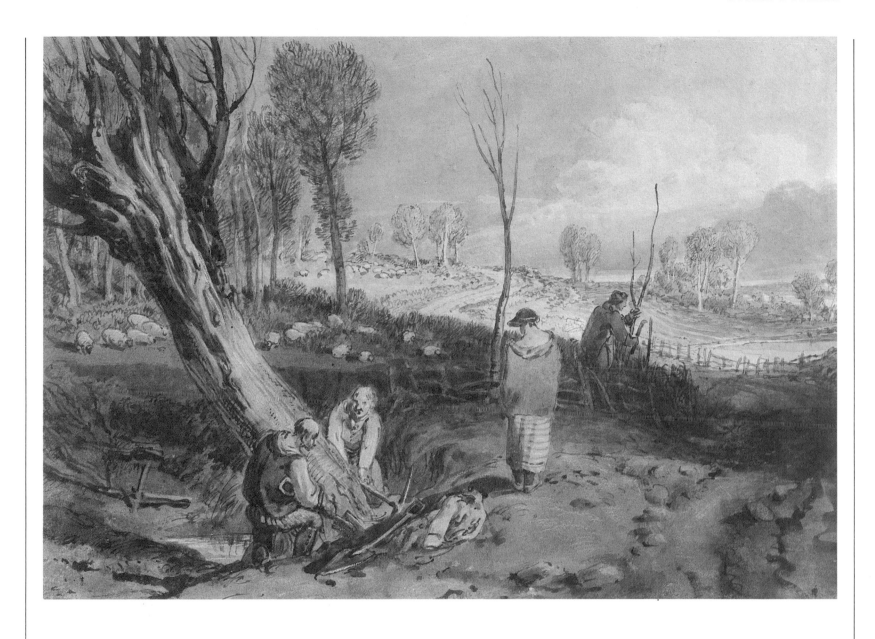

Hedging and Ditching, c.1808. Design for Liber Studiorum

Painting the Air

For Ruskin, writing, painting and worship always went together. As a child, then an adolescent, he wrote and drew endlessly: poems and sketches celebrating the places he had seen while travelling with his parents, devout summaries of the sermons he heard every Sunday, letters to his father, essays on architecture and natural history. His first piece on Turner dates from 1836, when he was seventeen. The Reverend John Eagles had written dismissively of Turner's oil paintings, reserving especial scorn for the Venetian picture *Juliet and her Nurse* (see p.123). Ruskin's indignant defence was inspired as much by the elation of his exploration of Venice as by his reverence for Turner. Having seen Ruskin's exuberant defence of his art, Turner tactfully but firmly discouraged publication. It was not until 1843, when Ruskin was twenty-four years old, that he published his thoughts on Turner's art.

The first volume of *Modern Painters* was not like anything that anyone had ever read before. It was a monumental act of devotion to Turner, and to other contemporary artists that Ruskin admired. But it was more than that. It was a celebration of what Turner and his fellow landscape artists had painted: clouds, mists, mountains, rivers, trees. The book's preoccupations are by no means confined to art history – an academic discipline which did not exist in its present form when Ruskin's interest in Turner began. *Modern Painters* focuses on Turner the two great intellectual energies which had shaped Ruskin's early life: his love of Romantic poetry, and his Christian faith. Turner's art provided the means of uniting these forces. Ruskin did not hesitate to claim Turner as a poet, writing in reply to

criticism of his book that Turner's pictures 'are not prosaic statements of the phenomena of nature, – they are statements of them under the influence of ardent feeling; they are, in a word, the most fervent and real poetry which the English nation is at present producing' (*Works*, 3.651). Nor did he hesitate to claim religious exaltation as the proper frame of mind for an understanding of Turner's art. 'It is the very stamp and essence of the purest poetry, that it can only be so met and understood; and that the clash of common interests, and the roar of the selfish world, must be hushed about the heart, before it can hear the still, small, voice, wherein rests the power communicated from the Holiest' (*Works*, 3.653).

What Turner thought of this is not recorded. He did not share Ruskin's faith. But he did share his passion for poetry, and it is likely that he would have felt more sympathetic to the specific associations that Ruskin persistently makes between his work and the writing of the Romantic poets who had been so important to the development of his art. Ruskin quotes a passage from Shelley's *Prometheus Unbound* as the literary counterpart of Turner's character as a painter:

> The point of one white star is quivering still,
> Deep in the orange light of widening dawn,
> Beyond the purple mountains. Through a chasm
> Of wind-divided mist the darker lake
> Reflects it, now it fades: it gleams again,
> As the waves fall, and as the burning threads
> Of woven cloud unravel in pale air,
> 'Tis lost! and through yon peaks of cloudlike snow
> The roseate sunlight quivers. *(Act ii, Sc.1)*

What we see above our heads – like the coming of the dawn, described so graphically by Shelley here – was for Ruskin central to the energy of Turner's work.

The untouchable radiance of the sky has always seemed the home of sacred power to its human observers. The Romantic poets of Shelley's generation had acknowledged this source of spiritual strength in their interest in ancient religions which had elevated the sun to the status of a god. Turner was intensely interested in the idea of sun-worship as it found expression in contemporary scholarship and poetry, and it had a far-reaching influence on his art. Ruskin was not, in 1843, interested in solar mythology, though he became so in later years. But he was profoundly sympathetic to Turner's insistence, repeated throughout the whole range and variety of his work, that the sky *matters*.

In *Modern Painters*, particularly in the first volume, Ruskin makes Turner's veneration for the light of the sky a Christian phenomenon, which it was not. But the basic perception of his writing on Turner's skies – that Turner revered the sky, and that he was right to do so – lies at the heart of his understanding of the artist. Ruskin's point is that Turner's extraordinary sensitivity to the changing phenomena of clouds, mist and light was not simply a technical accomplishment. The fidelity with which he attempted to follow nature was an act of religious faith, and one from which we should draw instruction.

In writing about Turner's skies, Ruskin repeatedly reminds us that our complacent assumption that we know what the sky is like – do we not see it every day of our lives? – is an illusion. We do not know what the sky looks like, because we do not look at it. We take it for granted. This is what neither Turner nor Ruskin will allow us to do. For them, the process of communicating the power and changefulness of the sky is a matter of both duty and vivid pleasure. Some of Ruskin's most careful writing in *Modern Painters* is directed to this end.

But Ruskin's long habit of looking upwards was eventually to bring him more sorrow than delight. One of the defining characteristics of the sky, to those of Turner's generation and to Ruskin himself, had seemed its inviolability. Far above us, its vicissitudes were the expression of its own celestial laws, untouched by human suffering or sin. Towards the end of Ruskin's life, it was becoming clear that pollution could change all that. The smoke of the nineteenth century was marking and staining the sky itself. Ruskin's late lectures on 'The Storm Cloud of the Nineteenth Century' could not be further from what he had joyfully written about Turner's skies as a young man. They are one of the most poignant reminders of the difference in years that separated him from the Romantic hero of *Modern Painters*. To his readers now, with urgent reason to feel troubled about human responsibility for events in the sky, their apocalyptic grief has begun to gather new and still darker shades of meaning.

Indistinctness is my fault.
J. M. W. Turner, to a dissatisfied patron

27

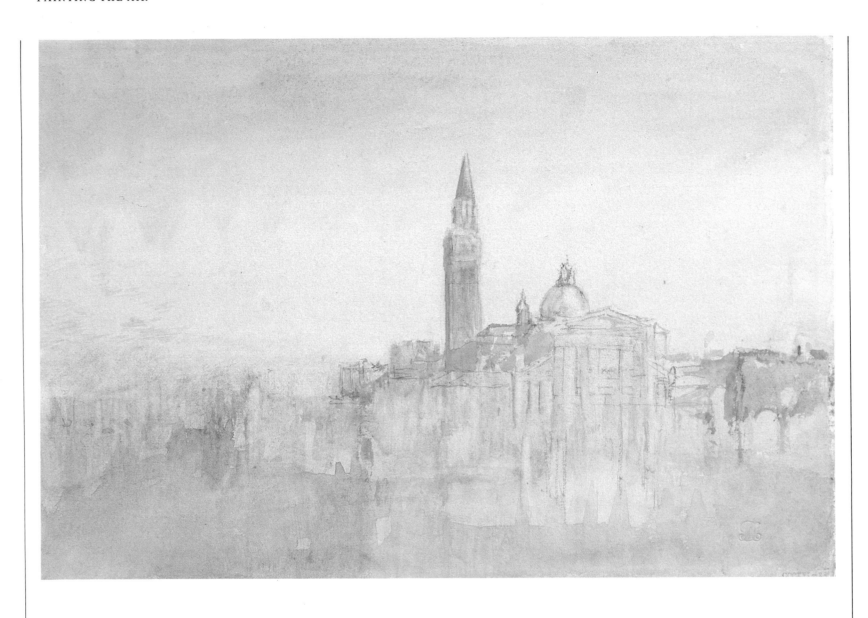

San Giorgio from Dogana, Venice, 1840

The open sky

LET US BEGIN THEN with the simple open blue of the sky. This is of course the colour of the pure atmospheric air, not the aqueous vapour, but the pure azote and oxygen, and it is the total colour of the whole mass of that air between us and the void of space. It is modified by the varying quantity of aqueous vapour suspended in it, whose colour, in its most imperfect and therefore most visible state of solution, is pure white (as in steam); which receives, like any other white, the warm hues of the rays of the sun, and, according to its quantity and imperfect solution, makes the sky paler, and at the same time more or less grey, by mixing warm tones with its blue. This grey aqueous vapour, when very decided, becomes mist, and when local, cloud. Hence the sky is to be considered as a transparent blue liquid, in which, at various elevations, clouds are suspended, those clouds being themselves only particular visible spaces of a substance with which the whole mass of this liquid is more or less impregnated. Now, we all know this perfectly well, and yet we so far forget it in practice, that we little notice the constant connection kept up by nature between her blue and her clouds; and we are not offended by the constant habit of the old masters, of considering blue sky as totally distinct in its nature and far separated from the vapours which float in it. With them, cloud is cloud, and blue is blue, and no kind of connection between them is ever hinted at. The sky is thought of as a clear, high, material dome, the clouds as separate bodies suspended beneath it; and in consequence, however delicate and exquisitely removed in tone their skies may be, you always look *at* them, not *through* them. Now if there be one characteristic of the sky more valuable or necessary to be rendered than another, it is that which Wordsworth has given in the second book of *The Excursion*:

> The chasm of sky above my head
> Is Heaven's profoundest azure; no domain
> For fickle, short-lived clouds, to occupy,
> Or to pass through; but rather an *abyss*
> In which the everlasting stars abide,
> And whose soft gloom, and boundless depth, might tempt
> The curious eye to look for them by day.

And in his *American Notes*, I remember Dickens notices the same truth, describing himself as lying drowsily on the barge deck, looking not at, but *through* the sky. And if you look intensely at the pure blue of a serene sky, you will see that there is a variety and fulness in its very repose. It is not flat dead colour, but a deep, quivering, transparent body of penetrable air, in which you trace or imagine short falling spots of deceiving light, and dim shades, faint veiled vestiges of dark vapour; and it is this trembling transparency which our great modern master has especially aimed at and given. His blue is never laid on in smooth coats, but in breaking, mingling, melting hues, a quarter of an inch of which, cut off from all the rest of the picture, is still *spacious*, still infinite and immeasurable in depth. It is a painting of the air, something into which you can see, through the parts which are near you, into those which are far off; something which has no surface and through which we can plunge far and farther, and without stay or end, into the profundity of space; whereas, with all the old landscape painters except Claude, you may indeed go a long way before you come to the sky, but you will strike hard against it at last.

Sunrise on the sea

Take, for instance, the illustrated edition of Rogers's Poems, and open it at the eightieth page, and observe how every attribute which I have pointed out in the upper sky is there rendered with the faithfulness of a mirror; the long lines of parallel bars, the delicate curvature from the wind, which the inclination of the sail shows you to be from the west; the excessive sharpness of every edge which is turned to the wind, the faintness of every opposite one, the breaking up of each bar into rounded masses; and finally, the inconceivable variety with which individual form has been given to every member of the multitude, and not only individual form, but roundness and substance even where there is scarcely a hair's-breadth of cloud to express them in. Observe above everything the varying indication of space and depth in the whole, so that you may look through and through from one cloud to another, feeling not merely how they retire to the horizon, but how they melt back into the recesses of the sky; every interval being filled with absolute air, and all its spaces so melting and fluctuating, and fraught with change as with repose, that as you look, you will fancy that the rays shoot higher and higher into the vault of light, and that the pale streak of horizontal vapour is melting away from the cloud that it crosses. Now watch for the next barred sunrise, and take this vignette to the window, and test it by nature's own clouds, among which you will find forms and passages, I do not say merely *like*, but apparently the actual originals of parts of this very drawing. And with whom will you do this, except with Turner? Will you do it with Claude, and set that

Sunrise on the Sea. Vignette from Rogers's Poems, *1834*

blank square yard of blue, with its round, white, flat fixtures of similar cloud, beside the purple infinity of nature, with her countless multitudes of shadowy lines, and flaky waves, and folded veils of variable mist? Will you do it with Poussin, and set those massy steps of unyielding solidity, with the chariot and four driving up them, by the side of the delicate forms which terminate in threads too fine for the eye to follow them, and of texture so thin woven that the earliest stars shine through them? Will you do it with Salvator, and set that volume of violent and restless manufactory smoke beside those calm and quiet bars, which pause in the heaven as if they would never leave it more?

Perpetual form

In the Long Ships Lighthouse, Land's End, we have clouds without rain, at twilight, enveloping the cliffs of the coast, but concealing nothing, every outline being visible through their gloom; and not only the outline, for it is easy to do this, but the *surface*. The bank of rocky coast approaches the spectator inch by inch, felt clearer and clearer as it withdraws from the garment of cloud; not by edges more and more defined, but by a surface more and more

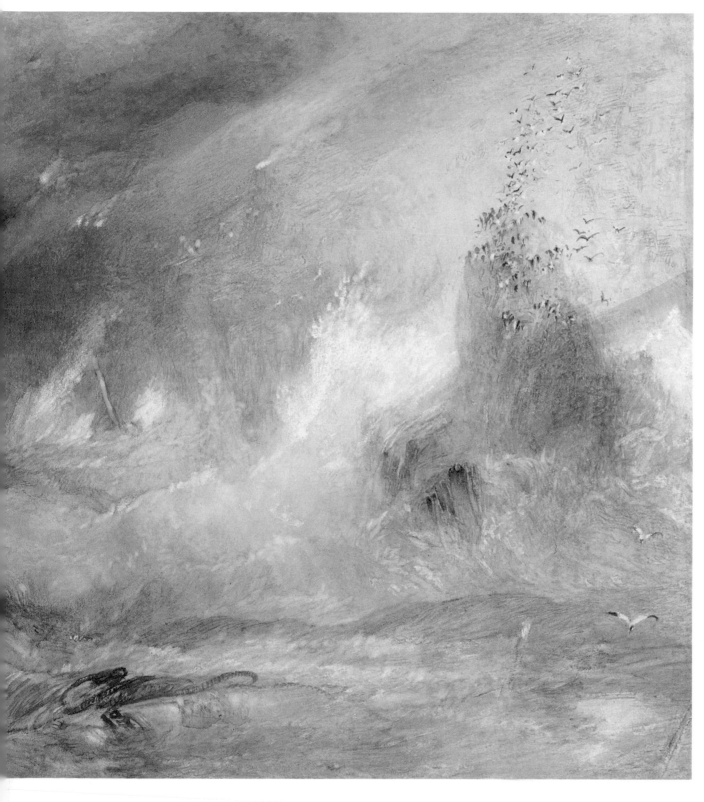

*Long Ships Lighthouse, Land's
End, c.1834-35*

unveiled. We have thus the painting, not of a mere transparent veil, but of a solid body of cloud, every inch of whose increasing distance is marked and felt. But the great wonder of the picture is the intensity of gloom which is attained in pure warm grey, without either blackness or blueness. It is a gloom dependent rather on the enormous space and depth indicated, than on actual pitch of colour; distant by real drawing, without a grain of blue; dark by real substance, without a stroke of blackness: and with all this, it is not formless, but full of indications of character, wild, irregular, shattered, and indefinite; full of the energy of storm, fiery in haste, and yet flinging back out of its motion the fitful swirls of bounding drift, of tortured vapour tossed up like men's hands, as in defiance of the tempest, the jets of resulting whirlwind, hurled back from the rocks into the face of the coming darkness, which, beyond all other characters, mark the raised passion of the elements. It is this untraceable, unconnected, yet perpetual form, this fulness of character absorbed in universal energy, which distinguish nature and Turner from all their imitators. To roll a volume of smoke before the wind, to indicate motion or violence by monotonous similarity of line and direction, is for the multitude; but to mark the independent passion, the tumultuous separate existence, of every wreath of writhing vapour, yet swept away and overpowered by one omnipotence of storm, and thus to bid us

> Be as a presence or a motion – one
> Among the many there; and while the mists
> Flying, and rainy vapours, call out shapes
> And phantoms from the crags and solid earth,
> As fast as a musician scatters sounds
> Out of an instrument, –
> [Wordsworth, *The Excursion*, Book IV]

this belongs only to nature and to him.

Infinity

As I before observed of mere execution, that one of the best tests of its excellence was the expression of *infinity*; so it may be noticed with respect to the painting of details generally, that more difference lies between one artist and another, in the attainment of this quality, than in any other of the efforts of art; and that if we wish, without reference to beauty of composition, or any other interfering circumstances, to form a judgement of the truth of painting, perhaps the very first thing we should look for, whether in one

thing or another – foliage, or clouds, or waves – should be the expression of *infinity* always and everywhere, in all parts and divisions of parts. For we may be quite sure that what is not infinite cannot be true. It does not, indeed, follow that what is infinite is always true, but it cannot be altogether false; for this simple reason, that it is impossible for mortal mind to compose an infinity of any kind for itself, or to form an idea of perpetual variation, and to avoid all repetition, merely by its own combining resources. The moment that we trust ourselves, we repeat ourselves, and therefore the moment we see in a work of any kind whatsoever the expression of infinity, we may be certain that the workman has gone to nature for it; while, on the other hand, the moment we see repetition, or want of infinity, we may be certain that the workman has *not* gone to nature for it . . .

When . . . we take up such a sky as that of Turner's Rouen seen from St Catherine's Hill, in the Rivers of France, and find, in the first place, that he has given us a distance over the hills in the horizon, into which when we are tired of penetrating, we must turn and come back again, there being not the remotest chance of getting to the end of it; and when we see that from this measureless distance up to the zenith, the whole sky is one ocean of alternate waves of cloud and light, so blended together that the eye cannot rest on any one without being guided to the next, and so to a hundred more, till it is lost over and over again in every

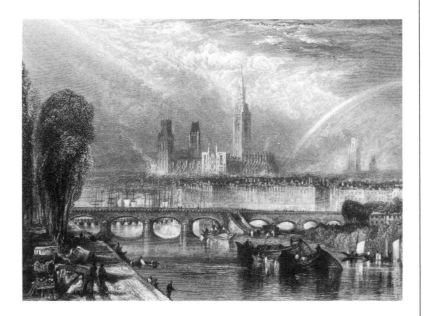

Rouen. Engraved in Turner's Annual Tour – the Seine, *1834*

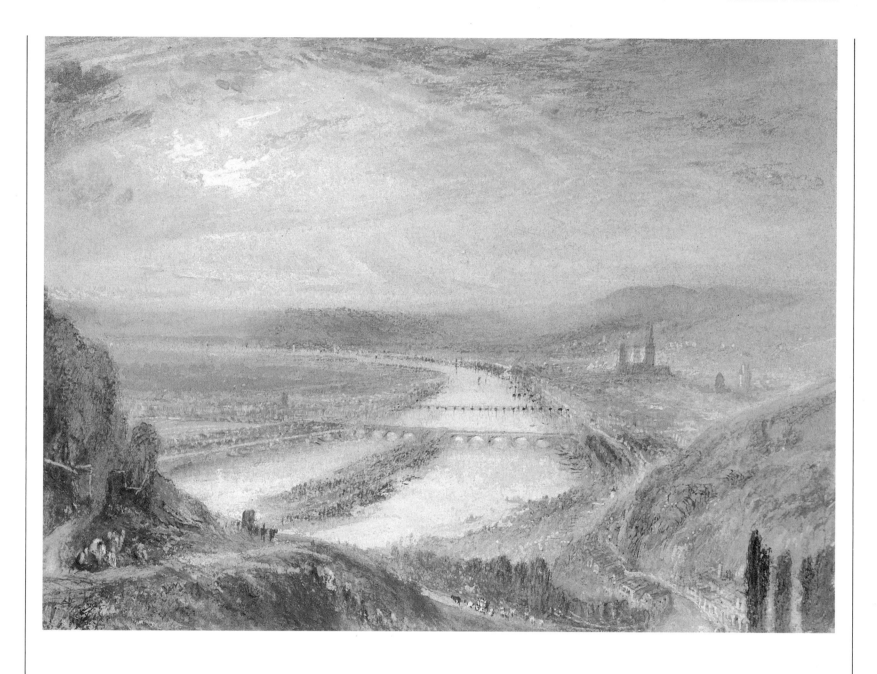

Rouen from St Catherine's Hill, c.1832

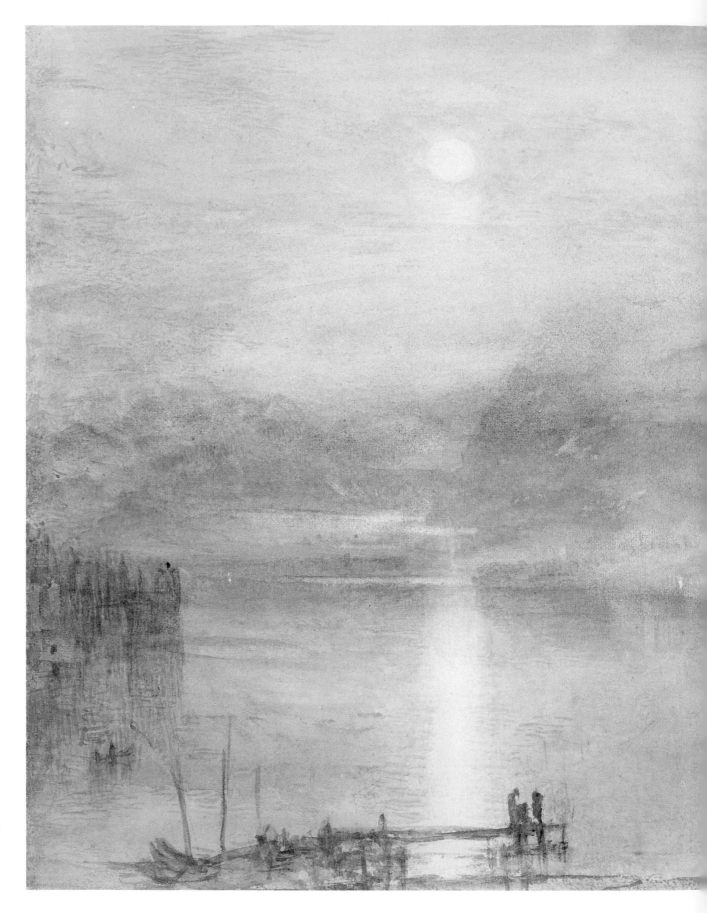

The Lake of Lucerne, Moonlight, the Righi in the distance, 1841

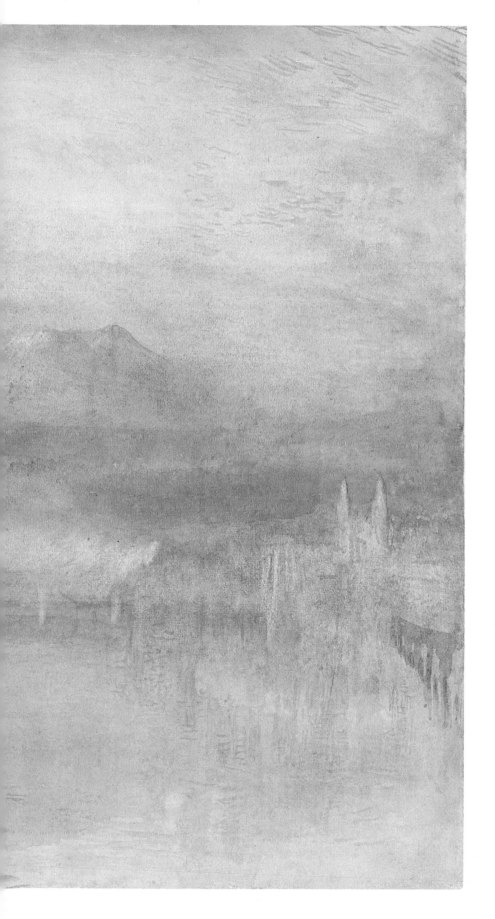

wreath; that if it divides the sky into quarters of inches, and tries to count or comprehend the component parts of any single one of those divisions, it is still as utterly defied and defeated by the part as by the whole; that there is not one line out of the millions there which repeats another, not one which is unconnected with another, not one which does not in itself convey histories of distance and space, and suggest new and changeful form; then we may be all but certain, though these forms are too mysterious and too delicate for us to analyse, though all is so crowded and so connected that it is impossible to test any single part by particular laws, yet without any such tests we may be sure that this infinity can only be based on truth, that it *must* be nature, because man could not have originated it, and that every form must be faithful, because none is like another. And therefore it is that I insist so constantly on this great quality of landscape painting, as it appears in Turner: because it is not merely a constant and most important truth in itself, but it almost amounts to a demonstration of every other truth. And it will be found a far rarer attainment in the works of other men than is commonly supposed, and the sign, wherever it is really found, of the very highest art. For we are apt to forget that the greatest *number* is no nearer infinity than the least, if it be definite number; and the vastest bulk is no nearer infinity than the most minute, if it be definite bulk; so that a man may multiply his objects for ever and ever, and be no nearer infinity than he had reached with one, if he do not vary them and confuse them; and a man may reach infinity in every touch and line, and part, and unit, if in these he be truthfully various and obscure. And we shall find, the more we examine the works of the old masters, that always, and in all parts, they are totally wanting in every feeling of infinity, and therefore in *all* truth: and even in the works of the moderns, though the aim is far more just, we shall frequently perceive an erroneous choice of means, and a substitution of mere number or bulk for real infinity.

Mist

I need not, however, insist upon Turner's peculiar power of rendering *mist*, and all those passages of confusion between earth and air, when the mountain is melting into the cloud, or the horizon into the twilight; because his supremacy in these points is altogether undisputed, except by persons to whom it would be impossible to prove anything which did not fall under the form of a Rule of Three. Nothing is more natural than that the studied form and colour of this great artist should be little understood,

because they require, for the full perception of their meaning and truth, such knowledge and such time as not one in a thousand possesses, or can bestow; but yet the truth of them for that very reason is capable of demonstration, and there is hope of our being able to make it in some degree felt and comprehended even by those to whom it is now a dead letter, or an offence. But the aërial and misty effects of landscape, being matters of which the eye should be simply cognizant, and without effort of thought, as it is of light, must, where they are exquisitely rendered, either be felt at once, or prove that degree of blindness and bluntness in the feelings of the observer which there is little hope of ever conquering. Of course, for persons who have never seen in their lives a cloud vanishing on a mountain side, and whose conceptions of mist or vapour are limited to ambiguous outlines of spectral hackney-coaches and bodiless lamp-posts, discerned through a brown combination of sulphur, soot, and gas-light, there is yet some hope; we cannot indeed tell them what the morning mist is like in mountain air, but far be it from us to tell them that they are incapable of feeling its beauty if they will seek it for themselves. But if you have ever in your life had one opportunity, with your eyes and heart open, of seeing the dew rise from a hill pasture, or the storm gather on a sea-cliff, and if you yet have no feeling for the glorious passages of mingled earth and heaven which Turner calls up before you into breathing tangible being, there is indeed no hope for your apathy, art will never touch you, nor nature inform.

Colour in the sky

But is it singular enough that the chief attacks on Turner for overcharged brilliancy are made, not when there could by any possibility be any chance of his outstepping nature, but when he has taken subjects which no colours of earth could ever vie with or reach, such, for instance, as his sunsets among the high clouds. When I come to speak of skies, I shall point out what divisions, proportioned to their elevation, exist in the character of clouds. It is the highest region, that exclusively characterized by white, filmy, multitudinous, and quiet clouds, arranged in bars, or streaks, or flakes, of which I speak at present; a region which no landscape painters have ever made one effort to represent, except Rubens and Turner, the latter taking it for his most favourite and frequent study. Now we have been speaking hitherto of what is constant and necessary in nature, of the ordinary effects of daylight on ordinary colours, and we repeat again, that no gorgeous-

ness of the pallet can reach even these. But it is a widely different thing when nature herself takes a colouring fit, and does something extraordinary, something really to exhibit her power. She has a thousand ways and means of rising above herself, but incomparably the noblest manifestations of her capability of colour are in these sunsets among the high clouds. I speak especially of the moment before the sun sinks, when his light turns pure rose-colour, and when this light falls upon a zenith covered with countless cloud-forms of inconceivable delicacy, threads and flakes of vapour, which would in common daylight be pure snow-white, and which give therefore fair field to the tone of light. There is then no limit to the multitude, and no check to the intensity, of the hues assumed. The whole sky from the zenith to the horizon becomes one molten mantling sea of colour and fire; every black bar turns into massy gold, every ripple and wave into unsullied shadowless crimson, and purple, and scarlet, and colours for which there are no words in language, and no ideas in the mind – things which can only be conceived while they are visible; the intense hollow blue of the upper sky melting through it all, showing here deep, and pure, and lightless; there, modulated by the filmy formless body of the transparent vapour, till it is lost imperceptibly in its crimson and gold. Now there is no connection, no one link of association or resemblance between those skies and the work of any mortal hand but Turner's. He alone has followed nature in these her highest efforts; he follows her faithfully, but far behind; follows at such a distance below her intensity that the Napoleon of last year's Exhibition, and the Téméraire of the year before, would look colourless and cold if the eye came upon them after one of nature's sunsets among the high clouds. But there are a thousand reasons why this should not be believed. The concurrence of circumstances necessary to produce the sunsets of which I speak does not take place above five or six times in a summer, and then only for a space of from five to ten minutes, just as the sun reaches the horizon. Considering how seldom people think of looking for a sunset at all, and how seldom, if they do, they are in a position from which it can be fully seen, the chances that their attention should be awake, and their position favourable, during these few flying instants of the year, are almost as nothing. What can the citizen, who can see only the red light on the canvas of the waggon at the end of the street, and the crimson colour of the bricks of his neighbour's chimney, know of the flood of fire which deluges the sky from the horizon to the zenith? What can even the quiet inhabitant of the English lowlands, whose scene for the manifestation of the fire of heaven is limited to the tops of hayricks, and the rooks' nests in the old elm trees, know of the

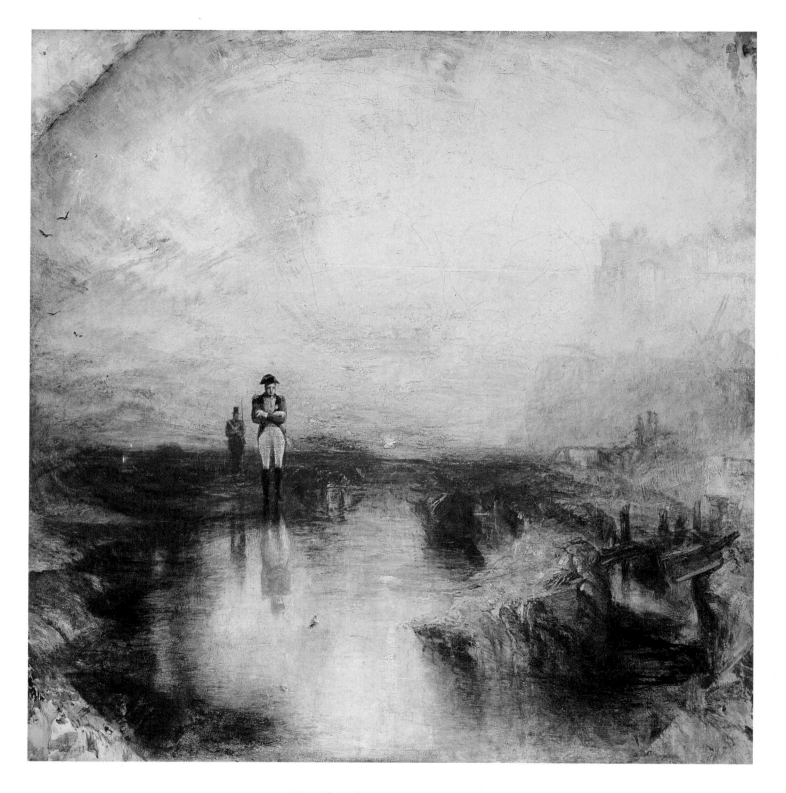

War: The Exile and the Rock Limpet, 1842

Sunset, 1845-50

mighty passages of splendour which are tossed from Alp to Alp over the azure of a thousand miles of champaign? Even granting the constant vigour of observation, and supposing the possession of such impossible knowledge, it needs but a moment's reflection to prove how incapable the memory is of retaining for any time the distinct image of the sources even of its most vivid impressions. What recollection have we of the sunsets which delighted us last year? We may know that they were magnificent, or glowing, but no distinct image of colour or form is retained – nothing of whose *degree* (for the great difficulty with the memory is to retain, not facts, but *degrees* of fact) we could be so certain as to say of anything now presented to us, that it is like it. If we did say so, we should be wrong; for we may be quite certain that the energy of an impression fades from the memory, and becomes more and more indistinct every day; and thus we compare a faded and indistinct image with the decision and certainty of one present to the senses. How constantly do we affirm that the thunderstorm of last week was the most terrible one we ever saw in our lives, because we compare it, not with the thunderstorm of last year, but with the faded and feeble recollection of it! And so, when we enter an Exhibition, as we have no definite standard of truth before us, our feelings are toned down and subdued to the quietness of colour, which is all that human power can ordinarily attain to; and when we turn to a piece of higher and closer truth, approaching the pitch of the colour of nature, but to which we are not guided, as we should be in nature, by corresponding gradations of light everywhere around us, but which is isolated and cut off suddenly by a frame and a wall, and surrounded by darkness and coldness, what can we expect but that it should surprise and shock the feelings? Suppose where the 'Napoleon' hung in the Academy, there could have been left, instead, an opening in the wall, and through that opening, in the midst of the obscurity of the dim room and the smoke-laden atmosphere, there could suddenly have been poured the full glory of a tropical sunset, reverberated from the sea; how would you have shrunk, blinded, from its scarlet and intolerable lightnings! What picture in the room would not have been blackness after it? And why then do you blame Turner because he dazzles you? Does not the falsehood rest with those who do *not*? There was not one hue in this whole picture which was not far below what nature would have used in the same circumstances, nor was there one inharmonious or at variance with the rest. The stormy blood-red of the horizon, the scarlet of the breaking sunlight, the rich crimson browns of the wet and illumined sea-weed, the pure gold and purple of the upper sky, and, shed through it all, the deep passage of solemn

blue, where the cold moonlight fell on one pensive spot of the limitless shore – all were given with harmony as perfect as their colour was intense; and if, instead of passing, as I doubt not you did, in the hurry of your unreflecting prejudice, you had paused but so much as one quarter of an hour before the picture, you would have found the sense of air and space blended with every line, and breathing in every cloud, and every colour instinct and radiant with visible, glowing, absorbing light.

The cloud-balancings

We have seen that when the earth had to be prepared for the habitation of man, a veil, as it were, of intermediate being was spread between him and its darkness, in which were joined, in a subdued measure, the stability and insensibility of the earth, and the passion and perishing of mankind.

But the heavens, also, had to be prepared for his habitation.

Between their burning light, their deep vacuity, and man, as between the earth's gloom of iron substance, and man, a veil had to be spread of intermediate being; which should appease the unendurable glory to the level of human feebleness, and sign the changeless motion of the heavens with a semblance of human vicissitude.

Between the earth and man arose the leaf. Between the heaven and man came the cloud. His life being partly as the falling leaf, and partly as the flying vapour.

Has the reader any distinct idea of what clouds are? We had some talk about them long ago, and perhaps thought their nature, though at that time not clear to us, would be easily enough understandable when we put ourselves seriously to make it out. Shall we begin with one or two easiest questions?

That mist which lies in the morning so softly in the valley, level and white, through which the tops of the trees rise as if through an inundation – why is *it* so heavy? and why does it lie so low, being yet so thin and frail that it will melt away utterly into splendour of morning, when the sun has shone on it but a few moments more? Those colossal pyramids, huge and firm, with outlines as of rocks, and strength to bear the beating of the high sun full on their fiery flanks – why are *they* so light, their bases high over our heads, high over the heads of the Alps? why will these melt away, not as the sun *rises*, but as he *descends*, and leave the stars of twilight clear, while the valley vapour gains again upon the earth like a shroud?

Or that ghost of a cloud, which steals by yonder clump of pines: nay, which does *not* steal by them, but haunts them, wreathing yet

round them, and yet – and yet, slowly: now falling in a fair waved line like a woman's veil; now fading, now gone: we look away for an instant, and look back, and it is again there. What has it to do with that clump of pines, that it broods by them and weaves itself among their branches, to and fro? Has it hidden a cloudy treasure among the moss at their roots, which it watches thus? Or has some strong enchanter charmed it into fond returning, or bound it fast within those bars of bough? And yonder filmy crescent, bent like an archer's bow above the snowy summit, the highest of all the hill – that white arch which never forms but over the supreme crest – how is it stayed there, repelled apparently from the snow – nowhere touching it, the clear sky seen between it and the mountain edge, yet never leaving it – poised as a white bird hovers over its nest?

Or those war-clouds that gather on the horizon, dragon-crested, tongued with fire – how is their barbed strength bridled? what bits are these they are champing with their vaporous lips; flinging off flakes of black foam? Leagued leviathans of the Sea of Heaven, out of their nostrils goeth smoke, and their eyes are like the eyelids of the morning. The sword of him that layeth at them cannot hold; the spear, the dart, nor the habergeon. [Job 41:20, 18, 26] Where ride the captains of their armies? Where are set the measures of their march? Fierce murmurers, answering each other from morning until evening – what rebuke is this which has awed them into peace? what hand has reined them back by the way by which they came?

I know not if the reader will think at first that questions like these are easily answered. So far from it, I rather believe that some of the mysteries of the clouds never will be understood by us at all. 'Knowest thou the balancings of the clouds?' Is the answer ever to be one of pride? 'The wondrous works of Him which is *perfect* in knowledge?' [Job 37:16] Is *our* knowledge ever to be so?

The roofs of Fribourg

Out of a book containing fourteen sketches of this city; all more or less elaborate; and showing the way in which he used the pencil and pen together, up to the latest hour of his artist's life. The lesson ought surely not to be lost upon us when we consider that from Turner, least of all men, such indefatigable delineation was to have been expected; since his own special gift was that of expressing mystery, and the obscurities rather than the definitions of form. If a single title were to be given, to separate him from others, it ought to be 'the painter of clouds': this he was in earliest life; and this he

was, in heart and purpose, even when he was passing days in drawing the house roofs of Fribourg; for the sketches which at that period he liked to be asked to complete were such as those in the hundredth frame, of soft cloud wreathing above the deep Swiss waters.

All other features of natural scenery had been in some sort rendered before; mountains and trees by Titian, sun and moon by Cuyp and Rubens, air and sea by Claude. But the burning clouds in their courses, and the frail vapours in their changes, had never been so much as attempted by any man before him. The first words which he ever wrote, as significative of his aim in painting, were Milton's, beginning 'Ye mists and exhalations'. And the last drawing in which there remained a reflection of his expiring power, he made in striving to realise, for me, one of these faint and fair visions of the morning mist, fading from the Lake Lucerne.

'There ariseth a little cloud out of the sea, like a man's hand.'
'For what is your life?'[1]

The storm-cloud

Thursday, 22nd February 1883
Yesterday a fearfully dark mist all afternoon, with steady, south plague-wind of the bitterest, nastiest, poisonous blight, and fretful flutter. I could scarcely stay in the wood for the horror of it. Today, really rather bright blue and semi-cumuli, with the frantic Old Man blowing sheaves of lancets and chisels across the lake – not in strength enough, or whirl enough, to raise it in spray, but tracing every squall's outline in black on the silver grey waves, and whistling meanly, and as if on a flute made of a file.

Sunday, 17th August 1879
Raining in foul drizzle, slow and steady; sky pitch-dark, and I just get a little light by sitting in the bow-window; diabolic clouds over everything: and looking over my kitchen garden yesterday, I found it one miserable mass of weeds gone to seed, the roses in the higher garden putrefied into brown sponges, feeling like dead snails; and the half-ripe strawberries all rotten at the stalks.

And now I come to the most important sign of the plague-wind and the plague-cloud: that in bringing on their peculiar darkness, they *blanch* the sun instead of reddening it. And here I must note

1 1 Kings 18:44; James 4:14 – 'For what is your life? It is even a vapour, that appeareth for a little time and then vanisheth away'.

Fribourg, 1841

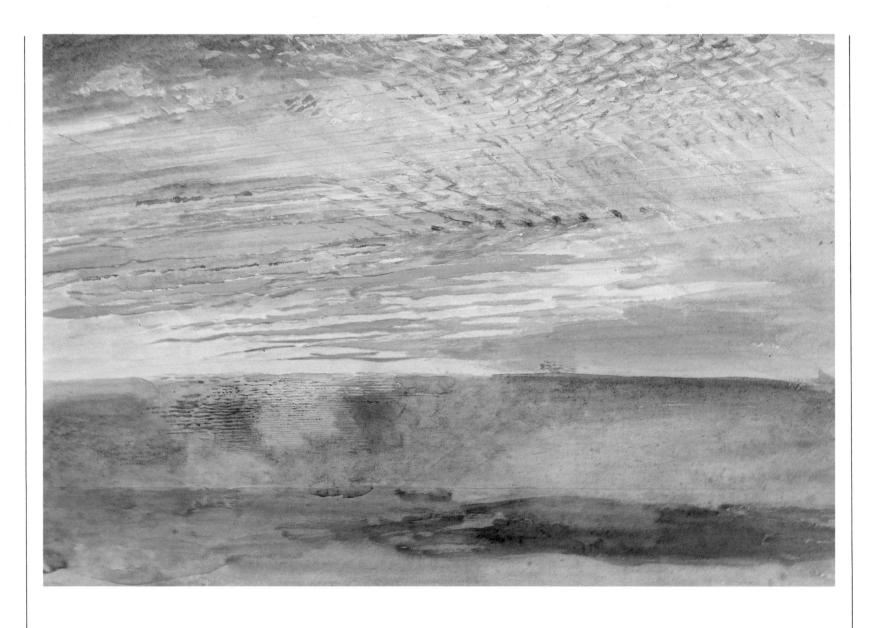

Ruskin: Sunset through London smoke, from Herne Hill, 1876

briefly to you the uselessness of observation by instruments, or machines, instead of eyes. In the first year when I had begun to notice the specialty of the plague-wind, I went of course to the Oxford observatory to consult its registrars. They have their anemometer always on the twirl, and can tell you the force, or at least the pace, of a gale, by day or night. But the anemometer can only record for you how often it has been driven round, not at all whether it went round *steadily*, or went round *trembling*. And on that point depends the entire question whether it is a plague breeze or a healthy one: and what's the use of telling you whether the wind's strong or not, when it can't tell you whether it's a strong medicine, or a strong poison?

But again – you have your *sun*-measure, and can tell exactly at any moment how strong, or how weak, or how wanting, the sun is. But the sun-measurer can't tell you whether the rays are stopped by a dense *shallow* cloud, or a thin *deep* one. In healthy weather, the sun is hidden behind a cloud, as it is behind a tree; and, when the cloud is past, it comes out again, as bright as before. But in plague-wind, the sun is choked out of the whole heaven, all day long, by a cloud which may be a thousand miles square and five miles deep.

And yet observe: that thin, scraggy, filthy, mangy, miserable cloud, for all the depth of it, can't turn the sun red, as a good, business-like fog does with a hundred feet or so of itself. By the plague-wind every breath of air you draw is polluted, half round the world; in a London fog the air itself is pure, though you choose to mix up dirt with it, and choke yourself with your own nastiness.

Now I'm going to show you a diagram of a sunset in entirely pure weather, above London smoke. I saw it and sketched it from my old post of observation – the top garret of my father's house at Herne Hill. There, when the wind is south, we are outside of the smoke and above it; and this diagram, admirably enlarged from my own drawing by my, now in all things best aide-de-camp, Mr Collingwood, shows you an old-fashioned sunset – the sort of thing Turner and I used to have to look at (nobody else ever would), constantly. Every sunset and every dawn, in fine weather, had something of the sort to show us. This is one of the last pure sunsets I ever saw, about the year 1876 – and the point I want you to note in it is, that the air being pure, the smoke on the horizon, though at last it hides the sun, yet hides it through gold and vermilion. Now, don't go away fancying there's any exaggeration in that study. The *prismatic* colours, I told you, were simply impossible to paint; these, which are transmitted colours, can indeed be suggested, but no more. The brightest pigment we have would look dim beside the truth.

I should have liked to have blotted down for you a bit of plague-cloud to put beside this; but Heaven knows, you can see enough of it nowadays without any trouble of mine; and if you want, in a hurry, to see what the sun looks like through it, you've only to throw a bad half-crown into a basin of soap and water.

Blanched Sun – blighted grass – blinded man. If, in conclusion, you ask me for any conceivable cause or meaning of these things – I can tell you none, according to your modern beliefs; but I can tell you what meaning it would have borne to the men of old time. Remember, for the last twenty years, England, and all foreign nations, either tempting her, or following her, have blasphemed the name of God deliberately and openly; and have done iniquity by proclamation, every man doing as much injustice to his brother as it is in his power to do. Of states in such moral gloom every seer of old predicted the physical gloom, saying, 'The light shall be darkened in the heavens thereof, and the stars shall withdraw their shining.' [Joel 2:10] All Greek, all Christian, all Jewish prophecy insists on the same truth through a thousand myths; but of all the chief, to former thought, was the fable of the Jewish warrior and prophet, for whom the sun hasted not to go down [see Joshua 10:13], with which I leave you to compare at leisure the physical result of your own wars and prophecies, as declared by your own elect journal not fourteen days ago – that the Empire of England, on which formerly the sun never set, has become one on which he never rises.[1]

1 The reference is to the *Pall Mall Gazette*. On 2 January it had published the report of 'registered sunshine' for the week ending 29 December; namely, 'nil'. The sunless weather continued, and on 23 January the *Gazette* published 'the following simple ditty:

> Old England is afraid of none,
> She fears no foemen's threats,
> For on her mighty empire
> The sun it never sets.
>
> He who retails this axiom in
> His generation wise is;
> The sun it never sets because
> The sun it never rises.' C. & W.

The Multitudinous Sea

For Turner and for Ruskin, the sea represents power. The land may be cultivated and inhabited, and it carries the ineradicable traces of the generations of lives it has supported. But the sea does not. Those who live by the ocean are always at its disposal – sometimes flourishing by means of the traffic it makes possible, sometimes menaced or destroyed by its uncontrollable storms. Ruskin was elated and disturbed by the inhuman vitality of the sea, and wrote about it again and again. It seemed to him the manifest expression of our fragility in the face of natural forces.

This was not in itself a new perception: artists and poets had been recording the terrors of tempests and shipwrecks for centuries, and they had done so with special zest in the Romantic period. Turner developed this interest to a new pitch of intensity. But he was always inclined to focus our gaze on the human side of the association between the sailors and the sea, whereas in Ruskin's early years it was above all the sea itself that he wanted to observe and to celebrate. This difference in emphasis is marked in Ruskin's account of Turner's great oil painting, *Slavers throwing overboard the dead and dying – Typhoon coming on*. The picture, painted in 1840, was among Turner's recent works when Ruskin wrote about it in 1843. What he had to say about the *Slavers* quickly became one of the most famous commentaries on Turner's art in existence, and has remained so. It is not hard to see why. Ruskin's awed account of the tumult in Turner's picture makes exhilarating reading. Yet to compare his extraordinary evocation with the picture itself is to be sharply reminded of their diverse lines of vision.

Turner's picture is an expression of horror, as its title suggests. We glimpse the ill-fated slaves struggling in the waves, still in chains. These grim images are a testimony of outrage, and they demand our attention. Ruskin had no quarrel with Turner's view of the slavers' activities, speaking of the ship as 'guilty'. But the subject of the painting is in his description demoted to a calm footnote: 'She is a slaver, throwing her slaves overboard. The near sea is encumbered with corpses.' What matters to him is the sea. It is the ocean, not the slaver, that is described by Ruskin as 'lurid', 'ghastly', 'sepulchral'. As Ruskin sees it, Turner's sea is a spectacle containing both human cruelty and divine anger. It has become the agent of universal destruction.

But only 'the concentrated knowledge of a life' had enabled Turner to paint this deathful sea. Ruskin is confident that the picture contains no 'morbid hue', praising it as 'ideal in the highest sense of the word'. He exulted in its confidence and power. For many years after, the *Slavers* became a regular presence in his life, for it was among the pictures that John James Ruskin gave to his son. It must have made a sobering companion. Feeling the immanence of suffering and mortality more directly as the years went by, Ruskin was eventually to sell it.

In Ruskin's early and middle years, it was most often the wild moods of the sea that took his attention and admiration. They spoke most clearly of the immensity of its power. But Ruskin never repeats himself in speaking of Turner's treatment of threatening seascapes. Just as no two skies in Turner's pictures are alike, so, Ruskin teaches us, no two seas express the same truths. Waves are not simply a rising and falling of salt water. As Ruskin evokes them, we

see that the breakers are as individual as clouds, and that they too carry a body of distinct meaning. A sea, as painted by Turner and described by Ruskin, becomes an appropriate subject for the most detailed contemplation. Ruskin's interest in Turner's *Laugharne Castle* is characteristic. We find him speaking, for instance, of the 'undulating lines' of the surging swell, 'whose grace and variety might alone serve us for a day's study'. The sea's danger expresses itself in beauty which must be acknowledged and contemplated.

As Ruskin grew older, he wrote about the sea from changing perspectives. In 1856, he published *The Harbours of England*, a commentary on twelve Turner plates depicting English coastal towns. In this book he broods on what the sea has meant to English character. Again, hardly a new subject – particularly at a time when the imperial and commercial expansion of the nation was at its height. Ruskin saw and admired the courage of sailors. But he always thought of himself as more Scottish than English, and he looked on English maritime pride with the eye of an outsider. He never forgot that it was based on uncertainty, vulnerability, risk. These are facts that he perceived as paramount in Turner's understanding of shipping and the sea: 'namely, that both ships and sea were things that broke to pieces'.

Nothing about the sea is permanent, even its dignity. Ruskin's meditation on Turner's elegiac picture *The Fighting Téméraire, tugged to her last berth to be broken up* may be read as an essay in patriotism. But it is also a deeply felt sermon on the limitations of patriotism. Military triumphs do not last; ships, like men, are mortal.

In his account of Turner's *Scarborough*, Ruskin reminds us of what does endure. Ruskin understands this picture as an expression of calm, and his study of the means by which its 'infinitude of peace' is achieved is one of his most penetrating explorations of Turner's art. In the first volume of *Modern Painters*, he had insisted that only Turner had the power to be faithful to nature, and that natural truth was wholly expressed in what we see. Now he goes further. As the concept of nature acquires a more abstract identity in his thought, it follows that fidelity to her teaching sometimes means moving beyond the appearances of fact. Ruskin asks us to look at the two piers in the picture: 'In all probability, the more distant pier would in reality, unless it is very greatly higher than the near one, have been lowered by perspective so as not to continue in the same longitudinal line at the top, – but Turner will not have it so'. Turner alters material fact to express truth more fully. Yet the most profound truths of nature must lie beyond his or any other art. Ruskin had written of the mastery that had enabled Turner to express the turbulence of the sea. Now he quietly confesses that 'the successive sigh and vanishing of the slow waves upon the sand, no art can render to us.'

*'Soapsuds and whitewash'! What would they have? I wonder what they think
the sea's like. I wish they'd been in it.*
J. M. W. Turner, responding to critics of his 'Snow Storm'

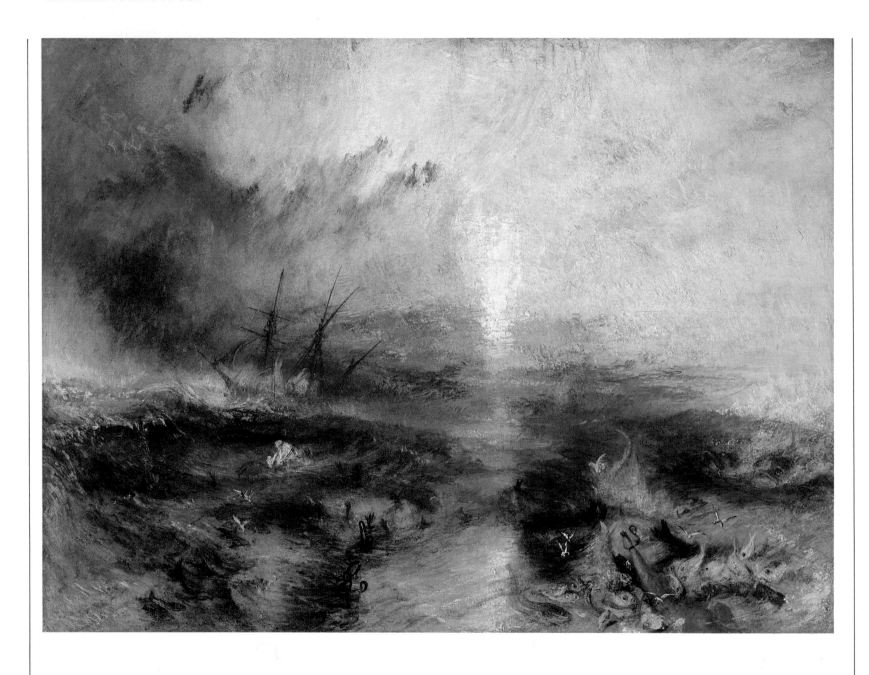

Slavers throwing overboard the dead and dying – Typhoon coming on, 1840

The open sea

BUT I THINK, the noblest sea that Turner has ever painted, and, if so, the noblest certainly ever painted by man, is that of the Slave Ship, the chief Academy picture of the Exhibition of 1840. It is a sunset on the Atlantic, after prolonged storm; but the storm is partially lulled, and the torn and streaming rain-clouds are moving in scarlet lines to lose themselves in the hollow of the night. The whole surface of sea included in the picture is divided into two ridges of enormous swell, not high, nor local, but a low broad heaving of the whole ocean, like the lifting of its bosom by deep-drawn breath after the torture of the storm. Between these two ridges the fire of the sunset falls along the trough of the sea, dyeing it with an awful but glorious light, the intense and lurid splendour which burns like gold, and bathes like blood. Along this fiery path and valley, the tossing waves by which the swell of the sea is restlessly divided, lift themselves in dark, indefinite, fantastic forms, each casting a faint and ghastly shadow behind it along the illumined foam. They do not rise everywhere, but three or four together in wild groups, fitfully and furiously, as the under strength of the swell compels or permits them; leaving between them treacherous spaces of level and whirling water, now lighted with green and lamp-like fire, now flashing back the gold of the declining sun, now fearfully dyed from above with the undistinguishable images of the burning clouds, which fall upon them in flakes of crimson and scarlet, and give to the reckless waves the added motion of their own fiery flying. Purple and blue, the lurid shadows of the hollow breakers are cast upon the mist of night, which gathers cold and low, advancing like the shadow of death upon the guilty[1] ship as it labours amidst the lightning of the sea, its thin masts written upon the sky in lines of blood, girded with condemnation in that fearful hue which signs the sky with horror, and mixes its flaming flood with the sunlight, and, cast far along the desolate heave of the sepulchral waves, incarnadines the multitudinous sea.[2]

I believe, if I were reduced to rest Turner's immortality upon any single work, I should choose this. Its daring conception, ideal in the highest sense of the word, is based on the purest truth, and wrought out with the concentrated knowledge of a life; its colour is absolutely perfect, not one false or morbid hue in any part or line, and so modulated that every square inch of canvas is a perfect composition; its drawing as accurate as fearless; the ship buoyant, bending, and full of motion; its tones as true as they are wonderful; and the whole picture dedicated to the most sublime of subjects and impressions (completing thus the perfect system of all truth, which we have shown to be formed by Turner's works) — the power, majesty, and deathfulness of the open, deep, illimitable sea.

Weight and power

Aiming at these grand characters of the sea, Turner almost always places the spectator, not on the shore, but twenty or thirty yards from it, beyond the first range of the breakers, as in the Land's End, Fowey, Dunbar, and Laugharne. The latter has been well engraved, and may be taken as a standard of the expression of fitfulness and power[1]. The grand division of the whole space of the sea by a few dark continuous furrows of tremendous swell (the breaking of one of which alone has strewed the rocks in front with ruin) furnishes us with an estimate of space and strength, which at once reduces the men upon the shore to insects; and yet through this terrific simplicity there are indicated a fitfulness and fury in the tossing of the individual lines, which give to the whole sea a wild, unwearied, reckless incoherency, like that of an enraged multitude, whose masses act together in phrensy, while not one individual feels as another. Especial attention is to be directed to the flatness of all the lines, for the same principle holds in sea which we have seen in mountains. All the size and sublimity of nature are given not by the height, but by the breadth, of her masses; and Turner, by following her in her sweeping lines, while he does not lose the elevation of its surges, adds in a tenfold degree to their power. Farther, observe the peculiar expression of *weight* which there is in Turner's waves, precisely of the same kind which we saw in his waterfall. We have not a cutting, springing, elastic line; no jumping or leaping in the waves: *that* is the characteristic of Chelsea Reach or Hampstead Ponds in a storm. But the surges roll and plunge with such prostration and hurling of their mass against the shore, that we feel the rocks are shaking under them. And, to add yet more to this impression, observe how little, comparatively, they are broken by the wind: above the floating wood, and along the shore, we have indication of a line of torn spray; but it is a mere fringe along the ridge of the surge, no interference with its gigantic body. The wind has no power over its tremendous unity of force and weight. Finally, observe how, on

1 She is a slaver, throwing her slaves overboard. The near sea is encumbered with corpses. J.R.
2 This my hand will rather
 The multitudinous seas incarnadine
 Making the green, one red.—*Macbeth*, ii. 2. 62.

1 The original watercolour is reproduced here. D.B.

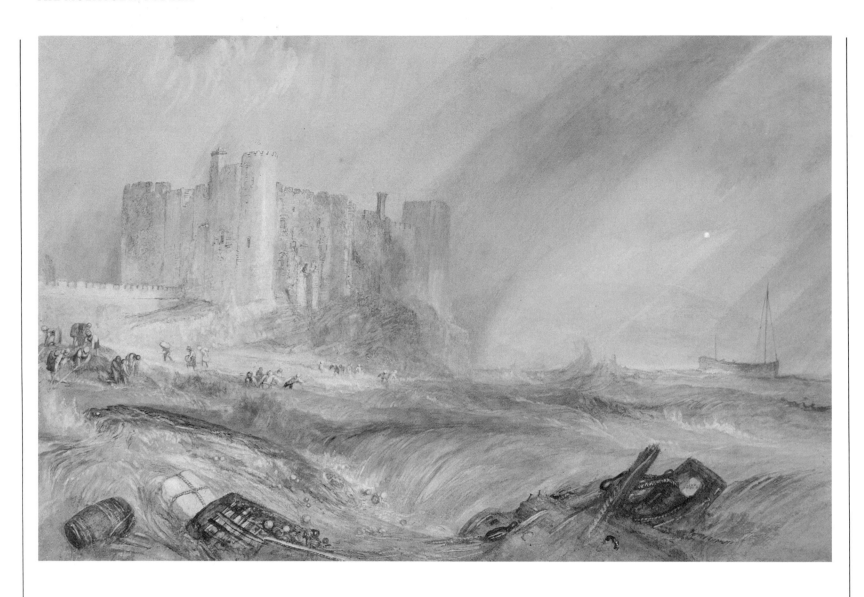

Laugharne Castle, Carmarthenshire, Coast of South Wales, c.1831

the rocks on the left, the violence and swiftness of the rising wave are indicated by precisely the same lines which we saw were indicative of fury in the torrent. The water on these rocks is the body of the wave which has just broken, rushing up over them; and in doing so, like the torrent, it does not break, nor foam, nor part upon the rock, but accomodates itself to every one of its swells and hollows with undulating lines, whose grace and variety might alone serve us for a day's study; and it is only where two streams of this rushing water meet in the hollow of the rock, that their force is shown by the vertical bound of the spray.

In the distance of this grand picture there are two waves which entirely depart from the principle observed by all the rest, and spring high into the air. They have a message for us which it is important that we should understand. Their leap is not a preparation for breaking, neither is it caused by their meeting with a rock. It is caused by their encounter with the recoil of the preceding wave. When a large surge, in the act of breaking, just as it curls over, is hurled against the face either of a wall or of a vertical rock, the sound of the blow is not a crash, nor a roar, it is a report as loud as, and in every respect similar to, that of a great gun, and the wave is dashed back from the rock with force scarcely diminished, but reversed in direction; it now recedes from the shore, and at the instant that it encounters the following breaker, the result is the vertical bound of both which is here rendered by Turner. Such a recoiling wave will proceed out to sea through ten or twelve ranges of following breakers, before it is overpowered.

Boats

Of all things, living or lifeless, upon this strange earth, there is but one which, having reached the mid-term of appointed human endurance on it, I still regard with unmitigated amazement. I know, indeed, that all around me is wonderful – but I cannot answer it with wonder: a dark veil, with the foolish words, *nature of things*, upon it, casts its deadening folds between me and their dazzling strangeness. Flowers open, and stars rise, and it seems to me they could have done no less. The mystery of distant mountain-blue only makes me reflect that the earth is of necessity mountainous; the sea-wave breaks at my feet, and I do not see how it should have remained unbroken. But one object there is still, which I never pass without the renewed wonder of childhood, and that is the bow of a Boat. Not of a racing-wherry, or revenue cutter, or clipper yacht; but the blunt head of a common, bluff, undecked sea-boat, lying aside in its furrow of beach sand.

The sum of Navigation is in that. You may magnify it or decorate it as you will: you do not add to the wonder of it. Lengthen it into hatchet-like edge of iron, strengthen it with complex tracery of ribs of oak, carve it and gild it till a column of light moves beneath it on the sea – you have made no more of it than it was at first. That rude simplicity of bent plank, that can breast its way through the death that is in the deep sea, has in it the soul of shipping. Beyond this, we may have more work, more men, more money; we cannot have more miracle.

For there is, first, an infinite strangeness in the perfection of the thing, as work of human hands. I know nothing else that man does, which is perfect, but that. All his other doings have some sign of weakness, affectation, or ignorance in them. They are overfinished or underfinished; they do not quite answer their end, or they show a mean vanity in answering it too well.

But the boat's bow is naïvely perfect: complete without an effort. The man who made it knew not he was making anything beautiful, as he bent its planks into those mysterious, ever-changing curves. It grows under his hand into the image of a sea-shell; the seal, as it were, of the flowing of the great tides and streams of ocean stamped on its delicate rounding. He leaves it when all is done, without a boast. It is simple work, but it will keep out water. And every plank thenceforward is a Fate, and has men's lives wreathed in the knots of it, as the cloth-yard shaft had their deaths in its plumes.

Then, also, it is wonderful on account of the greatness of the thing accomplished. No other work of human hands ever gained so much. Steam-engines and telegraphs indeed help us to fetch, and carry, and talk; they lift weights for us, and bring messages, with less trouble than would have been needed otherwise; this saving of trouble, however, does not constitute a new faculty, it only enhances the powers we already possess. But in that bow of the boat is the gift of another world. Without it, what prison wall would be so strong as that 'white and wailing fringe' of sea? What maimed creatures were we all, chained to our rocks, Andromeda-like, or wandering by the endless shores, wasting our incommunicable strength, and pining in hopeless watch of unconquerable waves! The nails that fasten together the planks of the boat's bow are the rivets of the fellowship of the world. Their iron does more than draw lightning out of heaven, it leads love round the earth.

Then also, it is wonderful on account of the greatness of the enemy that it does battle with. To lift dead weight; to overcome length of languid space; to multiply or systematise a given force; this we may see done by the bar, or beam, or wheel, without wonder. But to war with that living fury of waters, to bare its

49

breast, moment after moment, against the unwearied enmity of ocean – the subtle, fitful, implacable smiting of the black waves, provoking each other on, endlessly, all the infinite march of the Atlantic rolling on behind them to their help – and still to strike them back into a wreath of smoke and futile foam, and win its way against them, and keep its charge of life from them; does any other soulless thing do as much as this?

I should not have talked of this feeling of mine about a boat, if I had thought it was mine only; but I believe it to be common to all of us who are not seamen. With the seaman, wonder changes into fellowship and close affection; but to all landsmen, from youth upwards, the boat remains a piece of enchantment; at least unless we entangle our vanity in it, and refine it away into mere lath, giving up all its protective nobleness for pace. With those in whose eyes the perfection of a boat is swift fragility, I have no sympathy. The glory of a boat is, first its steadiness of poise – its assured standing on the clear softness of the abyss; and, after that, so much capacity of progress by oar or sail as shall be consistent with this defiance of the treachery of the sea. And, this being understood, it is very notable how commonly the poets, creating for themselves an ideal of motion, fasten upon the charm of a boat. They do not usually express any desire for wings, or, if they do, it is only in some vague and half-unintended phrase, such as 'flit' or 'soar', involving wingedness. Seriously, they are evidently content to let the wings belong to Horse, or Muse, or Angel, rather than to themselves; but they all, somehow or other, express an honest wish for a Spiritual Boat. I will not dwell on poor Shelley's paper navies, and seas of quicksilver, lest we should begin to think evil of boats in general because of that traitorous one in Spezzia Bay; but it is a triumph to find the pastorally minded Wordsworth imagine no other way of visiting the stars than in a boat 'no bigger than the crescent moon' [Prologue to *Peter Bell*]; and to find Tennyson – although his boating, in an ordinary way, has a very marshy and punt-like character – at last, in his highest inspiration [*In Memoriam*, ci], enter in where the wind began 'to sweep a music out of sheet and shroud.'

Fishing

But, meanwhile, the marine deities were incorruptible. It was not possible to starch the sea; and precisely as the stiffness fastened upon men, it vanished from ships. What had once been a mere raft, with rows of formal benches, pushed along by laborious flap of oars, and with infinite fluttering of flags and swelling of poops above, gradually began to lean more heavily into the deep water, to sustain a gloomy weight of guns, to draw back its spider-like feebleness of limb, and open its bosom to the wind, and finally darkened down from all its painted vanities into the long, low hull, familiar with the overflying foam; that has no other pride but in its daily duty and victory; while, through all these changes, it gained continually in grace, strength, audacity, and beauty, until at last it has reached such a pitch of all these, that there is not, except the very loveliest creatures of the living world, anything in nature so absolutely notable, bewitching, and, according to its means and measure, heart-occupying, as a well-handled ship under sail in a stormy day. Any ship, from lowest to proudest, has due place in that architecture of the sea; beautiful, not so much in this or that piece of it, as in the unity of all, from cottage to cathedral, into their great buoyant dynasty. Yet, among them, the fisher-boat, corresponding to the cottage on the land (only far more sublime than a cottage ever can be), is on the whole the thing most venerable. I doubt if ever academic grove were half so fit for profitable meditation as the little strip of shingle between two black, steep, overhanging sides of stranded fishing-boats. The clear, heavy water-edge of ocean rising and falling close to their bows, in that unaccountable way which the sea has always in calm weather, turning the pebbles over and over as if with a rake, to look for something, and then stopping for a moment down at the bottom of the bank, and coming up again with a little run and clash, throwing a foot's depth of salt crystal in an instant between you and the round stone you were going to take in your hand; sighing, all the while, as if it would infinitely rather be doing something else. And the dark flanks of the fishing-boats all aslope above, in their shining quietness, hot in the morning sun, rusty and seamed with square patches of plank nailed over their rents; just rough enough to let the little flat-footed fisher-children haul or twist themselves up to the gunwales, and drop back again along some stray rope; just round enough to remind us, in their broad and gradual curves, of the sweep of the green surges they know so well, and of the hours when those old sides of seared timber, all ashine with the sea, plunge and dip into the deep green purity of the mounded waves more joyfully than a deer lies down among the grass of spring, the soft white cloud of foam opening momentarily at the bows, and fading or flying high into the breeze where the sea-gulls toss and shriek – the joy and beauty of it, all the while, so mingled with the sense of unfathomable danger, and the human effort and sorrow going on perpetually from age to age, waves rolling for ever, and winds moaning for ever, and faithful hearts trusting and sickening for ever, and brave lives dashed

Study of Boats, c.1828-30

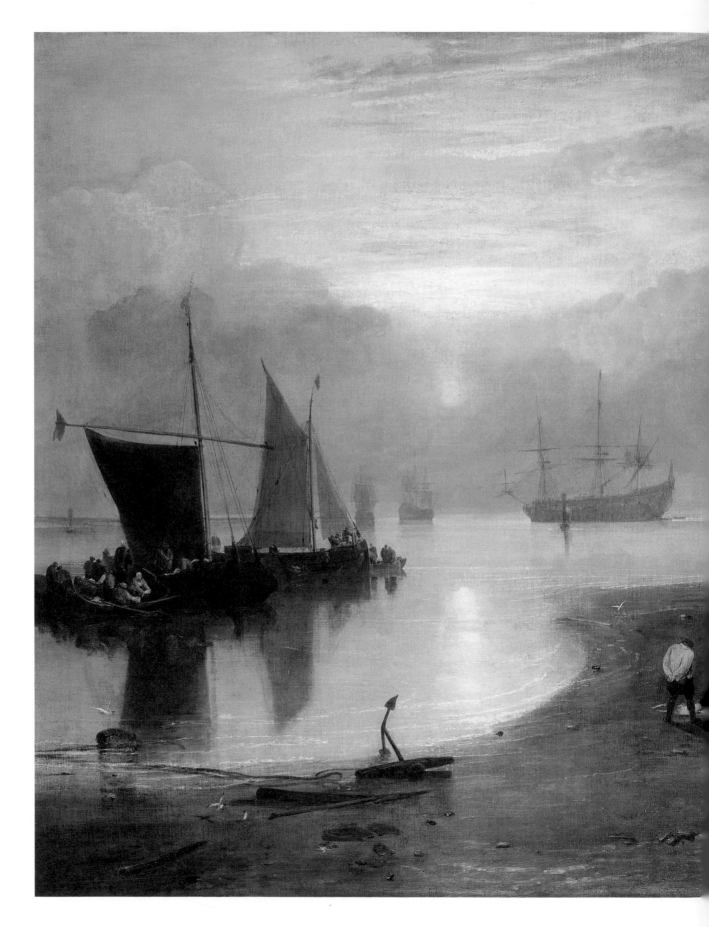

Sun rising through vapour:
Fishermen cleaning and selling fish,
1807

away about the rattling beach like weeds for ever; and still at the helm of every lonely boat, through starless night and hopeless dawn, His hand, who spread the fisher's net over the dust of the Sidonian palaces, and gave into the fisher's hand the keys of the kingdom of heaven.

Storms and wrecks

Of one thing I am certain; Turner never drew anything that could be *seen*, without having seen it. That is to say, though he would draw Jerusalem from someone else's sketch, it would be, nevertheless, entirely from his own experience of ruined walls: and though he would draw ancient shipping (for an imitation of Vandevelde, or a vignette to the voyage of Columbus) from such data as he could get about such things which he could no more see with his own eyes, yet when, of his own free will, in the subject of Ilfracombe, he, in the year 1818, introduces a shipwreck, I am perfectly certain that, before the year 1818, he had *seen* a ship-wreck, and, moreover, one of that horrible kind – a ship dashed to pieces in deep water, at the foot of an inaccessible cliff. Having once seen this, I perceive, also, that the image of it could not be effaced from his mind. It taught him two great facts, which he never afterwards forgot; namely, that both ships and sea were things that broke to pieces. *He never afterwards painted a ship quite in fair order*. There is invariably a feeling about his vessels of strange awe and danger; the sails are in some way loosening, or flapping as if in fear; the swing of the hull, majestic as it may be, seems more at the mercy of the sea than in triumph over it; the ship never looks gay, never proud, only warlike and enduring. The motto he chose, in the Catalogue of the Academy, for the most cheerful marine he ever painted, the Sun of Venice going to Sea, marked the uppermost feeling in his mind:

> Nor heeds the Demon that in grim repose
> Expects his evening prey.

I notice above the subject of his last marine picture, the Wreck-buoy, and I am well persuaded that from that year 1818, when he first saw a ship rent asunder, he never beheld one at sea, without, in his mind's eye, at the same instant, seeing her skeleton.

But he had seen more than the death of the ship. He had seen the sea feed her white flames on souls of men; and heard what a storm-gust sounded like, that had taken up with it, in its swirl of a moment, the last breaths of a ship's crew. He never forgot either the sight or the sound. Among the last plates prepared by his own

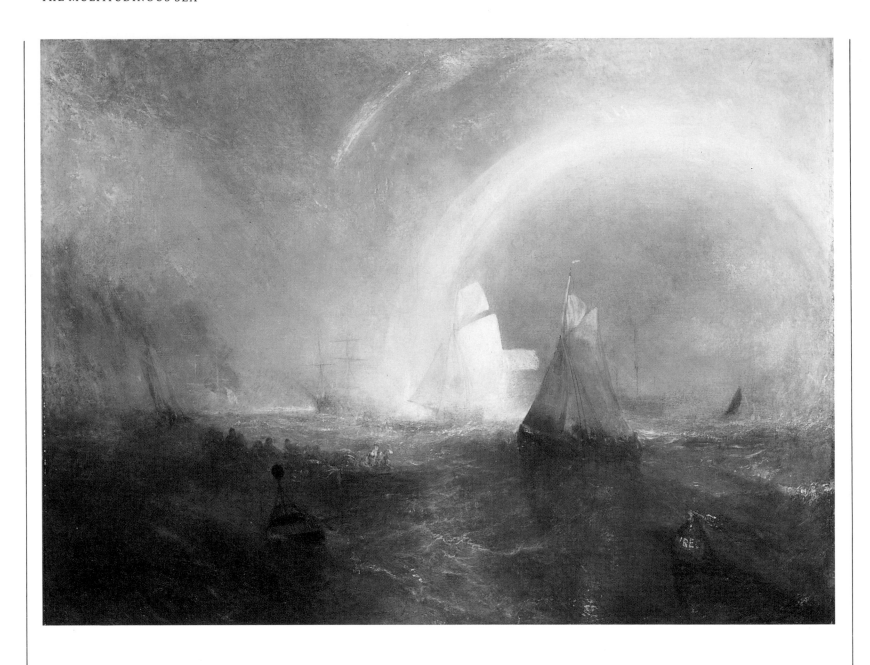

The Wreck Buoy, c.1807. Reworked and exhibited 1849

The Lost Sailor

hand for the Liber Studiorum (all of them, as was likely from his advanced knowledge, finer than any previous pieces of the series, and most of them unfortunately never published, being retained beside him for some last touch – for ever delayed), perhaps the most important is one of the body of a drowned sailor, dashed against a vertical rock in the jaws of one merciless, immeasurable wave.

The old Téméraire

The work which thus nobly closes the series is a solemn expression of a sympathy with seamen and with ships, which had been one of the governing emotions in Turner's mind throughout his life. It is also the last of a group of pictures, painted at different times, but all illustrative of one haunting conception, of the central struggle at Trafalgar. The first was, I believe, exhibited in the British Institution in 1808, under the title of 'The battle of Trafalgar, as seen from the mizen shrouds of the *Victory*'. A magnificent picture, remarkable in many ways, but chiefly for its endeavour to give the spectator a complete map of everything visible in the ships *Victory* and *Redoutable* at the moment of Nelson's death-wound. Then came the 'Trafalgar', now at Greenwich Hospital, representing the

Victory after the battle; a picture which, for my own part, though said to have been spoiled by ill-advised compliances on Turner's part with requests for alteration, I would rather have, than any one in the National Collection. Lastly came this '*Téméraire*', the best memorial that Turner could give to the ship which was the *Victory's* companion in her closing strife.[1]

The painting of the *Téméraire* was received with a general feeling of sympathy. No abusive voice, as far as I remember, was ever raised against it. And the feeling was just; for of all pictures of subjects not visibly involving human pain, this is, I believe, the most pathetic that was ever painted. The utmost pensiveness which can ordinarily be given to a landscape depends on adjuncts of ruin: but no ruin was ever so affecting as this gliding of the vessel to her grave. A ruin cannot be, for whatever memories may be connected with it, and whatever witness it may have borne to the courage or the glory of men, it never seems to have offered itself to their danger, and associated itself with their acts, as a ship of battle can. The mere facts of motion, and obedience to human guidance, double the interest of the vessel: nor less her organized perfectness, giving her the look, and partly the character of a living creature, that may indeed be maimed in limb, or decrepit in frame, but must either live or die, and cannot be added to nor diminished from – heaped up and dragged down – as a building can. And this particular ship, crowned in the Trafalgar hour of trial with chief victory – prevailing over the fatal vessel that had given Nelson death – surely, if ever anything without a soul deserved honour or affection, we owed them here. Those sails that strained so full bent into the battle – that broad bow that struck the surf aside, enlarging silently in steadfast haste, full front to the shot – resistless and without reply – those triple ports whose choirs of flame rang forth in their courses, into the fierce revenging monotone, which, when it died away, left no answering voice to rise any more upon the sea against the strength of England – those sides that were wet with the long runlets of English life-blood, like press-planks at vintage, gleaming goodly crimson down to the cast and clash of the washing foam – those pale masts that stayed themselves up against the war-ruin, shaking out their ensigns through the thunder, till sail and ensign drooped – steep in the

1 She was the second ship in Nelson's line; and, having little provisions or water on board, was what sailors call 'flying light', so as to be able to keep pace with the fast-sailing *Victory*. When the latter drew upon herself all the enemy's fire, the *Téméraire* tried to pass her, to take it in her stead; but Nelson himself hailed her to keep astern. The *Téméraire* cut away her studding-sails, and held back, receiving the enemy's fire into her bows without returning a shot. Two hours later, she lay with a French seventy-four gun ship on each side of her, both her prizes, one lashed to her mainmast, and one to her anchor. J.R.

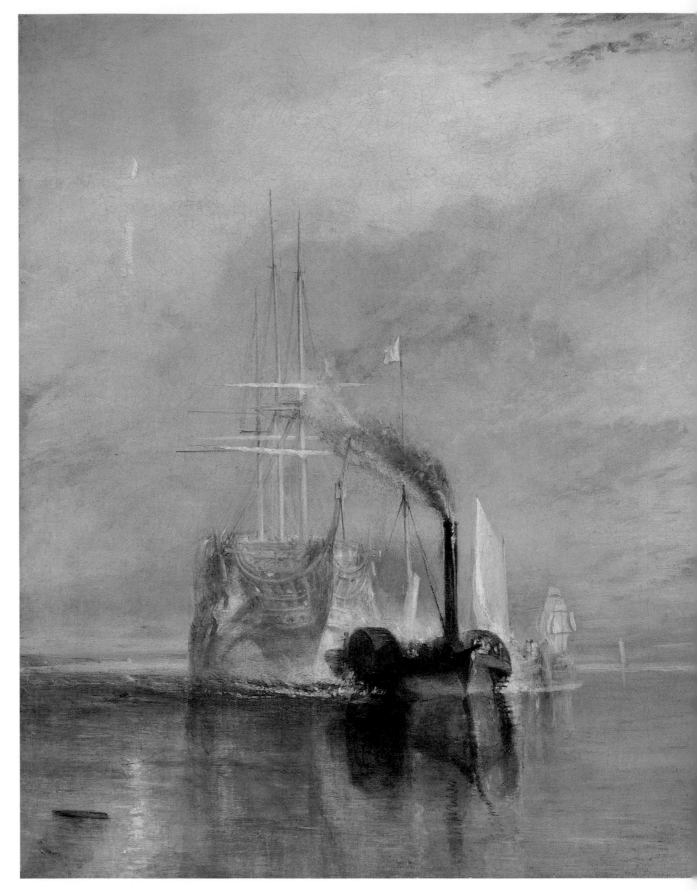

The Fighting Téméraire, tugged to her last berth to be broken up, 1839

death-stilled pause of Andalusian air, burning with its witness-cloud of human souls at rest – surely, for these some sacred care might have been left in our thoughts – some quiet space amidst the lapse of English waters?

Nay, not so. We have stern keepers to trust her glory to – the fire and the worm. Never more shall sunset lay golden robe on her, nor starlight tremble on the waves that part at her gliding. Perhaps, where the low gate opens to some cottage-garden, the tired traveller may ask, idly, why the moss grows so green on its rugged wood; and even the sailor's child may not answer, nor know, that the night-dew lies deep in the war-rents of the wood of the old *Téméraire*.

Calm

I have put this plate last in the series, thinking that the reader will be glad to rest in its morning quietness, after so much tossing among the troubled foam. I said in the course of the introduction, that nothing is so perfectly calm as Turner's calmness; and I know very few better examples of this calmness than the plate before us, uniting, as it does, the glittering of the morning clouds, and trembling of the sea, with an infinitude of peace in both. There are one or two points of interest in the artifices by which the intense effect of calm is produced. Much is owing, in the first place, to the amount of absolute gloom obtained by the local blackness of the boats on the beach; like a piece of the midnight left unbroken by the dawn. But more is owing to the treatment of the distant harbour mouth. In general, throughout nature, Reflection and Repetition are *peaceful* things; that is to say, the image of any object, seen in calm water, gives us an impression of quietness, not merely because we know the water must be quiet in order to be reflective; but because the fact of the repetition of this form is lulling to us in its monotony, and associated more or less with an idea of quiet succession, or reproduction, in events or things throughout nature: that one day should be like another day, one town the image of another town, or one history the repetition of another history, being more or less results of quietness, while dissimilarity and non-succession are also, more or less, results of interference and disquietude. And thus, though an echo actually increases the quantity of sound heard, its repetition of the notes or syllables of sound, gives an idea of calmness attainable in no other way; hence the feeling of calm given to a landscape by the notes of the cuckoo. Understanding this, observe the anxious *doubling* of every object by a visible echo or shadow throughout this picture.

Scarborough, c.1825

The grandest feature of it is the steep distant cliff; and therefore the dualism is more marked here than elsewhere; the two promontories or cliffs, and two piers below them, being arranged so that the one looks almost like the shadow of the other, cast irregularly on mist. In all probability, the more distant pier would in reality, unless it is very greatly higher than the near one, have been lowered by perspective so as not to continue in the same longitudinal line at the top, but Turner will not have it so; he reduces them to exactly the same level, so that the one looks like the phantom of the other; and so of the cliffs above.

Then observe, each pier has, just below the head of it, in a vertical line, another important object, one a buoy, and the other a stooping figure. These carry on the double group in the calmest way, obeying the general law of vertical reflection, and throw down two long shadows on the near beach. The intenseness of the parallelism would catch the eye in a moment, but for the light-house, which breaks the group and prevents the artifice from being too open. Next come the two heads of boats, with their two bowsprits, and the two masts of the one farthest off, all monotonously double, but for the diagonal mast of the nearer one, which again hides the artifice. Next, put your finger over the white central figure, and follow the minor incidents round the beach; first, under the lighthouse, a stick, with its echo below a little to the right; above, a black stone, and its echo to the right; under the white figure, another stick, with its echo to the left; then a starfish,[1] and a white spot its echo to the left; then a dog, and a basket to double its light; above, a fisherman, and his wife for an echo; above them, two lines of curved shingle; above them, two small black figures; above them, two unfinished ships, and two forked masts; above the forked masts, a house with two gables, and its echo exactly over it in two gables more; next to the right, two fishing-boats with sails down; farther on, two fishing-boats with sails up, each with its little white reflection below; then two larger ships, which, lest his trick should be found out, Turner puts a dim third between; then below, two fat colliers, leaning away from each other, and two thinner colliers, leaning towards each other; and now at last, having doubled everything all round the beach, he gives one strong single stroke to gather all together, places his solitary central white figure, and the Calm is complete.

It is also to be noticed, that not only the definite repetition has a power of expressing serenity, but even the slight sense of *confusion* induced by the continual doubling is useful; it makes us feel not well awake, drowsy, and as if we were out too early, and had to rub our eyes yet a little, before we could make out whether there were really two boats or one.

I do not mean that every means which we may possibly take to enable ourselves to see things double, will be always the most likely to ensure the ultimate tranquillity of the scene, neither that any such artifice as this would be of avail, without the tender and loving drawing of the things themselves, and of the light that bathes them; nevertheless the highest art is full of these little cunnings, and it is only by the help of them that it can succeed in at all equalling the force of the natural impression.

One great monotony, that of the successive sigh and vanishing of the slow waves upon the sand, no art can render to us. Perhaps the silence of early light, even on the 'field dew consecrate'[2] of the grass itself, is not so tender as the lisp of the sweet belled lips of the clear waves in their following patience. We will leave the shore as their silver fringes fade upon it, desiring thus, as far as may be, to remember the sea. We have regarded it perhaps too often as an enemy to be subdued; let us, at least this once, accept from it, and from the soft light beyond the cliffs above, the image of the state of a perfect Human Spirit,—

> The memory, like a cloudless air,
> The conscience, like a sea at rest.[3]

1 I have mentioned elsewhere that Turner was fond of this subject of Scarborough, and that there are four drawings of it by him, if not more, under different effects, having this much common to the four, that there is always a starfish on the beach. J.R.

2 *Midsummer Night's Dream*, v. 2.
3 Tennyson, *In Memoriam*, xciv.

Truth of Earth

It is in writing about Turner's vision of mountains, valleys, lakes, or rivers that Ruskin might be expected to show himself closest to the Romantic poets who had claimed the earth as a sacred dwelling. But this turns out not to be the case. Though his response to Turner's landscape art is founded on the devotion he had learned from Wordsworth and his inheritors, what Ruskin has to say is often deliberately and unexpectedly prosaic. With his tireless attention to detail and form, Ruskin thinks about the earth in a way that might strike the reader as being closer to that of the scientist than poet or painter.

This is more than an accident of style. Ruskin had been drawn to the exactitude of the scientist's investigative methods since early boyhood. He was especially enthusiastic about the pursuit of geology – then a changing and controversial discipline – and was an active and well-informed member of the Geological Society while still a schoolboy. He maintained his interest in the developing practices of science, and he continued to publish work of a scientific nature (including texts on geology, ornithology, and botany) into his old age. As scientific orthodoxy grew more powerful and professional, he increasingly wrote in a spirit of opposition, claiming that the technical advances of scientific methodology had deprived its disciples of the necessary capacity for wonder. But in 1843, when Ruskin was writing about the marvellous structures and energies of mountain, river, and plain, science and art still seemed the most natural of allies.

It strikes us as odd, now, to find Ruskin describing Turner as a scientific painter. But this is a claim that he repeats throughout *Modern Painters*. After a long and careful meditation on the character of mountains in the first volume, Ruskin directs his readers to examine the mountain landscape of Turner's vignette *The Battle of Marengo*. The vignette hardly looks like a piece of scientific evidence to us. But this is how Ruskin describes it: 'It needs no comment. It cannot but carry with it, after what has been said, the instant conviction that Turner is as much of a geologist as he is of a painter'. This was not, in Ruskin's terms, as bizarre a remark as it might seem. He was not asserting that Turner had made a study of the subject in any academic sense: simply that his understanding of the ways in which the earth behaves was so acute that it had led him to conclusions which could only be confirmed by scientific observation. Ruskin tells us that another vignette, the *Alps at Daybreak*, might profitably illustrate a lecture on geology. Turner is a great imaginative painter, but he is also a scrupulous and therefore invaluable mirror of natural truth. Science, in Ruskin's argument, has no monopoly on the intellectual excitement of accurate observation.

The patient particularity with which Ruskin examines Turner's methods in the first volume of *Modern Painters* is especially striking when he comes to look at the painter's treatment of water. Here Ruskin is often preoccupied with matters of technical expertise, for to represent a body of water is one of the most difficult things an artist can attempt.

How is it possible to use paint to produce a sense of the *surface* of water? What gives Turner the power to depict a waterfall? To all such questions the answer is the same: Turner is able to paint water because he has been attentive to the fact that there is no such thing as 'water'. There are only individual streams, lakes or rivers – all different, changing at diverse times of day, and drawing their identity from particular and unrepeatable moments of light and weather.

Writing about natural phenomena in Turner's pictures, Ruskin contends, moreover, that they are alive. Water is inseparable from the human existence which it supports. A stream becomes, in Ruskin's rendering of Turner's effects, an animate being, with specific characteristics and a will of its own – as fascinating as the animals which, as Ruskin reminds us, Turner drew with such sensitivity and vigour.

Throughout *Modern Painters*, Ruskin directs us to look at the wholeness of the paintings which represent the vitality of nature. This life includes people, for Turner rarely draws a landscape without some representation of those who inhabit it. But the human figures do not control the pictures. They are assimilated into the overall design, as part of a larger livingness. The painter, Ruskin stresses, organizes and directs this action in order to make its meaning apparent: he never simply records it. But the business of the artist, as defined by Ruskin, is not to impose thoughts, ideas or experiences on to a picture. The significance of the image belongs to nature.

Ruskin understands the central motive of *Rietz, near Saumur*, which he describes in detail in the fifth volume of *Modern Painters* (1860), as an idea derived directly from human activity in a natural landscape. The picture, dominated by its placid river, is 'the expression of rude but perfect peace, slightly mingled with an indolent languor and despondency'. Ruskin's terms here are not Turner's, and an unmistakable shade of disapproval at the feckless ways of the French peasantry creeps into his account ('You see the road is covered with litter . . . the steps of the cottage door have been too high for comfort originally, only it was less trouble to cut three large stones than four or five small'). But this inertia, which Ruskin can't help shaking his head at, becomes a kind of natural piety in his interpretation of the picture. Ruskin describes how Turner has grouped the lines of his composition in order to point to an old building, which he identifies as a church of a kind that he knows well: 'I may walk in and out as much as I please, but that how often soever, I shall always find some one praying at the Holy Sepulchre, in the darkest aisle, and my going in and out will not disturb them. For they *are* praying, which in many a handsomer and highlier-furbished edifice might, perhaps, not be so assuredly the case.'

The formal point that Ruskin is making here is one which he stresses throughout *Modern Painters*: no detail of Turner's pictures can be lost without diminishing their totality of meaning. But the tone of his meditative analysis of the picture is very different from that of his excited response to Turner's art in the first volume of the work. The simple Christian belief of the peasants is regarded half wistfully, half contemptuously. Ruskin had left such faith behind. His first joyous response to Turner had been grounded in the religion of his youth, and he was never to recapture its intoxication.

True Genius rises with its subject
J. M. W. Turner, annotating Shee's *Elements of Art*

The Battle of Marengo, c.1827

Mountain truth

MOUNTAINS ARE TO the rest of the body of the earth, what violent muscular action is to the body of man. The muscles and tendons of its anatomy are, in the mountain, brought out with force and convulsive energy, full of expression, passion, and strength; the plains and the lower hills are the repose and the effortless motion of the frame, when its muscles lie dormant and concealed beneath the lines of its beauty, yet ruling those lines in their every undulation. This, then, is the first grand principle of the truth of the earth. The spirit of the hills is action, that of the lowlands repose; and between these there is to be found every variety of motion and of rest, from the inactive plain, sleeping like the firmament, with cities for stars, to the fiery peaks, which, with heaving bosoms and exulting limbs, with the clouds drifting like hair from their bright foreheads, lift up their Titan hands to heaven, saying, 'I live for ever!'

But there is this difference between the action of the earth, and that of a living creature; that while the exerted limb marks its bones and tendons through the flesh, the excited earth casts off the flesh altogether, and its bones come out from beneath. Mountains are the bones of the earth, their highest peaks are invariably those parts of its anatomy which in the plains lie buried under five and twenty thousand feet of solid thickness of superincumbent soil, and which spring up in the mountain ranges in vast pyramids or wedges, flinging their garment of earth away from them on each side. The masses of the lower hills are laid over and against their sides, like the masses of lateral masonry against the skeleton arch of an unfinished bridge, except that they slope up to and lean against the central ridge: and, finally, upon the slopes of these lower hills are strewed the level beds of sprinkled gravel, sand, and clay, which form the extent of the champaign. Here then is another grand principle of the truth of earth, that the mountains must come from under all, and be the support of all; and that everything else must be laid in their arms, heap above heap, the plains being the uppermost. Opposed to this truth is every appearance of the hills being laid upon the plains, or built upon them. Nor is this a truth only of the earth on a large scale, for every minor rock (in position) comes out from the soil about it as an island out of the sea, lifting the earth near it like waves beating on its sides.

Such being the structure of the framework of the earth, it is next to be remembered that all soil whatsoever, whether it is accumulated in greater quantity than is sufficient to nourish the moss or the wallflower, has been so, either by the direct transporting agency of water, or under the guiding influence and power of water. All plains capable of cultivation are deposits from some kind of water; some from swift and tremendous currents, leaving their soil in sweeping banks and furrowed ridges; others, and this is in mountain districts almost invariably the case, by slow deposit from a quiet lake in the mountain hollow, which has been gradually filled by the soil carried into it by streams, which soil is of course finally left spread at the exact level of the surface of the former lake, as level as the quiet water itself. Hence we constantly meet with plains in hill districts which fill the hollows of the hills with as perfect and faultless a level as water, and out of which the steep rocks rise at the edge, with as little previous disturbance, or indication of their forms beneath, as they do from the margin of a quiet lake. Every delta, and there is one at the head of every lake in every hill district, supplies an instance of this. The rocks at Altorf plunge beneath the plain which the lake has left, at as sharp an angle as they do into the lake itself beside the chapel of Tell. The plain of the Arve, at Sallenche, is terminated so sharply by the hills to the south-east, that I have seen a man sleeping with his back supported against the mountain, and his legs stretched on the plain; the slope which supported his back rising 5000 feet above him, and the couch of his legs stretched for five miles before him. In distant effect these champaigns lie like deep, blue, undisturbed water, while the mighty hills around them burst out from beneath, raging and tossing like a tumultuous sea. The valleys of Meyringen, Interlachen, Altorf, Sallenche, St Jean de Maurienne; the great plain of Lombardy itself, as seen from Milan or Padua, under the Alps, the Euganeans, and the Apennines; and the Campo Felice under Vesuvius, are a few, out of the thousand instances which must occur at once to the mind of every traveller.

Let the reader now open Rogers's *Italy* . . . and look at the vignette which heads it of the Battle of Marengo.[1] It needs no comment. It cannot but carry with it, after what has been said, the instant conviction that Turner is as much of a geologist as he is of a painter. It is a summary of all we have been saying, and a summary so distinct and clear, that without any such explanation it must have forced upon the mind the impression of such facts; of the plunging of the hills underneath the plain, of the perfect level and repose of this latter laid in their arms, and of the tumultuous action of the emergent summits.

Turner's geology

Now, if I were lecturing on geology, and were searching for some means of giving the most faithful idea possible of the external

1 The original watercolour is reproduced here. D.B.

The Alps at Daybreak. Vignette from Rogers's Poems, *1834*

appearance caused by this structure of the primary hills, I should throw my geological outlines aside, and take up Turner's vignette of the Alps at Daybreak. After what has been said, a single glance at it will be enough. Observe the exquisite decision with which the edge of the uppermost plank of the great peak is indicated by its clear dark side and sharp shadow; then the rise of the second low ridge on its side, only to descend again precisely in the same line; the two fissures of this peak, one pointing to its summit, the other rigidly parallel to the great slope which descends towards the sun; then the sharp white *aiguille* on the right, with the great fissure from its summit, rigidly and severely square, as marked below, where another edge of rock is laid upon it. But this is not all; the black rock in the foreground is equally a member of the mass, its chief slope parallel with that of the mountain, and all its fissures and lines inclined in the same direction; and, to complete the mass of evidence more forcibly still, we have the dark mass on the left articulated with absolute right lines, as parallel as if they had been drawn with a rule, indicating the tops of two of these huge plates or planks, pointing, with the universal tendency, to the great ridge, and intersected by fissures parallel to it. Throughout the extent of mountain, not one horizontal line, nor an approach to it, is discernible. This cannot be chance, it cannot be composition, it may not be beautiful; perhaps nature is very wrong to be so parallel, and very disagreeable in being so straight; but this *is* nature, whether we admire it or not.

Mount Lebanon

But perhaps the finest instance, or at least the most marked of all, will be found in the exquisite Mount Lebanon, with the convent of St Antonio, engraved in Finden's Bible.[1] There is not one shade nor touch on the rock which is not indicative of the lines of stratification; and every fracture is marked with a straightforward simplicity which makes you feel that the artist has nothing in his heart but a keen love of the pure unmodified truth. There is no effort to disguise the repetition of forms, no apparent aim at artificial arrangement or scientific grouping; the rocks are laid one above another with unhesitating decision; every shade is understood in a moment, felt as a dark side, or a shadow, or a fissure, and you may step from one block or bed to another until you reach the mountain summit. And yet, though there seems no effort to disguise the repetition of forms, see how it *is* disguised, just as nature would have done it, by the perpetual play and changefulness of the very lines which appear so parallel; now bending a little up, or down, or losing themselves, or running into each other, the old story over and over again – infinity. For here is still the great distinction between Turner's work and that of a common artist. Hundreds could have given the parallelism of blocks, but none but himself could have done so without the actual repetition of a single line or feature.

Mountain form

The Caudebec in the Rivers of France, is a fine instance of almost every fact which we have been pointing out. We have in it, first, the clear expression of what takes place constantly among the hills; that the river, as it passes through the valley, will fall backwards and forwards from side to side, lying first, if I may so speak, with all its weight against the hills on the one side, and then against those on the other; so that, as here it is exquisitely told, in each of its circular sweeps the whole force of its current is brought deep and close to the bases of the hills, while the water on the side next the plain is shallow, deepening gradually. In consequence of this, the hills are cut away at their bases by the current, so that their slopes are interrupted by precipices mouldering to the water. Observe, first, how nobly Turner has given us the perfect unity of the whole mass of hill, making us understand that every ravine in it has been cut gradually by streams. The first eminence, beyond the city, is not disjointed from, nor independent of, the one succeeding, but evidently part of the same whole, originally united, separated only by the action of the stream between. The

1 The original watercolour is reproduced here. D.B.

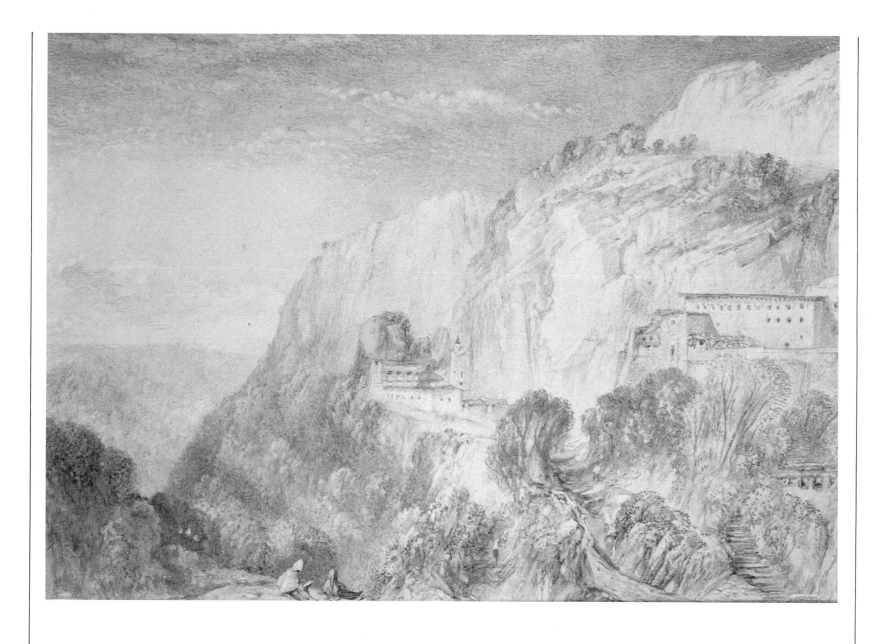

Mount Lebanon and the Convent of Sant' Antonio, c.1835

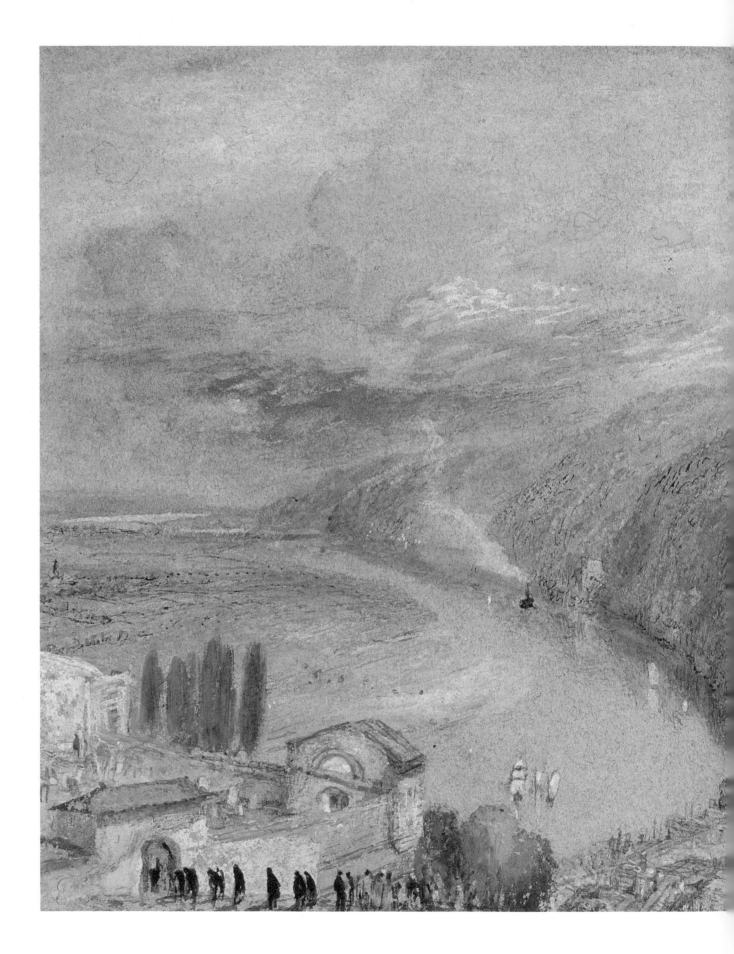

Caudebec, c.1832

association of the second and third is still more clearly told, for we see that there has been a little longitudinal valley running along the brow of their former united mass, which, after the ravine had been cut between, formed the two jags which Turner has given us at the same point in each of their curves. This great triple group has, however, been originally distinct from those beyond it; for we see that these latter are only the termination of the enormous even slope, which appears again on the extreme right, having been interrupted by the rise of the near hills. Observe how the descent of the whole series is kept gentle and subdued, never suffered to become steep except where it has been cut away by the river, the sudden precipice caused by which is exquisitely marked in the last two promontories, where they are defined against the bright horizon; and, finally, observe how, in the ascent of the nearest eminence beyond the city, without one cast shadow or any division of distances, every yard of surface is felt to be retiring by the mere painting of its details, how we are permitted to walk up it, and along its top, and are carried, before we are half-way up, a league or two forward into the picture. The difficulty of doing this, however, can scarcely be appreciated except by an artist.

I do not mean to assert that this great painter is acquainted with the geological laws and facts he has thus illustrated; I am not aware whether he be or not; I merely wish to demonstrate, in points admitting of demonstration, that intense observation of, and strict adherence to, truth, which it is impossible to demonstrate in its less tangible and more delicate manifestations. However I may *feel* the truth of every touch and line, I cannot *prove* truth, except in large and general features; and I leave it to the arbitration of every man's reason, whether it be not likely that the painter who is thus so rigidly faithful in great things that every one of his pictures might be the illustration of a lecture on the physical sciences, is not likely to be faithful also in small.

The surface of water

I believe it is a result of the experience of all artists, that it is the easiest thing in the world to give a certain degree of depth and transparency to water; but that it is next to impossible, to give a full impression of surface. If no reflection be given, a ripple being supposed, the water looks like lead: if reflection be given, it, in nine cases out of ten, looks *morbidly* clear and deep, so that we always go down *into* it, even when the artist most wishes us to glide *over* it. Now, this difficulty arises from the very same circumstance which occasions the frequent failure in effect of the best-

drawn foregrounds . . . the change, namely, of focus necessary in the eye in order to receive rays of light coming from different distances. Go to the edge of a pond in a perfectly calm day, at some place where there is duckweed floating on the surface, not thick, but a leaf here and there. Now, you may either see in the water the reflection of the sky, or you may see the duckweed; but you cannot, by any effort, see both together. If you look for the reflection, you will be sensible of a sudden change or effort in the eye, by which it adapts itself to the reception of the rays which have come all the way from the clouds, have struck on the water, and so been sent up again to the eye. The focus you adopt is one fit for great distance; and, accordingly, you will feel that you are looking down a great way under the water, while the leaves of the duckweed, though they lie upon the water at the very spot on which you are gazing so intently, are felt only as a vague uncertain interruption, causing a little confusion in the image below, but entirely undistinguishable as leaves, and even their colour unknown and unperceived. Unless you think of them, you will not even feel that anything interrupts your sight, so excessively slight is their effect. If, on the other hand, you make up your mind to look for the leaves of the duckweed, you will perceive an instantaneous change in the effort of the eye, by which it becomes adapted to receive near rays, those which have only come from the surface of the pond. You will then see the delicate leaves of the duckweed with perfect clearness, and in vivid green; but, while you do so, you will be able to perceive nothing of the reflections in the very water on which they float, nothing but a vague flashing and melting of light and dark hues, without form or meaning, which to investigate, or find out what they mean or are, you must quit your hold of the duckweed, and plunge down.

Hence it appears, that whenever we see plain reflections of comparatively distant objects, in near water, we cannot possibly see the surface, and *vice versa*; so that when in a painting we give the reflections with the same clearness with which they are visible in nature, we presuppose the effort of the eye to look under the surface, and, of course, destroy the surface, and induce an effect of clearness which, perhaps, the artist has not particularly wished to attain, but which he has found himself forced into, by his reflections, in spite of himself. And the reason of this effect of clearness appearing preternatural is, that people are not in the habit of looking at water with the distant focus adapted to the reflections, unless by particular effort. We invariably, under ordinary circumstances, use the surface focus; and, in consequence, receive nothing more than a vague and confused impression of the reflected colours and lines, however clearly, calmly, and vigor-

ously all may be defined underneath, if we choose to look for them. We do not look for them, but glide along over the surface, catching only playing light and capricious colour for evidence of reflection, except where we come to images of objects close to the surface, which the surface focus is of course adapted to receive; and these we see clearly, as of the weeds on the shore, or of sticks rising out of the water, etc. Hence, the ordinary effect of water is only to be rendered by giving the reflections of the *margin* clear and distinct (so clear they usually are in nature, that it is impossible to tell where the water begins); but the moment we touch the reflection of distant objects, as of high trees or clouds, that instant we must become vague and uncertain in drawing, and, though vivid in colour and light as the object itself, quite indistinct in form and feature. If we take such a piece of water as that in the foreground of Turner's Château of Prince Albert, the first impression from it is 'What a wide *surface*!' We glide over it a quarter of a mile into the picture before we know where we are, and yet the water is as calm and crystalline as a mirror; but we are not allowed to tumble into it, and gasp for breath as we go down, we are kept upon the surface, though that surface is flashing and radiant with every hue of cloud, and sun, and sky, and foliage. But the secret is in the drawing of these reflections. We cannot tell, when we look *at* them and *for* them, what they mean. They have all character, and are evidently reflections of something definite and determined; but yet they are all uncertain and inexplicable; playing colour and palpitating shade, which, though we recognize them in an instant for images of something, and feel that the water is bright, and lovely, and calm, we cannot penetrate nor interpret; we are not allowed to go down to them, and we repose, as we should in nature, upon the lustre of the level surface. It is in this power of saying everything, and yet saying nothing too plainly, that the perfection of art here, as in all other cases, consists. But, as it was before shown . . . that the focus of the eye required little alteration after the first half-mile of distance, it is evident that on the *distant* surface of water, *all* reflections will be seen plainly; for the same focus adapted to a moderate distance of surface will receive with distinctness rays coming from the sky, or from any other distance, however great. Thus we always see the reflection of Mont Blanc on the Lake of Geneva, whether we take pains to look for it or not, because the water upon which it is cast is itself a mile off; but if we would see the reflection of Mont Blanc in the Lac de Chède, which is close to us, we must take some trouble about the matter, leave the green snakes swimming upon the surface, and plunge for it. Hence reflections, if viewed collectively, are always clear in proportion to the distance of the water on

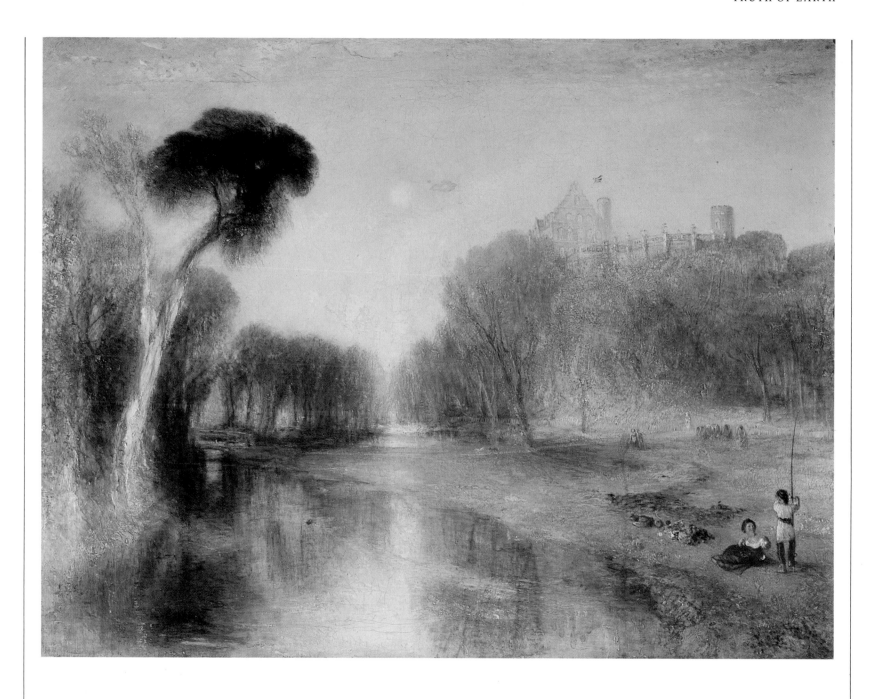

Rosenau: Seat of Prince Albert, 1841

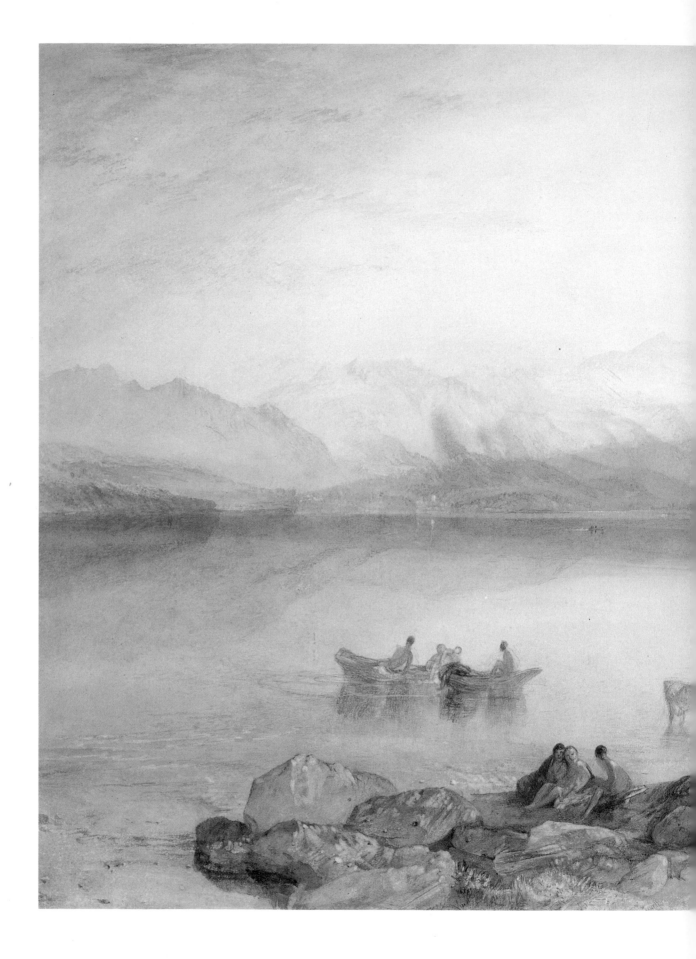

Ullswater, c. 1833

which they are cast. And now look at Turner's Ulleswater, or any of his distant lake expanses, and you will find every crag and line of the hills rendered in them with absolute fidelity, while the near surface shows nothing but a vague confusion of exquisite and lustrous tint. The reflections even of the clouds will be given far off, while those of near boats and figures will be confused and mixed among each other, except just at the water-line.

The force of water

It will be remembered that it was said above, that Turner was the only painter who ever represented the surface of calm or the *force* of agitated water. He obtains this expression of force in falling or running water by fearless and full rendering of its forms. He never loses himself and his subject in the splash of the fall, his presence of mind never fails as he goes down; he does not blind us with the spray, or veil the countenance of his fall with its own drapery. A little crumbling white, or lightly rubbed paper, will soon give the effect of indiscriminate foam; but nature gives more than foam, she shows beneath it, and through it, a peculiar character of exquisitely studied form bestowed on every wave and line of fall; and it is this variety of definite character which Turner always aims at, rejecting, as much as possible, everything that conceals or overwhelms it. Thus, in the Upper Fall of the Tees, though the whole basin of the fall is blue and dim with the rising vapour, yet the attention of the spectator is chiefly directed to the concentric zones and delicate curves of the falling water itself; and it is impossible to express with what exquisite accuracy these are given. They are the characteristic of a powerful stream descending without impediment or break, but from a narrow channel, so as to expand as it falls. They are the constant form which such a stream assumes as it descends; and yet I think it would be difficult to point to another instance of their being rendered in art. You will find nothing in the waterfalls even of our best painters, but springing lines of parabolic descent, and splashing shapeless foam; and, in consequence, though they may make you understand the swift-ness of the water, they never let you feel the weight of it; the stream in their hands looks *active*, not *supine*, as if it leaped, not as if it fell. Now water will leap a little way, it will leap down a weir or over a stone, but it *tumbles* over a high fall like this; and it is when we have lost the parabolic line, and arrived at the catenary, when we have lost the *spring* of the fall, and arrived at the *plunge* of it, that we begin really to feel its weight and wildness. Where water takes its first leap from the top, it is cool, and collected, and

71

Fall of the Tees, Yorkshire. England and Wales, *1827*

uninteresting, and mathematical; but it is when it finds that it has got into a scrape, and has farther to go than it thought, that its character comes out: it is then that it begins to writhe, and twist, and sweep out, zone after zone, in wilder stretching as it falls; and to send down the rocket-like, lance-pointed, whizzing shafts at its sides, sounding for the bottom. And it is this prostration, this hopeless abandonment of its ponderous power to the air, which is always peculiarly expressed by Turner, and especially in the case before us; while our other artists, keeping to the parabolic line, where they do not lose themselves in smoke and foam, make their cataract look muscular and wiry, and may consider themselves fortunate if they can keep it from stopping. I believe the majesty of motion which Turner has given by these concentric catenary lines must be felt even by those who have never seen a high waterfall, and therefore cannot appreciate their exquisite fidelity to nature.

Torrent-drawing

When water, not in very great body, runs in a rocky bed much interrupted by hollows, so that it can rest every now and then in a pool as it goes along, it does not acquire a continuous velocity of motion. It pauses after every leap, and curdles about, and rests a little and then goes on again; and if in this comparatively tranquil and rational state of mind it meets with any obstacle, as a rock or stone, it parts on each side of it with a little bubbling foam, and goes round; if it comes to a step in its bed, it leaps it lightly, and then after a little splashing at the bottom, stops again to take breath. But if its bed be on a continuous slope, not much interrupted by hollows, so that it cannot rest, or if its own mass be so increased by flood that its usual resting-places are not sufficient for it, but that it is perpetually pushed out of them by the following

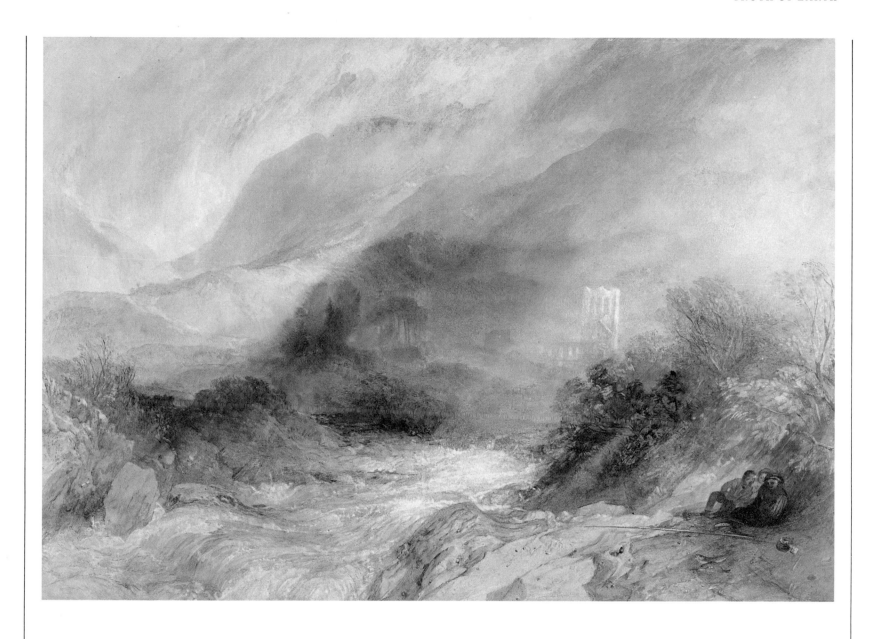

Llanthony Abbey, c.1835

current, before it has had time to tranquillize itself, it of course gains velocity with every yard that it runs; the impetus got at one leap is carried to the credit of the next, until the whole stream becomes one mass of unchecked accelerating motion. Now when water in this state comes to an obstacle, it does not part at it, but clears it, like a race-horse; and when it comes to a hollow, it does not fill it up and run out leisurely at the other side, but rushes down into it and comes up again on the other side, as a ship into the hollow of the sea. Hence the whole appearance of the bed of the stream is changed, and all the lines of the water altered in their nature. The quiet stream is a succession of leaps and pools; the leaps are light and springy, and parabolic, and make a great deal of splashing when they tumble into the pools; then we have a space of quiet curdling water and another similar leap below. But the stream when it has gained an impetus, *takes the shape* of its bed, goes down into every hollow, not with a leap, but with a swing, not foaming, nor splashing, but in the bending line of a strong sea-wave, and comes up again on the other side, over rock and ridge, with the ease of a bounding leopard; if it meet a rock three or four feet above the level of its bed, it will often neither part nor foam, nor express any concern about the matter, but clear it in a smooth dome of water, without apparent exertion, the whole surface of the surge being drawn into parallel lines by its extreme velocity, so that the whole river has the appearance of a deep and raging sea, with this only difference, that the torrent-waves always break backwards, and sea-waves forwards. Thus, then, in the water which has gained an impetus, we have the most exquisite arrangements of curved lines, perpetually changing from convex to concave, and *vice versa*, following every swell and hollow of the bed with their modulating grace, and all in unison of motion, presenting perhaps the most beautiful series of inorganic forms which nature can possibly produce; for the sea runs too much into similar and concave curves with sharp edges, but every motion of the torrent is united, and all its curves are modifications of beautiful line.

We see, therefore, why Turner seizes on these curved lines of the torrent, not only as being among the most beautiful forms of nature, but because they are an instant expression of the utmost power and velocity, and tell us how the torrent has been flowing before we see it. For the leap and splash might be seen in the sudden freakishness of a quiet stream, or the fall of a rivulet over a mill-dam; but the undulating line is the attribute of the mountain-torrent, whose fall and fury have made the valleys echo for miles; and thus the moment we see one of its curves over a stone in the foreground, we know it has come far and fiercely. And in the drawing we have been speaking of, the Lower Fall of the Tees, in the foreground of the Killiecrankie and Rhymer's Glen, and of the St Maurice in Rogers's *Italy*, we shall find the most exquisite instances of the use of such lines; but the most perfect of all in the Llanthony Abbey, which may be considered as the standard of torrent-drawing. The chief light of the picture here falls upon the surface of the stream, swelled by recent rain; and its mighty waves come rolling down close to the spectator, green and clear, but pale with anger, in broad, unbroken, oceanic curves, bending into each other without break, though jets of fiery spray are cast into the air along the rocky shore, and rise in the sunshine in dusty vapour. The whole surface is one united race of mad motion; all the waves dragged, as I have described, into lines and furrows by their swiftness; and every one of those fine forms is drawn with the most studied chiaroscuro of delicate colour, greys and greens, as silvery and pure as the finest passages of Paul Veronese, and with a refinement of execution which the eye strains itself in looking into. The rapidity and gigantic force of this torrent, the exquisite refinement of its colour, and the vividness of foam which is obtained through a general middle tint, render it about the most perfect piece of painting of running water in existence.

River motion

Again, in the scene on the Loire, with the square precipice and fiery sunset, in the Rivers of France, repose has been aimed at in the same way, and most thoroughly given; but the immense width of the river at this spot makes it look like a lake or sea, and it was therefore necessary that we should be made thoroughly to understand and feel that this is not the calm of still water, but the tranquillity of a majestic current. Accordingly, a boat swings at anchor on the right; and the stream, dividing at its bow, flows towards us in two long, dark waves, especial attention to which is enforced by the one on the left being brought across the reflected stream of sunshine, which is separated and broken by the general undulation and agitation of the water in the boat's wake; a wake caused by the water's passing it, not by *its* going through the water.

River colour

Well, the first reason that I gave you these Loire drawings was this of their infallible decision; the second was their extreme modesty in colour. They are, beyond all other works that I know existing,

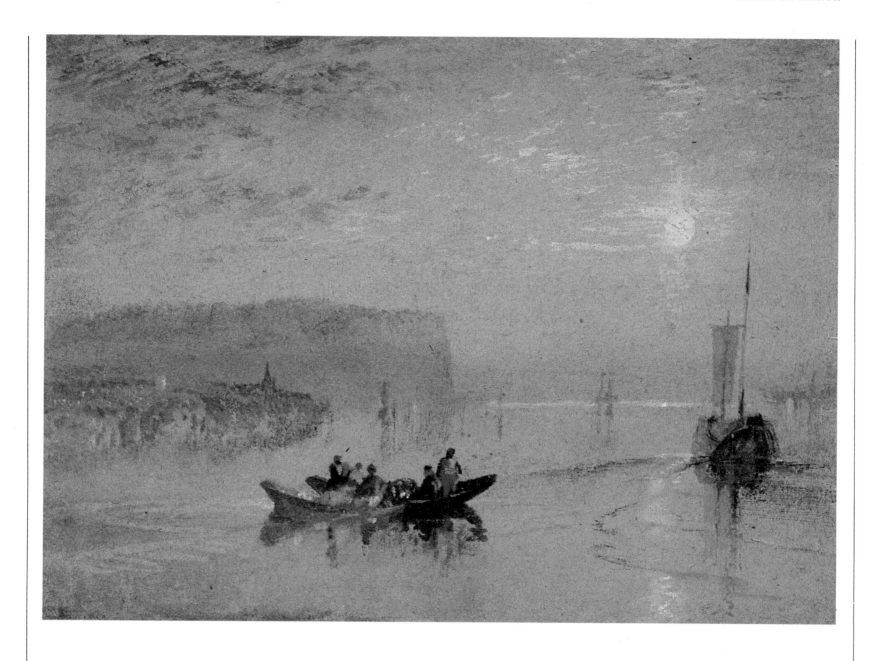

Scene on the Loire, near the Coteaux de Mauves, c.1826-30

Scene on the Loire, c.1826-30

dependent for their effect on low, subdued tones; their favourite choice in time of day being either dawn or twilight, and even their brightest sunsets produced chiefly out of grey paper. This last, the loveliest of all, gives the warmth of a summer twilight with a tinge of colour on the grey paper so slight that it may be a question with some of you whether any is there. And I must beg you to observe, and receive as a rule without any exception, that whether colour be gay or sad, the value of it depends never on violence, but always on subtlety. It may be that a great colourist will use his utmost force of colour, as a singer his full power of voice; but, loud or low, the virtue is in both cases always in refinement, never in loudness. The west window of Chartres is bedropped with crimson deeper than blood; but it is as soft as it is deep, and as quiet as the light of dawn.

The task of the least

The reader has probably been surprised at my assertions made often before now, and reiterated here, that the *minutest* portion of a great composition is helpful to the whole. It certainly does not seem easily conceivable that this should be so. I will go farther, and say that it is inconceivable. But it is the fact.

We shall discern it to be so by taking one or two compositions to pieces, and examining the fragments. In doing which, we must remember that a great composition always has a leading emotional purpose, technically called its motive, to which all its lines and forms have some relation. Undulating lines, for instance, are expressive of action; and would be false in effect if the motive of the picture was one of repose. Horizontal and angular lines are expressive of rest and strength; and would destroy a design whose purpose was to express disquiet and feebleness. It is therefore necessary to ascertain the motive before descending to the detail.

One of the simplest subjects, in the series of the Rivers of France, is 'Rietz, near Saumur'. . . . To get at it completely, we must know something of the Loire.

The district through which it here flows is, for the most part, a low place, yet not altogether at the level of the stream, but cut into steep banks of chalk or gravel, thirty or forty feet high, running for miles at about an equal height above the water.

These banks are excavated by the peasantry, partly for houses, partly for cellars, so economizing vineyard space above; and thus a kind of continuous village runs along the river-side, composed half of caves, half of rude buildings, backed by the cliff, propped against it, therefore always leaning away from the river; mingled

with overlappings of vineyard trellis from above, and little towers or summer-houses for outlook, when the grapes are ripe, or for gossip over the garden wall.

It is an autumnal evening, then, by this Loire side. The day has been hot, and the air is heavy and misty still; the sunlight warm, but dim; the brown vine-leaves motionless: all else quiet. Not a sail in sight on the river,[1] its strong noiseless current lengthening the stream of low sunlight.

The motive of the picture, therefore, is the expression of rude but perfect peace, slightly mingled with an indolent languor and despondency; the space between intervals of enforced labour; happy, but listless, and having little care or hope about the future; cutting its home out of this gravel bank, and letting the vine and the river twine and undermine as they will; careless to mend or build, so long as the walls hold together, and the black fruit swells in the sunshine.

To get this repose, together with rude stability, we have therefore horizontal lines and bold angles. The grand horizontal space and sweep of Turner's distant river show perhaps better in the etching than in the Plate; but depend wholly for value on the piece of near wall. It is the vertical line of its dark side which drives the eye up into the distance, right against the horizontal, and so makes it felt, while the flatness of the stone prepares the eye to understand the flatness of the river. Farther: hide with your finger the little ring on that stone, and you will find the river has stopped flowing. That ring is to repeat the curved lines of the river bank, which express its line of current, and to bring the feeling of them down near us. On the other side of the road the horizontal lines are taken up again by the dark pieces of wood, without which we should still lose half our space.

Next: the repose is to be not only perfect, but indolent: the repose of out-wearied people; not caring much what becomes of them.

You see the road is covered with litter. Even the crockery is left outside the cottage to dry in the sun, after being washed up. The steps of the cottage door have been too high for comfort originally, only it was less trouble to cut three large stones than four or five small. They are now all aslope and broken, not repaired for years. Their weighty forms increase the sense of languor throughout the scene, and of stability also, because we feel how difficult it would be to stir them. The crockery has its work to do also; the arched door on the left being necessary to show the great thickness of walls and the strength they require to prevent falling in of the cliff

1 The sails in the engraving were put in to catch the public eye. There are none in the drawing. J.R.

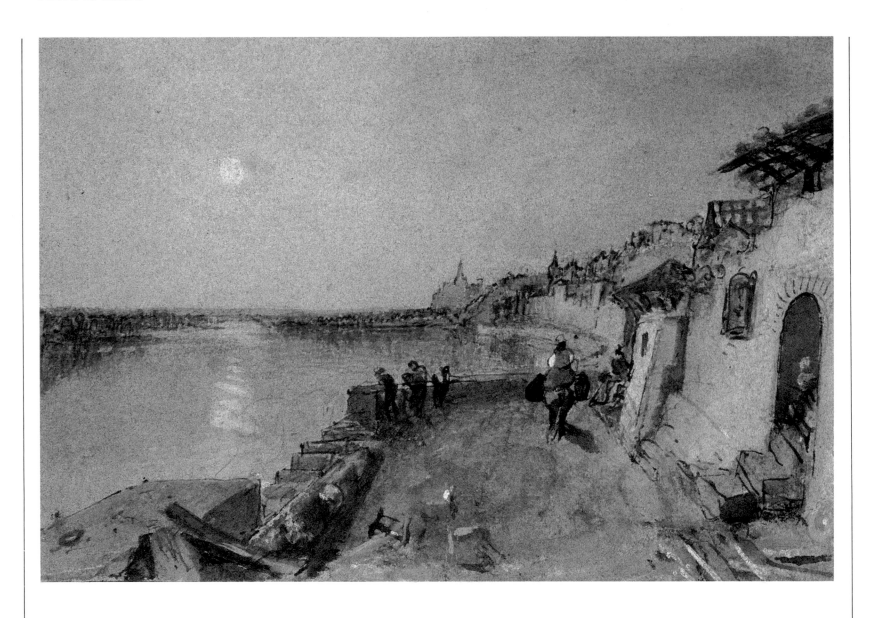

Rietz, near Saumur, c.1826-30

above; as the horizontal lines must be diffused on the right, so this arch must be diffused on the left; and the large round plate on one side of the steps, with the two small ones on the other, are to carry down the element of circular curvature. Hide them, and see the result.

As they carry the arched group of forms down, the arched window-shutter diffuses it upwards, where all the lines of the distant buildings suggest one and the same idea of disorderly and careless strength, mingling masonry with rock.

So far of the horizontal and curved lines. How of the radiating ones? What has the black vine trellis got to do?

Lay a pencil or ruler parallel with its lines. You will find that they all point to the massive building in the distance. To which, as nearly as is possible without at once showing the artifice, every other radiating line points also; almost ludicrously when it is once pointed out; even the curved line of the top of the terrace runs into it, and the last sweep of the river evidently leads to its base. And so nearly is it in the exact centre of the picture, that one diagonal from corner to corner passes through it, and the other only misses the base by the twentieth of an inch.

If you are accustomed to France, you will know in a moment by its outline that this massive building is an old church.

Without it, the repose would not have been essentially the labourer's rest – rest as of the Sabbath. Among all the groups of lines that point to it, two are principal: the first, those of the vine trellis: the second, those of the handles of the saw left in the beam: the blessing of human life, and its labour.

Whenever Turner wishes to express profound repose, he puts in the foreground some instrument of labour cast aside. See, in Rogers's *Poems*, the last vignette, 'Datur hora quieti', with the plough in the furrow: and in the first vignette of the same book, the scythe on the shoulder of the peasant going home. (There is nothing about the scythe in the passage of the poem which this vignette illustrates.)

Observe, farther, the outline of the church itself. As our habitations are, so is our church, evidently a heap of old, but massive walls, patched, and repaired, and roofed in, and over and over, until its original shape is hardly recognizable. I know the kind of church well – can tell even here, two miles off, that I shall find some Norman arches in the apse, and a flamboyant porch, rich and dark, with every statue broken out of it; and a rude wooden belfry above all; and a quantity of miserable shops built in among the buttresses; and that I may walk in and out as much as I please, but that how often soever, I shall always find some one praying at the Holy Sepulchre, in the darkest aisle, and my going in and out will not disturb them. For they *are* praying, which in many a handsomer and highlier-furbished edifice might, perhaps, not be so assuredly the case.

Lastly: what kind of people have we on this winding road? Three indolent ones, leaning on the wall to look over into the gliding water; and a matron with her market panniers; by her figure, not a fast rider. The road, besides, is bad, and seems unsafe for trotting, and she has passed without disturbing the cat, who sits comfortably on the block of wood in the middle of it.

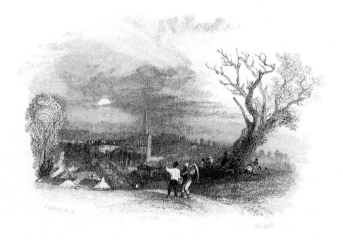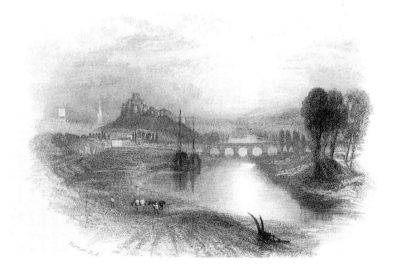

The first and last vignettes from Rogers's Poems, *1834*

Turner's Myths

Myths were always important to Turner. Ruskin's Evangelical Christian beliefs as a young man initially made him hostile to this aspect of his hero's work. But as he grew older, and lost his hold on the Christian faith, he felt the need to look more carefully at what Turner had made of myth. What he saw led him to change his mind about its significance. In his later writing, and especially in the fifth and final volume of *Modern Painters*, mythology became a crucial point of contact between the painter and his critic. Ruskin's long meditation on Turner as a mythological painter became one of the most far-reaching ways in which Turner's art enabled him to acknowledge and express his own deepest preoccupations.

Turner's interest in mythology is a reminder that his intellectual growth was neither as isolated nor as idiosyncratic as the legends which grew up about him after his death might suggest. Classical myths had long been accepted as a decorative and decorous subject for art. But the Romantic period saw a new and much more serious exploration of what such myths might really have meant to the peoples who created them – and what they might still mean to those who wanted to reclaim them. Scholars, poets, antiquarians and artists all turned their attention to the study of ancient mythologies, often asserting that they were comparable with or even superior to the Christian religion.

Quite where Turner stood in relation to the more controversial debates concerning the status and worth of non-Christian myths is uncertain. Characteristically, he left little written evidence of his thoughts on the vehement arguments that evolved. But his pictures make it clear that he was not drawn to mythological motifs just because they were fashionable. Such subjects enabled him to explore some of the questions that lay closest to his imagination: questions about human relations with the natural world, the character of religion, the lessons of history.

One of the areas that provided a focus for contemporary scholarship was the theory that ancient mythology was an expression of the worship of nature. This idea has a long history, but began to develop in new directions in the early nineteenth century. The sun, as the source of all life, could be seen as the central divinity, taking various guises, of primeval religions. This was a notion that held special interest for painters, because the sun was also the source of light. Turner is said to have proclaimed that 'The sun is God' on his deathbed. The story is probably apocryphal, but it points to a preoccupation of momentous importance in his work. Ruskin came to see it as his central motive, contending that Turner's sustained contemplation of light confirmed his identity as a great mythological artist.

In 1857, Ruskin wrote about Turner's *Ulysses Deriding Polyphemus*. The picture is ablaze with light, and Ruskin finds complex significance in this radiance. As he interprets it, it is firstly an autobiographical statement, Ulysses's flaming torch suggesting Turner to be armed with the light of nature, escaping to open sea in the light of the dawn. Ruskin is here exploiting an exegetical method drawn from another context: he is reading the picture as a preacher might examine a Biblical text, searching out identifiable layers of allegorical meaning. The technique, uncomfortably constrained in this instance, was to be used with a great deal

more subtlety in later accounts of Turner's mythological art. Here Ruskin confesses that the 'mythological portion' of the picture is of limited interest to him: 'its real power is in its pure nature, and not in its fancy'. This was a distinction he would soon cease to make. But the 'pure nature' of the picture is already, in his account, imbued with mythological energy, as Turner confuses his image of the rising sun with that of Apollo and his chariot rising from the horizon, 'leaping up into the sky and shaking their crests out into flashes of scarlet cloud'.

Three years later, in the final volume of *Modern Painters*, Ruskin meditates on deeper kinds of meaning in Turner's art. He had not abandoned the insight of the early volumes of the book: Turner was still, for him, essentially a painter of the truths of nature. But he had now come to believe that such natural truth was also spiritual in a sense still wider and deeper than could be contained within Christian tradition. Myths, particularly Greek myths, grew out of the moral comprehension of nature which had inspired Turner's most powerful work, and reference to these myths will illuminate our perception of his pictures – even pictures which might seem to have no mythological content. Ruskin shows how a rain-cloud in the *Slavers* might be understood in a context which juxtaposes Biblical texts with the Greek myth of Pegasus, placing both within the English landscapes in which Turner had learned his business – for the Greeks had never seen cloud fly 'as we may in our own England'.

These patterns of interpretation make new demands upon the reader, as Ruskin expects us to follow his thought through circuitous and sometimes strange paths of knowledge. We are under no obligation to accept every implication of Ruskin's deeply personal revision of Turner's images. But his approach in the final volume of *Modern Painters* is one which enables us to see fresh dimensions of dignity in Turner's work. Paintings such as Turner's watercolours of Salisbury and Stonehenge become, as Ruskin describes them, much more than skilfully dramatic evocations of weather and place. Whether or not we agree with his specific line of interpretation, it is hard to dispute Ruskin's basic premise. We need to recognise that Turner had purposes that were not simply aesthetic.

Ruskin's contemplation of Turner's overtly mythological pictures, the *Garden of the Hesperides* and *Apollo and Python*, reveals a darker side to his changing view of Turner's art. To think about a dragon in a garden is of course to revisit a Christian myth, and Ruskin is acutely aware of this. Apollo's Python, too, becomes in Ruskin's version a Satanic incarnation. In this sense Ruskin intends nothing at all new in what he is saying about Turner's imagery. What is new is his gathering conviction that light could not win a final victory over the shades of dragon and serpent. Sunlight, Ruskin tells us, 'is the type of the wisdom of God'. This is the wisdom that Turner had translated into paint. But he had, in the sadness of Ruskin's interpretation, also prophesied its defeat. He had become 'the painter of the loveliness of nature, with the worm at its root: Rose and cankerworm, – both with his utmost strength; the one *never* separate from the other.'

The Sun is God.
J. M. W. Turner, on his deathbed

The English Pegasus

I SAY, 'WILD' fountains; because the kind of fountain from which Pegasus is named is especially the 'fountain of the great deep' of Genesis [7:11]; sudden and furious, (cataracts of heaven, not windows, in the Septuagint); the mountain torrent caused by thunderous storm, or as our 'fountain' – a Geyser-like leaping forth of water. Therefore, it is the deep and full source of streams, and so used typically of the source of evils, or of passions; whereas the word 'spring' with the Greeks is like our 'well-head' – a gentle issuing forth of water continually. But, because both the lightning-fire and the gushing forth, as of a fountain, are the signs of the poet's true power, together with perpetuity, it is Pegasus who strikes the earth with his foot, on Helicon, and causes Hippocrene to spring forth – 'the horse's well-head'. It is perpetual; but has, nevertheless, the Pegasean storm-power.

Wherein we may find, I think, sufficient cause for putting honour upon the rain-cloud. Few of us, perhaps, have thought, in watching its career across our own mossy hills, or listening to the murmur of the springs amidst the mountain quietness, that the chief masters of the human imagination owed, and confessed that they owed, the force of their noblest thoughts, not to the flowers of the valley, nor the majesty of the hill, but to the flying cloud.

Yet they never saw it fly, as we may in our own England. So far,

The Locks of Typhon. Engraved by Ruskin after detail in 'Slavers', Modern Painters V, 1860

at least, as I know the clouds of the south, they are often more terrible than ours, but the English Pegasus is swifter. On the Yorkshire and Derbyshire hills, when the rain-cloud is low and much broken, and the steady west wind fills all space with its strength,[1] the sun-gleams fly like golden vultures: they are flashes rather than shinings; the dark spaces and the dazzling race and skim along the acclivities, and dart and dip from crag to dell, swallow-like; no Graiæ these, grey and withered: Grey Hounds rather, following the Cerinthian stag with the golden antlers.

There is one character about these lower rain-clouds, partly affecting their connection with the upper sky, which I have never been able to account for; that which, as before noticed, Aristophanes fastened on at once for their distinctive character – their obliquity. They always fly in an oblique position, as in the Plate opposite, which is a careful facsimile of the first advancing mass of the rain-cloud in Turner's Slave Ship. When the head of the cloud is foremost, as in this instance, and rain falling beneath, it is easy to imagine that its drops, increasing in size as they fall, may exercise some retarding action on the wind. But the head of the cloud is not always first, the base of it is sometimes advanced. The only certainty is, that it will not shape itself horizontally, its thin-drawn lines and main contours will always be oblique, though its motion is horizontal; and, which is still more curious, their sloping lines are hardly ever modified in their descent by any distinct retiring tendency or perspective convergence. A troop of leaning clouds will follow one another, each stooping forward at the same apparent slope, round a fourth of the horizon.

Another circumstance which the reader should note in this cloud of Turner's, is the witch-like look of drifted or erected locks of hair at its left side. We have just read the words of the old Greek poet, 'Locks of the hundred-headed Typhon'; and must remember that Turner's account of this picture, in the Academy catalogue, was 'Slavers throwing overboard the Dead and Dying. *Typhoon* coming on.' The resemblance to wildly drifted hair is stronger in the picture than in the engraving; the grey and purple tints of torn cloud being relieved against golden sky beyond.

1 I have been often at great heights on the Alps in rough weather, and have seen strong gusts of storm in the plains of the south. But, to get full expression of the very heart and the meaning of wind, there is no place like a Yorkshire moor. I think Scottish breezes are thinner, very bleak and piercing, but not substantial. If you lean on them they will let you fall, but one may rest against a Yorkshire breeze as one would on a quick-set hedge. I shall not soon forget – having had the good fortune to meet a vigorous one on an April morning, between Hawes and Settle, just on the flat under Whernside – the vague sense of wonder with which I watched Ingleborough stand without rocking. J.R.

Messengers of fate

What opportunities Turner had of acquainting himself with classical literature, and how he used them, we shall see presently. In the meantime, let me simply assure the reader that, in various byways, he had gained a knowledge of most of the great Greek traditions, and that he felt them more than he knew them; his mind being affected, up to a certain point, precisely as an ancient painter's would have been, by external phenomena of nature. To him, as to the Greek, the storm-clouds seemed messengers of fate. He feared them, while he reverenced; nor does he ever introduce them without some hidden purpose, bearing upon the expression of the scene he is painting.

On that plain of Salisbury, he had been struck first by its widely-spacious pastoral life; and secondly, by its monuments of the two great religions of England – Druidical and Christian.

He was not a man to miss the possible connection of these impressions. He treats the shepherd life as a type of the ecclesiastical; and composes his two drawings so as to illustrate both.

In the drawing of Salisbury, the plain is swept by rapid but not distressful rain. The cathedral occupies the centre of the picture, towering high over the city, of which the houses (made on purpose smaller than they really are) are scattered about it like a flock of sheep. The cathedral is surrounded by a great light. The storm gives way at first in a subdued gleam over a distant parish church, then bursts down again, breaks away into full light about the cathedral, and passes over the city, in various sun and shade. In the foreground stands a shepherd leaning on his staff, watching his flock – bareheaded: he has given his cloak to a group of children, who have covered themselves up with it, and are shrinking from the rain; his dog crouches under a bank; his sheep, for the most part, are resting quietly, some coming up the slope of the bank towards him.

The rain-clouds in this picture are wrought with a care which I have never seen equalled in any other sky of the same kind. It is the rain of blessing – abundant, but full of brightness; golden gleams are flying across the wet grass, and fall softly on the lines of willows in the valley – willows by the watercourses; the little brooks flash out here and there between them and the fields. Turn now to the Stonehenge. That, also, stands in great light; but it is the Gorgon light – the sword of Chrysaor is bared against it. The cloud of judgement hangs above. The rock pillars seem to reel before its slope, pale beneath the lightning. And nearer, in the darkness, the shepherd lies dead, his flock scattered.

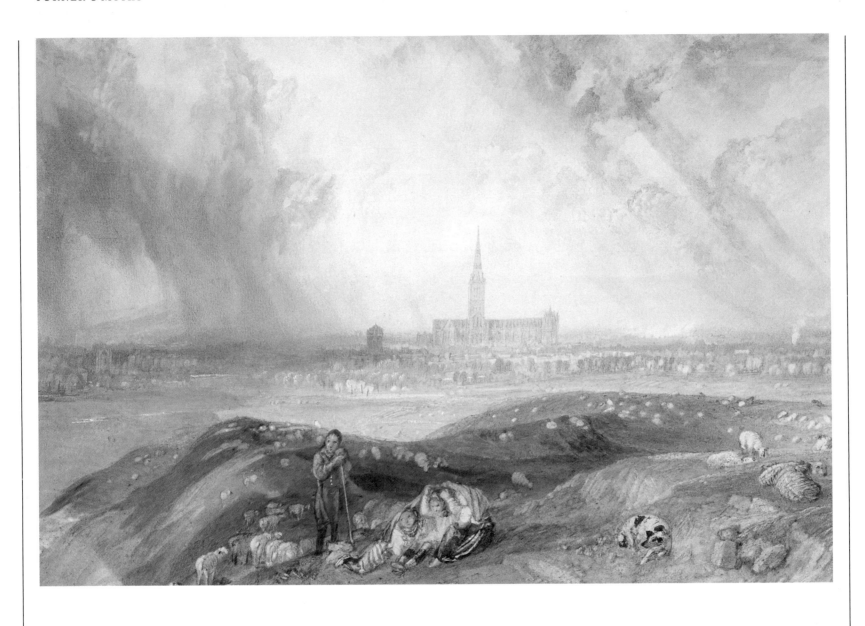

Salisbury, c.1828

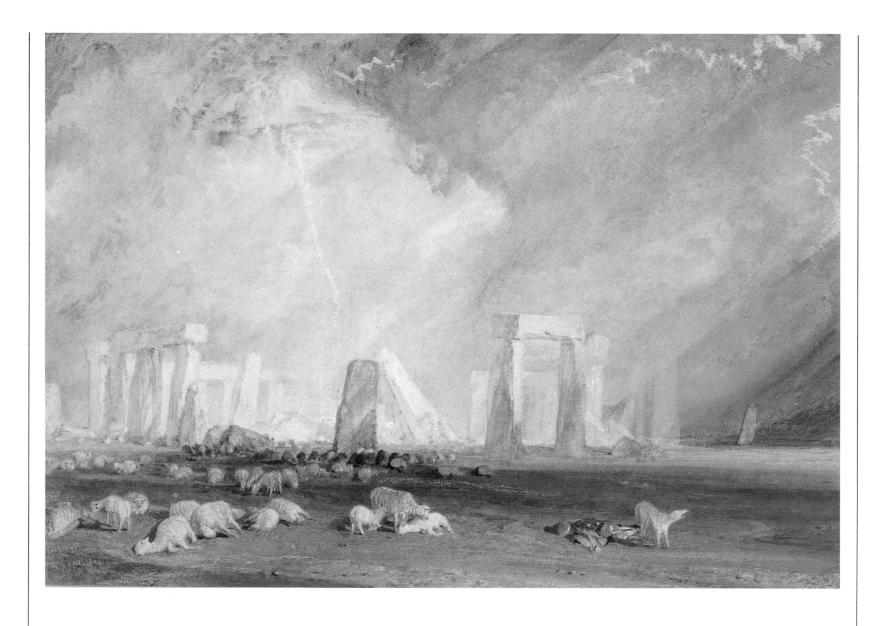

Stonehenge, c.1827

The dragon

Now, look at him, as Turner has drawn him. I cannot reduce the creature to this scale without losing half his power; his length, especially, seems to diminish more than it should in proportion to his bulk. In the picture he is far in the distance, cresting the mountain; and may be, perhaps, three-quarters of a mile long. The actual length on the canvas is a foot and eight inches; so that it may be judged how much he loses by the reduction, not to speak of my imperfect etching, and of the loss which, however well he might have been engraved, he would still have sustained, in the impossibility of expressing the lurid colour of his armour, alternate bronze and blue.

Still, the main points of him are discernible enough: and among all the wonderful things that Turner did in his day, I think this nearly the most wonderful. How far he had really found out for himself the collateral bearings of the Hesperid tradition I know not; but that he had got the main clue of it, and knew who the Dragon was, there can be no doubt; the strange thing is, that his conception of it throughout, down to the minutest detail, fits every one of the circumstances of the Greek traditions. There is, first, the Dragon's descent from Medusa and Typhon, indicated in the serpent-clouds floating from his head . . . then note the grovelling and ponderous body, ending in a serpent, of which we do not see the end. He drags the weight of it forward by his claws, not being able to lift himself from the ground ('Mammon, the least erected spirit that fell' [*Paradise Lost*, i.679]); then the grip of the claws themselves as if they would clutch (rather than tear) the rock itself into pieces; but chiefly, the designing of the body. Remember, one of the essential characters of the creature, as

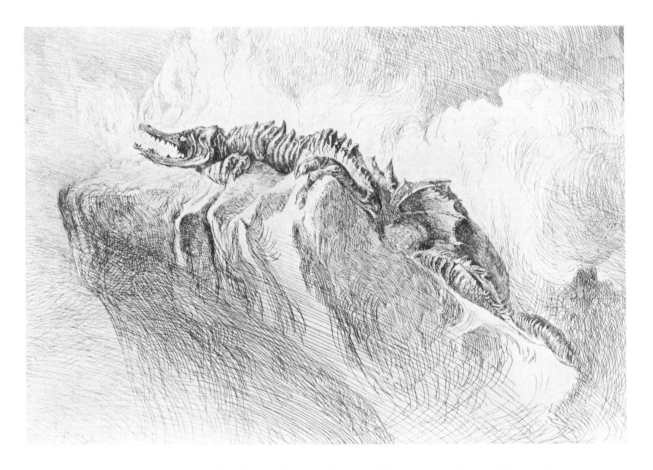

The Dragon. Engraved by Ruskin after detail in 'The Goddess of Discord . . .', Modern Painters V, 1860

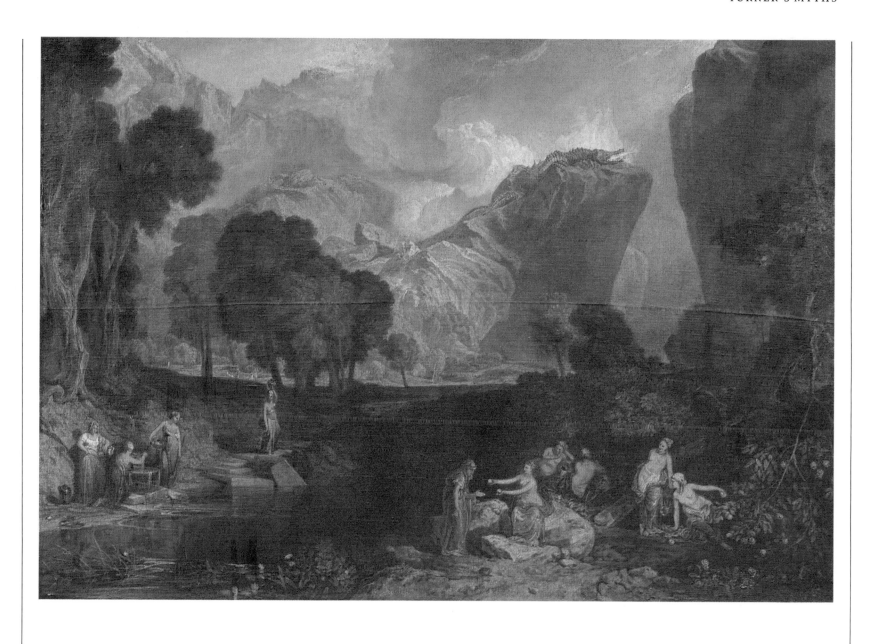

The Goddess of Discord choosing the Apple of Contention in the Garden of the Hesperides, 1806

descended from Medusa, is its coldness and petrifying power; this, in the demon of covetousness, must exist to the utmost; breathing fire, he is yet himself of ice. Now, if I were merely to draw this dragon as white, instead of dark, and take his claws away, his body would become a representation of a great glacier, so nearly perfect, that I know no published engraving of glacier breaking over a rocky brow so like the truth as this dragon's shoulders would be, if they were thrown out in light; there being only this difference, that they have the form, but not the fragility of the ice; they are at once ice and iron. 'His bones are like solid pieces of brass; his bones are like bars of iron; by his neesings a light doth shine.' [Job 41:18]

The strange unity of vertebrated action, and of a true bony contour, infinitely varied in every vertebra, with this glacial outline; together with the adoption of the head of the Ganges crocodile, the fish-eater, to show his sea descent (and this in the year 1806, when hardly a single fossil saurian skeleton existed within Turner's reach), renders the whole conception one of the most curious exertions of the imaginative intellect with which I am acquainted in the arts. . . .

Such then is our English painter's first great religious picture; and exponent of our English faith. A sad-coloured work, not executed in Angelico's white and gold; nor in Perugino's crimson and azure; but in a sulphurous hue, as relating to a paradise of smoke. That power, it appears, on the hill-top, is our British Madonna: whom, reverently, the English devotional painter must paint, thus enthroned, with nimbus about the gracious head. Our Madonna – or our Jupiter on Olympus – or, perhaps, more accurately still, our unknown god, sea-born, with the cliffs, not of Cyrene, but of England, for his altar; and no chance of any Mars' Hill proclamation concerning him, 'whom therefore ye ignorantly worship.' [Acts 17:23]

This is no irony. The fact is verily so. The greatest man of our England, in the first half of the ninteenth century, in the strength and hope of his youth, perceives this to be the thing he has to tell us of utmost moment, connected with the spiritual world. In each city and country of past time, the master-minds had to declare the chief worship which lay at the nation's heart; to define it; adorn it; show the range and authority of it. Thus in Athens, we have the triumph of Pallas; and in Venice the Assumption of the Virgin; here, in England, is our great spiritual fact for ever interpreted to us – the Assumption of the Dragon. No St George any more to be heard of; no more dragon-slaying possible: this child, born on St George's Day, can only make manifest the dragon, not slay him, sea-serpent as he is; whom the English Andromeda, not fearing,

takes for her lord. The fairy English Queen once thought to command the waves, but it is the sea-dragon now who commands her valleys; of old the Angel of the Sea ministered to them, but now the Serpent of the Sea; where once flowed their clear springs now spreads the black Cocytus pool; and the fair blooming of the Hesperid meadows fades into ashes beneath the Nereid's Guard.

The type of love

Five years after the Hesperides were painted, another great mythological subject appeared by Turner's hand. Another dragon – this time not triumphant, but in death-pang, the Python slain by Apollo.

Not in a garden, this slaying, but in a hollow, among wildest rocks, beside a stagnant pool. Yet, instead of the sombre colouring of the Hesperid hills, strange gleams of blue and gold flit around the mountain peaks, and colour the clouds above them.

The picture is at once the type, and the first expression of a great change which was passing in Turner's mind. A change, which was not clearly manifested in all its results until much later in his life; but in the colouring of this picture are the first signs of it; and in the subject of this picture, its symbol.

Had Turner died early, the reputation he would have left, though great and enduring, would have been strangely different from that which ultimately must now attach to his name. He would have been remembered as one of the severest of painters; his iron touch and positive forms would have been continually opposed to the delicacy of Claude and richness of Titian; he would have been spoken of, popularly, as a man who had no eye for colour. Perhaps here and there a watchful critic might have shown this popular idea to be false; but no conception could have been formed by any one of the man's real disposition or capacity.

It was only after the year 1820 that these were determinable, and his peculiar work discerned.

He had begun by faithful declaration of the sorrow there was in the world. It is now permitted him to see also its beauty. He becomes, separately and without rival, the painter of the loveliness and light of the creation.

Of its loveliness: that which may be beloved in it, the tenderest, kindest, most feminine of its aspects. Of its light: light not merely diffused, but interpreted; light seen pre-eminently in colour.

Claude and Cuyp had painted the sun*shine*, Turner alone, the sun *colour*.

Observe this accurately. Those easily understood effects of afternoon light, gracious and sweet so far as they reach, are produced by the softly warm or yellow rays of the sun falling through mist. They are low in tone, even in nature, and disguise the colours of objects. They are imitable even by persons who have little or no gift of colour, if the tones of the picture are kept low and in true harmony, and the reflected lights warm. But they never could be painted by great colourists. The fact of blue and crimson being effaced by yellow and grey, puts such effect at once out of the notice or thought of a colourist, unless he has some special interest in the motive of it. You might as well ask a musician to compose with only three notes, as Titian to paint without crimson and blue. Accordingly the colourists in general, feeling that no other than this yellow sunshine was imitable, refused it, and painted in twilight, when the colour was full. Therefore, from the imperfect colourists, from Cuyp, Claude, Both, Wilson, we get deceptive effect of sunshine; never from the Venetians, from Rubens, Reynolds, or Velasquez. From these we get only conventional substitutions for it, Rubens being especially daring in frankness of symbol.

Turner, however, as a landscape painter, had to represent sunshine of one kind or another. He went steadily through the subdued golden chord, and painted Cuyp's favourite effect, 'sun rising through vapour', for many a weary year. But this was not enough for him. He must paint the sun in his strength, the sun rising *not* through vapour. If you glance at that Apollo slaying the Python, you will see there is rose colour and blue on the clouds, as well as gold; and if then you turn to the Apollo in the Ulysses and Polyphemus – his horses are rising beyond the horizon – you see he is not 'rising through vapour', but above it; gaining somewhat of a victory over vapour, it appears.

The old Dutch brewer, with his yellow mist, was a great man and a good guide, but he was not Apollo. He and his dray-horses led the way through the flats, cheerily, for a little time; we have other horses now flaming out 'beyond the mighty sea'.

A victory over vapour of many kinds; Python-slaying in general. Look how the Python's jaws smoke as he falls back between the rocks: a vaporous serpent! We will see who he was presently.

The public remonstrated loudly in the cause of Python: 'He had been so yellow, quiet, and pleasant a creature; what meant these azure-shafted arrows, this sudden glare into darkness, this Iris message; Thaumantian; miracle-working; scattering our slumber down in Cocytus?' It meant much, but that was not what they should have first asked about it. They should have asked simply

was it a true message? Were these Thaumantian things so in the real universe?

It might have been known easily they were. One fair dawn or sunset, obediently beheld, would have set them right; and shown that Turner was indeed the only true speaker concerning such things that ever yet had appeared in the world. They would neither look nor hear – only shouted continuously, 'Perish Apollo. Bring us back Python.'

We must understand the real meaning of this cry, for herein rests not merely the question of the great right or wrong in Turner's life, but the question of the right or wrong of all painting. Nay, on this issue hangs the nobleness of painting as an art altogether, for it is distinctively the art of colouring, not of shaping or relating. Sculptors and poets can do these, the painter's own work is colour.

Thus, then, for the last time, rises the question, what is the true dignity of colour? We left that doubt a little while ago among the clouds, wondering what they had been made so scarlet for. Now Turner brings the doubt back to us, unescapable any more. No man, hitherto, had painted the clouds scarlet. Hesperid Æglé, and Erytheia, throned there in the west, fade into the twilights of four thousand years, unconfessed. Here is at last one who confesses them, but is it well? Men say these Hesperides are sensual goddesses – traitresses – that the Graiæ are the only true ones. Nature made the western and the eastern clouds splendid in fallacy. Crimson is impure and vile; let us paint in black if we would be virtuous.

Note, with respect to this matter, that the peculiar innovation of Turner was the perfection of the colour chord by means of *scarlet*. Other painters had rendered the golden tones, and the blue tones, of sky; Titian especially the last, in perfectness. But none had dared to paint, none seem to have seen, the scarlet and purple.

Nor was it only in seeing this colour in vividness when it occurred in full light, that Turner differed from preceding painters. His most distinctive innovation as a colourist was his discovery of the scarlet *shadow*. 'True, there is a sunshine whose light is golden, and its shadow grey; but there is another sunshine, and that the purest, whose light is white, and its shadow scarlet.' This was the essentially offensive, inconceivable thing, which he could not be believed in. There was some ground for the incredulity, because no colour is vivid enough to express the pitch of light of pure white sunshine, so that the colour given without the true intensity of light *looks* false. Nevertheless, Turner could not but report of the colour truly. 'I must indeed be lower in the key, but that is no reason why I should be false in the note. Here is sunshine which

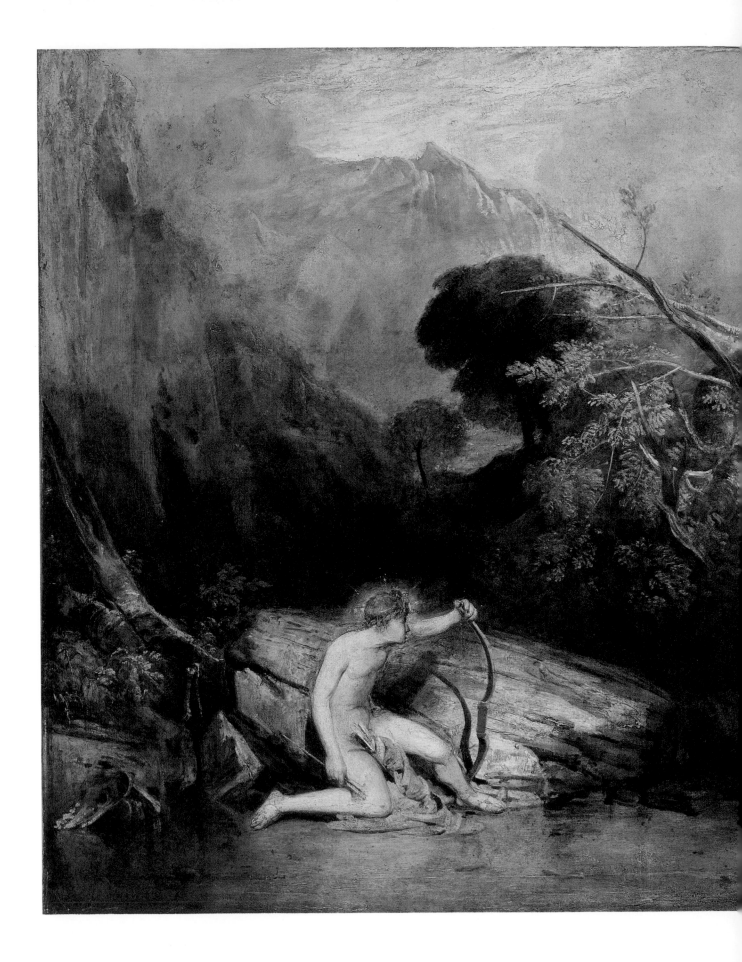

Apollo and Python, 1811

glows even when subdued; it has not cool shade, but fiery shade.'[1] This is the glory of sunshine.

Now, this scarlet colour – or pure red, intensified by expression of light – is, of all the three primitive colours, that which is most distinctive. Yellow is of the nature of simple light; blue connected with simple shade; but red is an entirely abstract colour. It is red to which the colourblind are blind, as if to show us that it was not necessary merely for the service or comfort of man, but that there was a special gift or teaching in this colour. Observe, farther, that it is this colour which the sunbeams take in passing through the *earth's atmosphere*. The rose of dawn and sunset is the hue of the rays passing close over the earth. It is also concentrated in the blood of man.

Unforeseen requirements have compelled me to disperse through various works, undertaken between the first and last portions of this essay, the examination of many points respecting colour, which I had intended to reserve for this place. I can now only refer the reader to these several passages, and sum their import; which is briefly, that colour generally, but chiefly the scarlet, used with the hyssop, in the Levitical law, is the great sanctifying element of visible beauty, inseparably connected with purity and life.

I must not enter here into the solemn and far-reaching fields of thought which it would be necessary to traverse, in order to detect the mystical connection between life and love, set forth in that Hebrew system of sacrificial religion to which we may trace most of the received ideas respecting sanctity, consecration, and purification. This only I must hint to the reader – for his own following out – that if he earnestly examines the original sources from which our heedless popular language respecting the washing away of sins has been borrowed, he will find that the fountain, in which sins are indeed to be washed away, is that of love, not of agony.

But, without approaching the presence of this deeper meaning of the sign, the reader may rest satisfied with the connection given him directly in written words, between the cloud and its bow. [Genesis 9:13] The cloud, or firmament, as we have seen, signifies the ministration of the heavens to man. That ministration may be in judgement or mercy – in the lightning, or the dew. But the bow, or colour of the cloud, signifies always mercy, the sparing of life; such ministry of the heaven as shall feed and prolong life. And as

the sunlight, undivided, is the type of wisdom and righteousness of God, so divided, and softened into colour by means of the firmamental ministry, fitted to every need of man, as to every delight, and becoming one chief source of human beauty, by being made part of the flesh of man; – thus divided, the sunlight is the type of the wisdom of God, becoming sanctification and redemption. Various in work – various in beauty – various in power.

Colour is, therefore, in brief terms, the type of love. Hence it is especially connected with the blossoming of the earth; and again, with its fruits; also, with the spring and fall of the leaf, and with the morning and evening of the day, in order to show the waiting of love about the birth and death of man.

And now, I think, we may understand, even far away in the Greek mind, the meaning of that Contest of Apollo with the Python. It was a far greater contest than that of Hercules with Ladon. Fraud and avarice might be overcome by frankness and force; but this Python was a darker enemy, and could not be subdued but by a greater god. Nor was the conquest slightly esteemed by the victor deity. He took his great name from it thenceforth – his prophetic and sacred name – the Pythian.

It could, therefore, be no merely devouring dragon – no mere wild beast with scales and claws. It must possess some more terrible character to make conquest over it so glorious. Consider the meaning of its name, *'the corrupter'*. That Hesperid dragon was a treasure-guardian. This is the treasure-destroyer – where moth and rust doth corrupt – the worm of eternal decay.

Apollo's contest with him is the strife of purity with pollution; of life with forgetfulness; of love, with the grave.

I believe this great battle stood, in the Greek mind, for the type of the struggle of youth and manhood with deadly sin – venomous, infectious, irrecoverable sin. In virtue of his victory over this corruption, Apollo becomes thenceforward the guide; the witness; the purifying and helpful God. The other gods help waywardly, whom they choose. But Apollo helps always: he is by name, not only Pythian, the conqueror of death; but Pæan – the healer of the people.

Well did Turner know the meaning of that battle: he has told its tale with fearful distinctness. The Mammon dragon was armed with adamant; but this dragon of decay is a mere colossal worm: wounded, he bursts asunder in the midst, and melts to pieces, rather than dies, vomiting smoke – a smaller serpent-worm rising out of his blood.

Alas, for Turner! This smaller serpent-worm, it seemed, he could not conceive to be slain. In the midst of all the power and beauty of nature, he still saw this death-worm writhing among the

1 Not, accurately speaking, shadow, but dark side. All shadow proper is negative in colour, but, generally, reflected light is warmer than direct light; and when the direct light is warm, pure, and of the highest intensity, its reflection is scarlet. Turner habitually, in his later sketches, used vermilion for his pen outline in effects of sun. J.R.

weeds. A little thing now, yet enough: you may see it in the foreground of the Bay of Baiæ, which has also in it the story of Apollo and the Sibyl; Apollo giving love; but not youth, nor immortality: you may see it again in the foreground of the Lake Avernus – the Hades lake – which Turner surrounds with delicatest beauty, the Fates dancing in circle; but in front, is the serpent beneath the thistle and the wild thorn. The same Sibyl, Deiphobe, holding the golden bough. I cannot get at the meaning of this legend of the bough; but it was, assuredly, still connected, in Turner's mind, with that help from Apollo. He indicated the strength of his feeling at the time when he painted the Python contest, by the drawing exhibited the same year, of the Prayer of Chryses. There the priest is on the beach alone, the sun setting. He prays to it as it descends; flakes of its sheeted light are borne to him by the melancholy waves, and cast away with sighs upon the sand.

How this sadness came to be persistent over Turner, and to conquer him, we shall see in a little while. It is enough for us to know at present that our most wise and Christian England, with all her appurtenances of school-porch and church-spire, had so disposed her teaching as to leave this somewhat notable child of hers without even cruel Pandora's gift.

He was without hope.

True daughter of Night, Hesperid Æglé was to him; coming between Censure, and Sorrow – and the Destinies.

What, for us, his work yet may be, I know not. But let not the real nature of it be misunderstood any more.

He is distinctively, as he rises into his own peculiar strength, separating himself from all men who had painted forms of the physical world before – the painter of the loveliness of nature, with the worm at its root: Rose and cankerworm – both with his utmost strength; the one *never* separate from the other.

The light of nature

. . . 'Polyphemus' asserts his perfect power, and is, therefore, to be considered as the *central picture* in Turner's career. And it is in some sort a type of his own destiny.

He had been himself shut up by one-eyed people, in a cave 'darkened with laurels' (getting no good, but only evil, from all the fame of the great of long ago) – he had seen his companions eaten in the cave by the one-eyed people – (many a painter of good promise had fallen by Turner's side in those early toils of his); at last, when his own time had like to have come, he thrust the rugged pine-trunk – all ablaze – (rough nature, and the light of it)

– into the faces of the one-eyed people, left them tearing their hair in the cloud-banks – got out of the cave in a humble way, under a sheep's belly – (helped by the lowliness and gentleness of nature, as well as by her ruggedness and flame) – and got away to open sea as the dawn broke over the Enchanted Islands. [*Odyssey*, book ix]

The printed catalogue describes this picture as 'gorgeous with *sunset* colours'. The first impression on most spectators would, indeed, be that it was evening, but chiefly because we are few of us in the habit of seeing summer sunrise. The time is necessarily morning – the Cyclops had been blinded as soon as he slept; Ulysses and his companions escaped when he drove out the flock in the early morning, and they put instantly to sea. The somewhat gloomy and deeply coloured tones of the lower crimson clouds, and of the stormy blue bars underneath them, are always given by Turner to skies which rise over any scene of death, or one connected with any deathful memories. But the morning light is unmistakably indicated by the pure whiteness of the mists, and upper mountain snows, above the Polyphemus; at evening they would have been in an orange glow; and, for more complete assurance still, if the reader will examine the sky close to the sun, on the right of it, he will find the horses of Apollo drawn in fiery outline, leaping up into the sky and shaking their crests out into flashes of scarlet cloud. The god himself is formless, he *is* the sun. The white column of smoke which rises from the mountain slope is a curious instance of Turner's careful reading of his text. (I presume him to have read Pope only.)

> The land of Cyclops lay in prospect near,
> The voice of goats and bleating flocks we hear,
> And from their mountains rising smokes appear.

Homer says simply: 'We were so near the Cyclops' land that we could see smoke, and hear the voices, and the bleating of the sheep and goats.' Turner was, however, so excessively fond of opposing a massive form with a light wreath of smoke (perhaps almost the only proceeding which could be said with him to have become a matter of recipe), that I do not doubt we should have had some smoke at any rate, only it is made more prominent in consequence of Pope's lines. The Cyclops' cave is low down at the shore – where the red fire is – and, considering that Turner was at this time Professor of Perspective to the Royal Academy, and that much outcry has lately been raised against supposed Pre-Raphaelite violations of perspective law, I think we may not unwarrantably inquire how our Professor supposed that *that* Cyclops could ever have got into *that* cave.

For the naval and mythological portion of the picture, I have not

Ulysses deriding Polyphemus, 1829

The Aiguillette, Valley of Cluses, France, 1802. Study for watercolour of 1806

much to say: its real power is in its pure nature, and not in its fancy. If Greek ships ever resembled this one, Homer must have been a calumnious and foul-mouthed person in calling them continually 'black ships'; and the entire conception, so far as its idealism and water-carriage are concerned, is merely a composition of the Lord Mayor's procession with a piece of ballet-scenery. The Cyclops is fine, passionate enough, and not disgusting in his hugeness; but I wish he were out of the way, as well as the sails and flags, that we might see the mountains better. The island rock is tunnelled at the bottom – on classical principles. The sea grows calm all at once, that it may reflect the sun; and one's first impression is that Leucothea is taking Ulysses right on the Goodwin Sands. But – granting the local calmness – the burnished glow upon the sea, and the breezy stir in the blue darkness about the base of the cliffs, and the noble space of receding sky, vaulted with its bars of cloudy gold, and the upper peaks of the snowy Sicilian promontory, are all as perfect and as great as human work can be. This sky is beyond comparison the finest that exists in Turner's oil-paintings. Next to it comes that of the 'Slaver'; and third, that of the *Téméraire*.

Greek hills

And here I am able to show you, fortunately, one of his works painted at this time of his most earnest thought; when his imagin-

ation was still freshly filled with the Greek mythology, and he saw for the first time with his own eyes the clouds come down upon the actual earth.

The scene is one which, in old times of Swiss travelling, you would all have known well; a little cascade which descends to the road from Geneva to Chamouni, near the village of Maglans, from under a subordinate ridge of the Aiguille de Varens, known as the Aiguillette. You, none of you, probably, know the scene now, for your only object is to get to Chamouni and up Mont Blanc and down again; but the Valley of Cluse, if you knew it, is worth many Chamounis; and it impressed Turner profoundly. The facts of the spot are here given in mere and pure simplicity; a quite unpicturesque bridge, a few trees partly stunted and blasted by the violence of the torrent in storm at their roots, a cottage with its mill-wheel – this has lately been pulled down to widen the road – and the brook shed from the rocks and finding its way to join the Arve. The scene is absolutely Arcadian. All the traditions of the Greek Hills, in their purity, were founded on such rocks and shadows as these; and Turner has given you the birth of the Shepherd Hermes on Cyllene, in its visible and solemn presence, the white cloud, Hermes Eriophoros, forming out of heaven upon the Hills; the brook, distilled from it, as the type of human life, born of the cloud and vanishing into the cloud, led down by the haunting Hermes among the ravines; and then, like the reflection of the cloud itself, the white sheep, with the dog of Argus guarding them, drinking from the stream.

The Alps. Vignette from Rogers's Italy, *1836*

Turner in England

Turner was born on 23rd April 1775 – St George's day, and Shakespeare's birthday. The coincidence has always seemed an uncanny confirmation of his special distinction as an English artist. It comes as something of a surprise, then, to learn that documentary evidence for the date is slight. It is not impossible that Turner, just as aware as anyone else of the resonance that the anniversary had for the English, settled on it himself. Such a choice, concealing the personal circumstances of his life and emphasizing its public meaning, would have been characteristic of the way in which he often preferred to conduct his affairs. He did not like attention to be focused on his own life, apparently caring for little other than his work. Nevertheless, he was a strongly emotional artist, and his attachment to a national identity, no less intense through being maintained from the sometimes sceptical perspective of an outsider, was one of the most powerful currents of feeling in his work.

Why should Turner have regarded himself as an outsider? Clearly there were many ways in which he did not. The evidence we have does not support the image of Turner as a grumpy recluse, refusing all contact with others. He was a gregarious man, who appreciated conversation and friendship, and was notably generous in his dealings with other artists. Still, there seems always to have been a marked degree of reserve in his character, in part perhaps due to his family circumstances. His mother's life remains something of a mystery, but what contemporary evidence survives suggests that she was not inclined to behave like a lady and,

like many another unmanageable woman of the period, she ended her days in a lunatic asylum. Turner and his father were devoted to each other, and Turner owed as much as Ruskin to the affectionate and practical support of a loyal father. But William Turner possessed no more gentility than his wife, and his uneducated accent and unconventional behaviour were a source of much patronising hilarity among his son's contemporaries. This must have caused Turner pain. His uncertain social position may lie at the deepest roots of the detachment with which he tirelessly observed and preserved the life of his countrymen.

Turner's ambiguous rank in society seems to have been much on Ruskin's mind when he first met the artist. He tells us that he had been warned that Turner was 'coarse, boorish, unintellectual, vulgar' (see p.21), and insists that he found in him an 'English-minded – gentleman'. A troubled need to be acknowledged as an English gentleman was one of the many bonds that drew Ruskin and Turner together. Ruskin, like Turner, was brought up in London; but he too felt a good deal of ambivalence about his national identity and social place. His sense of outsidership was of different origins, but it was an equally pervasive force in his life. Ruskin's parents were Scottish, not English, and he always felt himself to be at least half a Scot. Like Turner's father, though on a very much grander scale, Ruskin's father was a tradesman with a determined ambition that his son should make his mark in a world that seemed to offer a different kind of social status: that of the arts. This gave Ruskin, like

Turner, a reason to develop a sharp and penetrating eye for the characteristics and peculiarities of a social world of which he never felt wholly part.

Ruskin's identification with Turner's uneasy sense of himself as an Englishman directs his readings in profoundly personal and sometimes idiosyncratic ways. It is odd, for instance, to find him slipping into the use of 'we' when writing about Turner's English boyhood in the final volume of *Modern Painters*, with an effect that is both intimate and condescending (see pp.101-2). But his sympathy with Turner's distinctive Englishness allowed him to see aspects of the artist's work which few others would have thought worthy of notice – details like Turner's predilection for litter, and his liking for what Ruskin terms 'a succulent cluster or two of greengrocery' in the corners of his pictures, which Ruskin puts down to loving memories of early days in Covent Garden. More significantly, Ruskin knew that it was Turner's urban experiences that gave him his shrewd and unsentimental interest in the poor – an interest which Ruskin shared to the full, though it found very different expression in his work

Ruskin was inclined to associate Turner's English identity with some sense of melancholy, a viewpoint which is often infused with his own elegiac sense of England as a place of vanishing glory. It is a subtext in his account of Turner's Bolton Abbey, and still stronger in his later account of *Sunshine. On the Tamar*: 'thus it comes to pass that the loveliest hues, which in the hands of every other great painter express nothing but delight and purity, are with Turner wrought most richly when they are pensive: and wear with their dearest beauty the shadows of death.' This has more to do with Ruskin's own sorrowful state of mind in 1878 than the way in which Turner had painted the rural scene on the Tamar.

But Ruskin did not always see Turner's England in such a sombre light. His account of *Deal* is light-hearted; what he has to say about *A First-Rate Taking in Stores* is full of a sense of pride and delight in the master's skill. Ruskin sees in this picture exhilarating evidence of the unsurpassed fluency of Turner's powers of composition. Other paintings of English scenes provide him with the means of exploring such mastery in Turner's art: *Lancaster Sands*, and *Heysham and Cumberland Mountains*, are discussed in these terms in the first volume of *Modern Painters*. In such pictures, English landscape is perceived in terms of English people: hills and streams do not exist in isolation from those who live by them.

In his Oxford *Lectures on Landscape*, Ruskin explains his view of the relation between landscape and its inhabitants. 'It is so natural to suppose that the main interest of landscape is essentially in rocks and water and sky; and that figures are to be put, like the salt and mustard to a dish, only to give it a flavour. Put all that out of your heads at once.' People are the point of landscape. Mountains and streams have a human story to tell: their 'vital character' is an expression of that story, not simply of their physical characteristics. Looking at Turner's England, Ruskin made little separation between the English people and the landscape which has come to embody and record their history.

Have you seen my study – sky and water. Are they not glorious? Here I have my lessons day and night.

J. M. W. Turner, looking out of his studio window

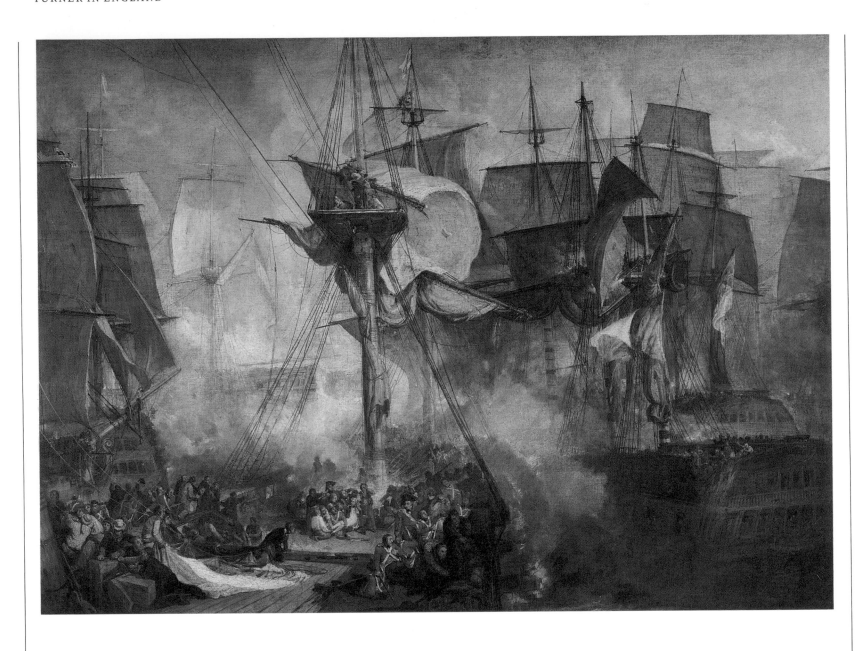

The Battle of Trafalgar, as seen from the mizzen starboard shrouds of the Victory. Exhibited 1806, reworked 1808

Boyhood

NEAR THE south-west corner of Covent Garden, a square brick pit or well is formed by a close-set block of houses, to the back windows of which it admits a few rays of light. Access to the bottom of it is obtained out of Maiden Lane, through a low archway and an iron gate; and if you stand long enough under the archway to accustom your eyes to the darkness you may see on the left hand a narrow door, which formerly gave quiet access to a respectable barber's shop, of which the front window, looking into Maiden Lane, is still extant, filled, in this year (1860), with a row of bottles, connected, in some defunct manner, with a brewer's business. A more fashionable neighbourhood, it is said, eighty years ago than now – never certainly a cheerful one – wherein a boy being born on St George's day, 1775, began soon after to take interest in the world of Covent Garden, and put to service such spectacles of life as it afforded.

No knights to be seen there, nor, I imagine, many beautiful ladies; their costume at least disadvantageous, depending much on incumbency of hat and feather, and short waists; the majesty of men founded similarly on shoebuckles and wigs; impressive enough when Reynolds will do his best for it; but not suggestive of much ideal delight to a boy.

'Bello ovile dov' io dormii agnello';[1] of things beautiful, besides men and women, dusty sunbeams up or down the street on summer mornings; deep furrowed cabbage-leaves at the green-grocer's; magnificence of oranges in wheelbarrows round the corner; and Thames' shore within three minutes' race.

None of these things very glorious; the best, however, that England, it seems, was then able to provide for a boy of gift: who, such as they are, loves them – never, indeed, forgets them. The short waists modify to the last his visions of Greek ideal. His foregrounds had always a cluster or two of greengrocery at the corners. Enchanted oranges gleam in Covent Gardens of the Hesperides; and great ships go to pieces in order to scatter chests of them on the waves. That mist of early sunbeams in the London dawn crosses, many and many a time, the clearness of Italian air; and by Thames' shore, with its stranded barges and glidings of red sail, dearer to us than Lucerne lake or Venetian lagoon – by Thames' shore we will die.

With such circumstance round him in youth, let us note what necessary effects followed upon the boy. I assume him to have had

Giorgione's sensibility (and more than Giorgione's, if that be possible) to colour and form. I tell you farther, and this fact you may receive trustfully, that his sensibility to human affection and distress was no less keen than even his sense for natural beauty – heartsight deep as eyesight.

Consequently, he attaches himself with the faithfullest child-love to everything that bears an image of the place he was born in. No matter how ugly it is – has it anything about it like Maiden Lane, or like Thames' shore? If so, it shall be painted for their sake. Hence, to the very close of life, Turner could endure ugliness which no one else, of the same sensibility, would have borne with for an instant. Dead brick walls, blank square windows, old clothes, market-womanly types of humanity – anything fishy and muddy, like Billingsgate or Hungerford Market, had great attraction for him; black barges, patched sails, and every possible condition of fog.

You will find these tolerations and affections guiding or sustaining him to the last hour of his life; the notablest of all such endurances being that of dirt. No Venetian ever draws anything foul; but Turner devoted picture after picture to the illustration of effects of dinginess, smoke, soot, dust, and dusty texture; old sides of boats, weedy roadside vegetation, dung-hills, straw-yards, and all the soilings and stains of every common labour.

And more than this, he not only could endure, but enjoyed and looked for *litter*, like Covent Garden wreck after the market. His pictures are often full of it, from side to side; their foregrounds differ from all others in the natural way that things have of lying about in them. Even his richest vegetation, in ideal work, is confused; and he delights in shingle, débris, and heaps of fallen stones. The last words he ever spoke to me about a picture were in gentle exultation about his St Gothard: 'that *litter* of stones which I endeavoured to represent.'

The second great result of this Covent Garden training was, understanding of and regard for the poor, whom the Venetians, we saw, despised; whom, contrarily, Turner loved, and more than loved – understood. He got no romantic sight of them, but an infallible one, as he prowled about the end of his lane, watching night effects in the wintry streets; nor sight of the poor alone, but of the poor in direct relations with the rich. He knew, in good and evil, what both classes thought of, and how they dealt with, each other.

Reynolds and Gainsborough, bred in country villages, learned there the country boy's reverential theory of 'the squire', and kept it. They painted the squire and the squire's lady as centres of the movements of the universe, to the end of their lives. But Turner

1 Dante's reference to Florence: '. . . the fair sheepfold wherein I used to sleep, a lamb', *Paradiso* XXV, 5. D.B.

perceived the younger squire in other aspects about his lane, occurring prominently in its night scenery, as a dark figure, or one of two, against the moonlight. He saw also the working of city commerce, from endless warehouse, towering over Thames, to the back shop in the lane, with its stale herrings – highly interesting these last; one of his father's best friends, whom he often afterwards visited affectionately at Bristol, being a fishmonger and glue-boiler; which gives us a friendly turn of mind towards herring-fishing, whaling, Calais poissardes, and many other of our choicest subjects in after-life; all this being connected with that mysterious forest below London Bridge on one side; and, on the other, with these masses of human power and national wealth which weigh upon us, at Covent Garden here, with strange compression, and crush us into narrow Hand Court.

'That mysterious forest below London Bridge' – better for the boy than wood of pine, or grove of myrtle. How he must have tormented the watermen, beseeching them to let him crouch anywhere in the bows, quiet as a log, so only that he might get floated down there among the ships, and round and round the ships, and with the ships, and by the ships, and under the ships, staring, and clambering; these the only quite beautiful things he can see in all the world, except the sky; but these, when the sun is on their sails, filling or falling, endlessly disordered by sway of tide and stress of anchorage, beautiful unspeakably; which ships also are inhabited by glorious creatures – red-faced sailors, with pipes, appearing over the gunwales, true knights, over their castle parapets – the most angelic beings in the whole compass of London world. And Trafalgar happening long before we can draw ships, we, nevertheless, coax all current stories out of the wounded sailors, do our best at present to show Nelson's funeral streaming up the Thames; and vow that Trafalgar shall have its tribute of memory some day. Which, accordingly, is accomplished – once, with all our might, for its death; twice, with all our might, for its victory; thrice in pensive farewell to the old *Téméraire*, and with it, to that order of things.

The love of Yorkshire

The first instance, therefore, of Turner's mountain drawing which I endeavoured to give accurately, in this book, was from those shores of Wharfe which, I believe, he never could revisit without tears; nay, which for all the latter part of his life, he never could even speak of, but his voice faltered. We will now examine this instance with greater care.

It is first to be remembered that in every one of his English or French drawings, Turner's mind was, in two great instincts, at variance with itself. The *affections* of it clung, as we have just seen, to humble scenery, and gentle wildness of pastoral life. But the *admiration* of it was, more than any other artist's whatsoever, fastened on largeness of scale. With all his heart, he was attached to the narrow meadows and rounded knolls of England; by all his imagination he was urged to the reverence of endless vales and measureless hills: nor could any scene be too contracted for his love, or too vast for his ambition. Hence, when he returned to English scenery after his first studies in Savoy and Dauphiné, he was continually endeavouring to reconcile old fondnesses with new sublimities; and, as in Switzerland he chose rounded Alps for the love of Yorkshire, so in Yorkshire he exaggerated scale, in memory of Switzerland, and gave to Ingleborough, seen from Hornby Castle, in great part the expression of cloudy majesty and height which he had seen in the Alps from Grenoble. We must continually remember these two opposite instincts as we examine the Turnerian topography of his subject of Bolton Abbey.

The Abbey is placed, as most lovers of our English scenery know well, on a little promontory of level park land, enclosed by one of the sweeps of the Wharfe. On the other side of the river, the flank of the dale rises in a pretty wooded brow, which the river, leaning against, has cut into two or three somewhat bold masses of rock, steep to the water's edge, but feathered above with copse of ash and oak. Above these rocks, the hills are rounded softly upwards to the moorland; the entire height of the brow towards the river being perhaps two hundred feet, and the rocky parts of it not above forty or fifty, so that the general impression upon the eye is that the hill is little more than twice the height of the ruins, or of the groups of noble ash trees which encircle them. One of these groups is conspicuous above the rest, growing on the very shore of the tongue of land which projects into the river, whose clear brown water, stealing first in mere threads between the separate pebbles of shingle, and eddying in soft golden lines towards its central currents, flows out of amber into ebony, and glides calm and deep below the rock on the opposite shore.

Except in this stony bed of the stream, the scene possesses very little more aspect of mountain character then belongs to some of the park and meadow land under the chalk hills near Henley and Maidenhead; and if it were faithfully drawn on all points, and on its true scale, would hardly more affect the imagination of the spectator, unless he traced, with such care as is never from any spectator to be hoped, the evidence of nobler character in the pebbled shore and unconspicuous rock. But the scene in reality

Bolton Abbey, c.1825

The Junction of the Greta and Tees at Rokeby, 1816-18

does affect the imagination strongly, and in a way wholly different from lowland hill scenery. A little farther up the valley the limestone summits rise, and that steeply, to a height of twelve hundred feet above the river, which foams between them in the narrow and dangerous channel of the Strid. Noble moorlands extend above, purple with heath, and broken into scars and glens; and around every soft tuft of wood, and gentle extent of meadow, throughout the dale, there floats a feeling of this mountain power, and an instinctive apprehension of the strength and greatness of the wild northern land.

It is to the association of this power and border sternness with the sweet peace and tender decay of Bolton Priory, that the scene owes its distinctive charm. The feelings excited by both characters are definitely connected by the melancholy tradition of the circumstances to which the Abbey owes its origin; and yet farther darkened by the nearer memory of the death, in the same spot which betrayed the boy of Egremont, of another, as young, as thoughtless, and as beloved.

> The stately priory was reared,
> And Wharfe, as he moved along,
> To matins joined a mournful voice,
> Nor failed at evensong.
>> [Wordsworth, 'The Force of Prayer; or,
>> the Founding of Bolton Priory']

All this association of various awe, and noble mingling of mountain strength with religious fear, Turner had to suggest, or he would not have drawn Bolton Abbey. He goes down to the shingly shore; for the Abbey is but the child of the Wharfe; it is the river, the great cause of the Abbey, which shall be his main subject; only the extremity of the ruin itself is seen, between the stems of the ash trees; but the waves of the Wharfe are studied with a care which renders this drawing unique among Turner's works, for its expression of the eddies of a slow mountain stream, and of their pausing in treacherous depth beneath the hollowed rocks.

The carelessness of nature

The blocks of stone which form the foreground of the Ulleswater are, I believe, the finest example in the world of the finished drawing of rocks which have been subjected to violent aqueous action. Their surfaces seem to palpitate from the fine touch of the waves, and every part of them is rising or falling, in soft swell or gentle depression, though the eye can scarcely trace the fine

shadows on which this chiselling of the surface depends. And with all this, every block of them has individual character, dependent on the expression of the angular lines of which its contours were first formed, and which is retained and felt through all the modulation and melting of the water-worn surface. And what is done here in the most important part of the picture, to be especially attractive to the eye, is often done by Turner with lavish and overwhelming power in the accumulated débris of a wide foreground, strewed with the ruin of ages; as, for instance, in the Junction of the Greta and Tees, where he has choked the torrent bed with a mass of shattered rock, thrown down with the profusion and carelessness of nature herself; and yet every separate block is a study, chiselled and varied in its parts, as if it were to be the chief member of a separate subject, yet without ever losing in a single instance its subordinate position, or occasioning, throughout the whole accumulated multitude, the repetition of a single line.

I consider cases like these, of perfect finish and new conception, applied and exerted in the drawing of every member of a confused and almost countlessly divided system, about the most wonderful, as well as the most characteristic, passages of Turner's foregrounds. It is done not less marvellously, though less distinctly, in the individual parts of all his broken ground, as in examples like these of separate blocks. The articulation of such a passage as the nearest bank, in the picture we have already spoken of at so great length, the Upper Fall of the Tees, might serve us for a day's study if we were to go into it part by part; but it is impossible to do this, except with the pencil; we can only repeat the same general observations about eternal change and unbroken unity, and tell you to observe how the eye is kept throughout on solid and retiring surfaces, instead of being thrown, as by Claude, on flat and equal edges. You cannot find a single edge in Turner's work; you are everywhere kept upon round surfaces, and you go back on these you cannot tell how, never taking a leap, but progressing imperceptibly along the unbroken bank, till you find yourself a quarter of a mile into the picture, beside the figure at the bottom of the waterfall.

Neatness in Deal

I have had occasion, elsewhere, to consider at some length, the peculiar love of the English for neatness and minuteness: but I have only considered, without accounting for, or coming to any conclusion about it; and, the more I think of it, the more it puzzles

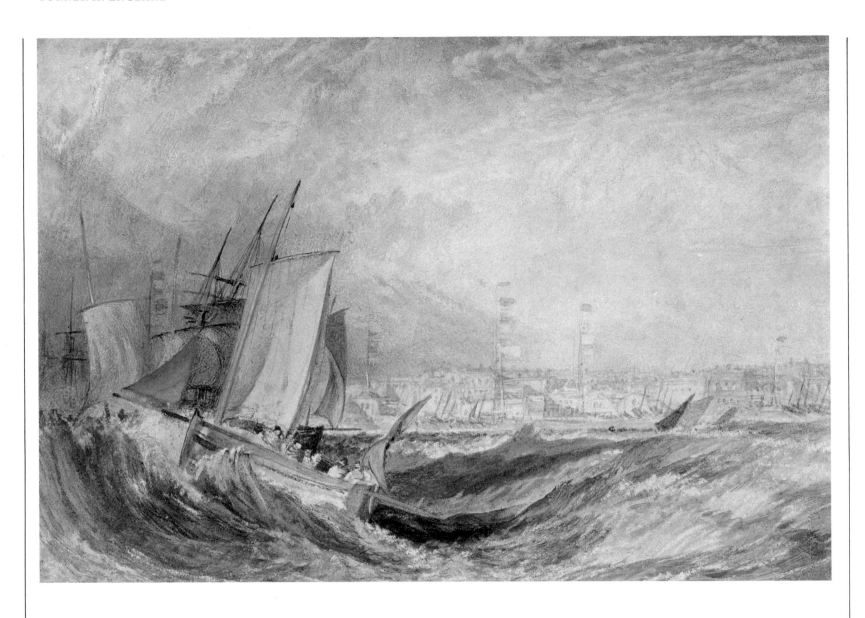

Deal, c.1826-28

me to understand what there can be in our great national mind which delights to such an extent in brass plates, red bricks, square kerbstones, and fresh green paint, all on the tiniest possible scale. The other day I was dining in a respectable English 'Inn and Posting-house', not ten miles from London, and, measuring the room after dinner, I found it exactly twice and a quarter the height of my umbrella. It was a highly comfortable room, and associated, in the proper English manner, with outdoor sports and pastimes, by a portrait of Jack Hall, fisherman of Eton, and of Mr C. Davis on his favourite mare; but why all this hunting and fishing enthusiasm should like to reduce itself, at home, into twice and a quarter the height of an umbrella, I could not in any wise then, nor have I at any other time been able to ascertain.

Perhaps the town of Deal involves as much of this question in its aspect and reputation, as any other place in Her Majesty's dominions: or at least it seemed so to me, coming to it as I did, after having been accustomed to the boat-life at Venice, where the heavy craft, massy in build and massy in sail, and disorderly in aquatic economy, reach with their mast-vanes only to the first stories of the huge marble palaces they anchor among. It was very strange to me, after this, knowing that whatever was brave and strong in the English sailor was concentrated in our Deal boatmen, to walk along that trim strip of conventional beach, which the sea itself seems to wash in a methodical manner, one shingle-step at a time; and by its thin toy-like boats, each with its head to sea, at regular intervals, looking like things that one would give a clever boy to play with in a pond, when first he got past petticoats; and the row of lath cots behind, all tidiness and telegraph, looking as if the whole business of the human race on earth was to know what o'clock it was, and when it would be high water – only some slight weakness in favour of grog being indicated here and there by a hospitable-looking open door, a gay bow-window, and a sign intimating that it is a sailor's duty to be not only accurate, but 'jolly'.

Turner was always fond of this neat, courageous, benevolent, merry, methodical Deal. He painted it very early, in the Southern Coast series, insisting on one of the tavern windows as the principal subject, with a flash of forked lightning streaming beyond it out at sea like a narrow flag. He has the same association in his mind in the present plate[1]; disorder and distress among the ships on the left, with the boat going to help them; and the precision of the little town stretching out in sunshine along the beach.

1 The original watercolour is reproduced here; Ruskin is referring to the engraving of it. D.B.

Only the pigs

The drawings we have hitherto examined have, without exception, expressed one consistent impression on the young painter's mind, that the world, however grave or sublime in some of its moods or passions, was nevertheless constructed entirely as it ought to be; and was a fair and noble world to live in, and to draw. Waterfalls, he thought, at Terni, did entirely right to fall; mountains, at Bonneville, did entirely right to rise; monks, at Fiesole, did well to measure their hours; lovers, at Farnley, to forget them; and the calm of Vesuvius was made more lovely, as its cone more lofty, by the intermittent blaze of its volcanic fire.

But a time has now come when he recognizes that all is not right with the world – a discovery contemporary, probably, with the more grave one that all was not right within himself. Howsoever it came to pass, a strange, and in many respects grievous metamorphosis takes place upon him, about the year 1825. Thenceforward he shows clearly the sense of a terrific wrongness and sadness, mingled in the beautiful order of the earth; his work becomes partly satirical, partly reckless, partly – and in its greatest and noblest features – tragic.

This new phase of temper shows itself first in a resolute portraiture of whatever is commonplace and matter-of-fact in life, to take its full place in opposition to the beautiful and heroic. We may trace this intent unmistakably in the Liber Studiorum, where indeed the commonplace prevails to an extent greatly destructive of the value of the series, considered as a whole; the 'Hedging and Ditching', 'Watercress Gatherers', 'Young Anglers', and other such

Pigs (T.B. XXX-93 – Studies near Brighton)

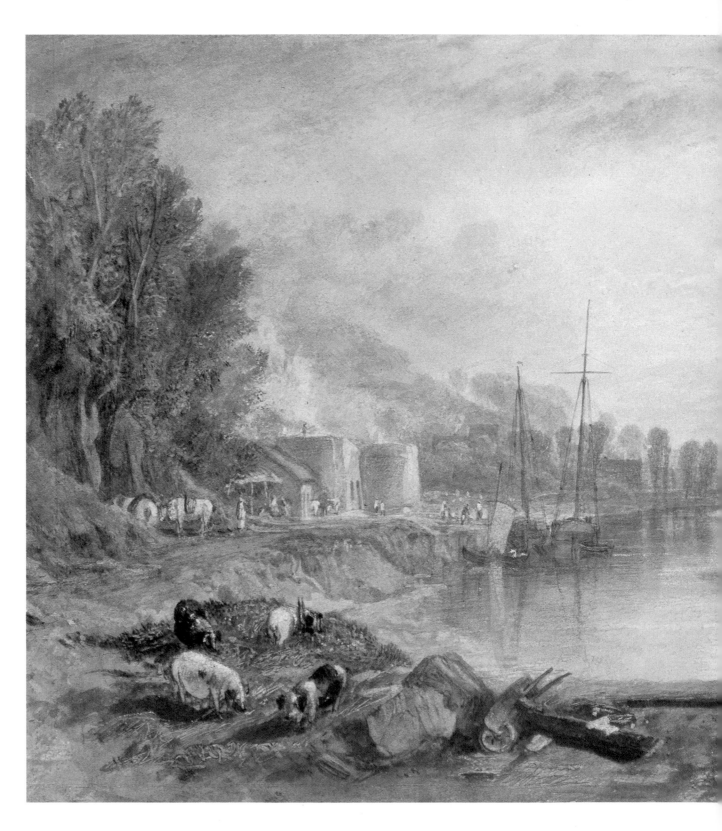

Sunshine. On the Tamar, c.1813

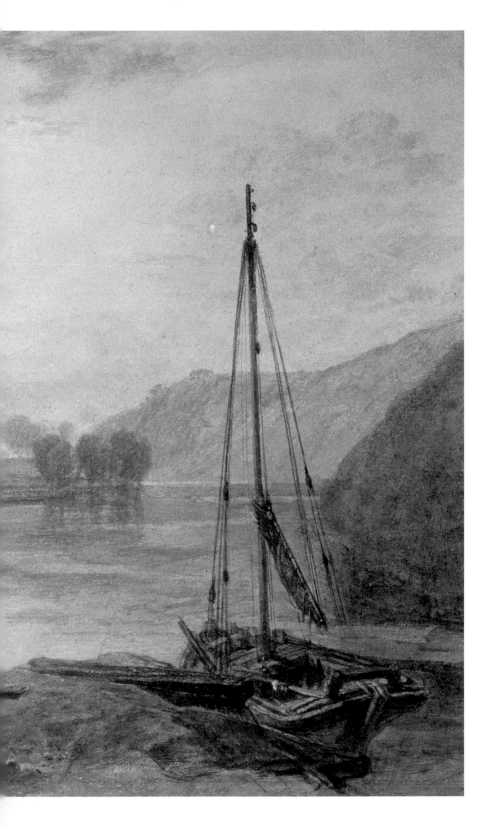

plates, introducing rather discord than true opponent emotion among the grander designs of pastoral and mountain scenery. With this change of feeling came a twofold change of technical method. He had no patience with his vulgar subjects, and dashed them in with violent pencilling and often crude and coarse colour, to the general hurting of his sensitiveness in many ways; and, perhaps, the slight loss of defining power in the hand. For his beautiful subjects, he sought now the complete truth of their colour but as a part of their melancholy sentiment; and thus it came to pass that the loveliest hues, which in the hands of every other great painter express nothing but delight and purity, are with Turner wrought most richly when they are pensive: and wear with their dearest beauty the shadows of death. How far he was himself responsible for this change, and how far it was under the conditions of his London life inevitable – and what modern philosophers would call the development of natural law – I have no means of deciding; but, assuredly, whether faultful or fated, real conditions of error affect his work from this time forward, in consequence of which it in many respects greatly lost its influence with the public. When they see, gathered now together in one group, examples of the drawings in which the calamitous change is expressed most clearly, the public may perhaps see how in the deepest sense their own follies were the cause of all that they blamed, and of the infinitely greater all that they lost.

This first drawing [*Sunshine. On The Tamar*], however . . . does not accurately belong to the group, yet it shows already one of Turner's specially English (in the humiliating sense) points of character – that, like Bewick, he could draw *pigs* better than any other animal. There is also some trace already of Turner's constant feeling afterwards. Sunshine, and rivers, and sweet hills; yes, and who is there to see or care for them? – Only the pigs.

The drawing is in his finest manner, earlier perhaps than some of the Yorkshires.

Composing seascape

There is, however, one more characteristic of Turner's second period, on which I have still to dwell, especially with reference to what has been above advanced respecting the fallacy of overtoil; namely, the magnificent ease with which all is done when it is *successfully* done. For there are one or two drawings of this time which are *not* done easily. Turner had in these set himself to do a fine thing to exhibit his powers; in the common phrase, to excel himself; so sure as he does this, the work is a failure. The worst

drawings that have ever come from his hands are some of this second period, on which he has spent much time and laborious thought; drawings filled with incident from one side to the other, with skies stippled into morbid blue, and warm lights set against them in violent contrast; one of Bamborough Castle, a large watercolour, may be named as an example. But the truly noble works are those in which, without effort, he has expressed his thoughts as they came, and forgotten himself; and in these the outpouring of invention is not less miraculous than the swiftness and obedience of the mighty hand that expresses it. Any one who examines the drawings may see the evidence of this facility, in the strange freshness and sharpness of every touch of colour; but when the multitude of delicate touches, with which all the aerial tones are worked, is taken into consideration, it would still appear impossible that the drawing could have been completed with *ease*, unless we had direct evidence on the matter: fortunately, it is not wanting. There is a drawing in Mr Fawkes's collection of a man-of-war taking in stores: it is of the usual size of those of the England Series, about sixteen inches by eleven: it does not appear one of the most highly finished, but it is still farther removed from slightness. The hull of a first-rate[1] occupies nearly one-half of the picture on the right, her bows towards the spectator, seen in sharp perspective from stem to stern, with all her port-holes, guns, anchors, and lower rigging elaborately detailed; there are two other ships of the line in the middle distance, drawn with equal precision; a noble breezy sea dancing against their broad bows, full of delicate drawing in its waves; a store-ship beneath the hull of the larger vessel, and several other boats, and a complicated cloudy sky. It might appear no small exertion of mind to draw the detail of all this shipping down to the smallest ropes, from memory, in the drawing-room of a mansion in the middle of Yorkshire, even if considerable time had been given for the effort. But Mr Fawkes sat beside the painter from the first stroke to the last. Turner took a piece of blank paper one morning after breakfast, outlined his ships, finished the drawing in three hours, and went out to shoot.

Reflections

Now one instance will be sufficient to show the exquisite care of Turner in this respect. On the left-hand side of his Nottingham, the water (a smooth canal) is terminated by a bank fenced up with wood, on which, just at the edge of the water, stands a white sign-post. A quarter of a mile back, the hill on which Nottingham Castle stands rises steeply nearly to the top of the picture. The upper part of this hill is in bright golden light, and the lower in very deep grey shadow, against which the white board of the sign-post is seen entirely in light relief, though, being turned from the light, it is itself in delicate middle tint, illumined only on the edge. But the image of all this in the canal is very different. First, we have the reflection of the piles of the bank sharp and clear, but under this we have not what we see above it, the dark *base* of the hill (for this being a quarter of a mile back, we could not see it over the fence if we were looking from below), but the golden summit of the hill, the shadow of the under part having no record nor place in the reflection. Now this summit, being very distant, cannot be seen clearly by the eye while its focus is adapted to the surface of the water, and accordingly its reflection is entirely vague and confused; you cannot tell what it is meant for, it is mere playing golden light. But the sign-post, being on the bank close to us, will be reflected clearly, and accordingly its distinct image is seen in the midst of this confusion; relieved, however, not now against the dark base, but against the illumined summit of the hill, and appearing therefore, instead of a white space thrown out from blue shade, a dark grey space thrown out from golden light. I do not know that any more magnificent example could be given of concentrated knowledge, or of the daring statement of most difficult truth. For who but this consummate artist would have had courage, even if he had perceived the laws which required it, to undertake, in a single small space of water, the painting of an entirely new picture, with all its tones and arrangements altered – what was made above bright by opposition to blue, being underneath made cool and dark by opposition to gold; or would have dared to contradict so boldly the ordinary expectation of the uncultivated eye, to find in the reflection a mockery of the reality? But the reward is immediate, for not only is the change most grateful to the eye, and most exquisite as composition, but the surface of the water in consequence of it is felt to be as spacious as it is clear, and the eye rests not on the inverted image of the material objects, but on the element which receives them. And we have a farther instance in this passage of the close study which is required to enjoy the works of Turner, for another artist might have altered the reflection or confused it, but he would not have reasoned upon it so as to find out *what the exact alteration must be*; and if we had tried to account for the reflection, we should have found it false or inaccurate. But the master mind of Turner,

1 'First-rate' was a term used when the British Navy was divided into six rates of vessels, according to the number of guns carried. D.B.

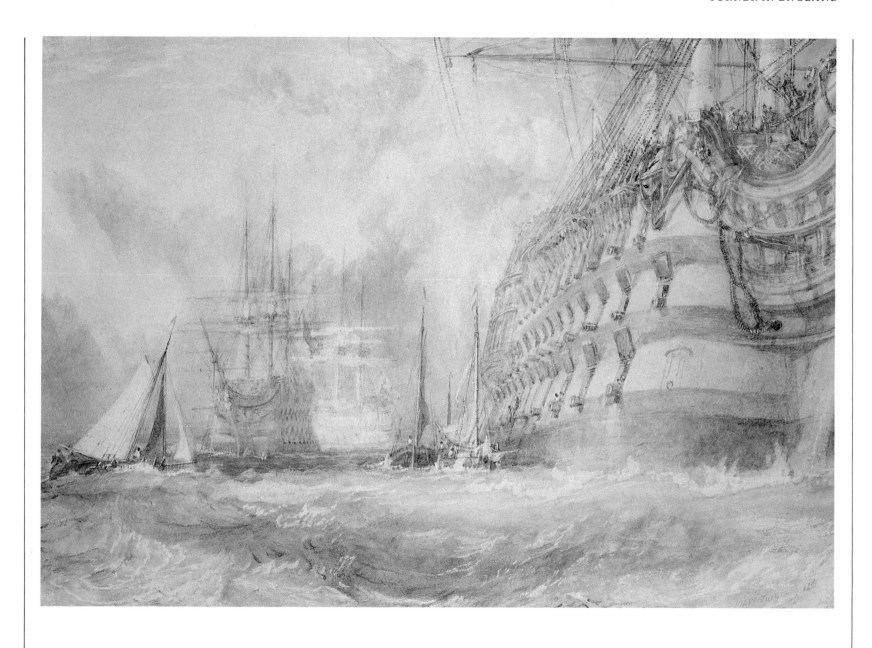

A First-rate taking in Stores, 1818

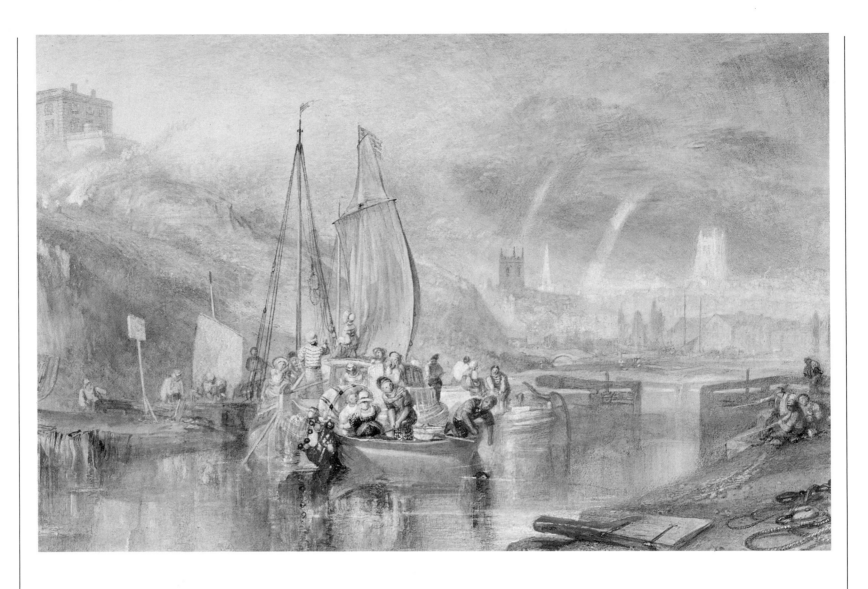

Nottingham, c.1831

without effort, showers its knowledge into every touch, and we have only to trace out even his slightest passages, part by part, to find in them the universal working of the deepest thought, that consistency of every minor truth which admits of and invites the same ceaseless study as the work of nature herself.

Composing landscape

Again in the 'Lancaster Sands', which is one of the plates[1] I have marked as most desirable for your possession, the stream of light which falls from the setting sun on the advancing tide stands similarly in need of some force of near object to relieve its brightness. But the incident which Turner has here adopted is the swoop of an angry sea-gull at a dog, who yelps at it, drawing back as the wave rises over his feet, and the bird shrieks within a foot of his face. Its unexpected boldness is a type of the anger of its ocean element, and warns us of the sea's advance just as surely as the abandoned plough told us of the ceased labour of the day.

It is not, however, so much in the selection of single incidents of this kind, as in the feeling which regulates the arrangement of the whole subject, that the mind of a great composer is known. A single incident may be suggested by felicitous chance, as a pretty motto might be for the heading of a chapter. But the great composers so arrange *all* their designs that one incident illustrates another, just as one colour relieves another. Perhaps the 'Heysham', of the Yorkshire series, which, as to its locality, may be considered a companion to the last drawing we have spoken of, the 'Lancaster Sands', presents as interesting an example as we could find of Turner's feeling in this respect. The subject is a simple north-country village, on the shore of Morecambe Bay; not in the common sense a picturesque village; there are no pretty bow-windows, or red roofs, or rocky steps of entrance to the rustic doors, or quaint gables; nothing but a single street of thatched and chiefly clay-built cottages, ranged in a somewhat monotonous line, the roofs so green with moss that at first we hardly discern the houses from the fields and trees. The village street is closed at the end by a wooden gate, indicating the little traffic there is on the road through it, and giving it something the look of a large farmstead, in which a right of way lies through the yard. The road which leads to this gate is full of ruts, and winds down a bad bit of hill between two broken banks of moor ground, succeeding immediately to the few enclosures which surround the village;

1 The original watercolour is reproduced here. D.B.

they can hardly be called gardens: but a decayed fragment or two of fencing fill the gaps in the bank; a clothes-line, with some clothes on it, striped blue and red, and a smock-frock, is stretched between the trunks of some stunted willows; a *very* small haystack and pig-sty being seen at the back of the cottage beyond. An empty, two-wheeled, lumbering cart, drawn by a pair of horses with huge wooden collars, the driver sitting lazily in the sun, sideways on the leader, is going slowly home along the rough road, it being about country dinner-time. At the end of the village there is a better house, with three chimneys and a dormer window in its roof, and the roof is of stone shingle instead of thatch, but very rough. This house is no doubt the clergyman's: there is some smoke from one of its chimneys, none from any other in the village; this smoke is from the lowest chimney at the back, evidently that of the kitchen, and it is rather thick, the fire not having been long lighted. A few hundred yards from the clergyman's house, nearer the shore, is the church, discernible from the cottages only by its low two-arched belfry, a little neater than one would expect in such a village; perhaps lately built by the Puseyite incumbent: and beyond the church, close to the sea, are two fragments of a border war-tower, standing on their circular mound, worn on its brow deep into edges and furrows by the feet of the village children. On the bank of moor, which forms the foreground, are a few cows, the carter's dog barking at a vixenish one: the milkmaid is feeding another, a gentle white one, which turns its head to her, expectant of a handful of fresh hay, which she has brought for it in her blue apron, fastened up round her waist; she stands with her pail on her head, evidently the village coquette, for she has a neat bodice, and pretty striped petticoat under the blue apron, and red stockings. Nearer us, the cowherd, barefooted, stands on a piece of the limestone rock (for the ground is thistly and not pleasurable to bare feet) — whether boy or girl we are not sure: it may be a boy, with a girl's worn-out bonnet on, or a girl with a pair of ragged trowsers on; probably the first, as the old bonnet is evidently useful to keep the sun out of our eyes when we are looking for strayed cows among the moorland hollows, and helps us at present to watch (holding the bonnet's edge down) the quarrel of the vixenish cow with the dog, which, leaning on our long stick, we allow to proceed without any interference. A little to the right the hay is being got in, of which the milkmaid has just taken her apronful to the white cow; but the hay is very thin, and cannot well be raked up because of the rocks; we must glean it like corn, hence the smallness of our stack behind the willows; and a woman is pressing a bundle of it hard together, kneeling against the rock's edge, to carry it safely to the hay-cart

Lancaster Sands, c.1826

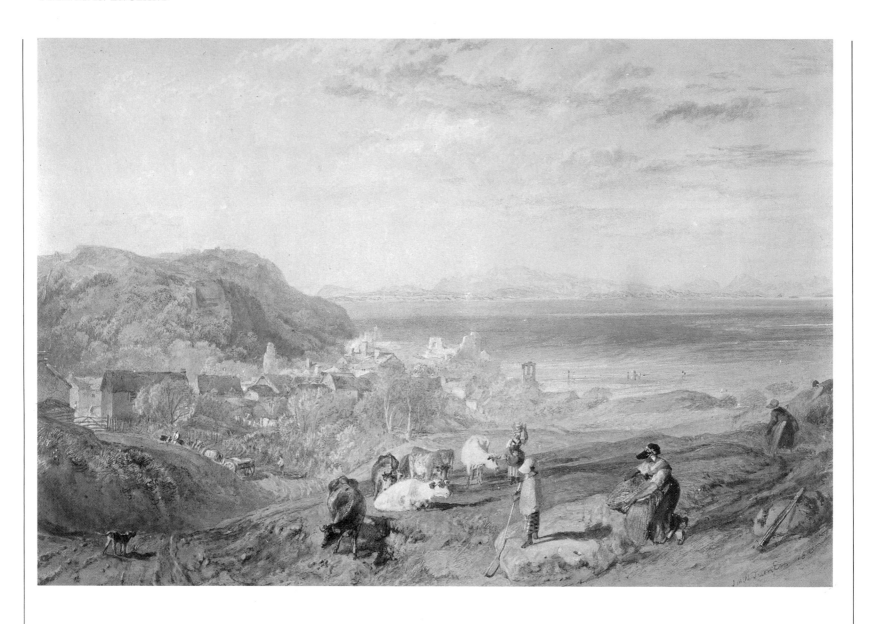

Heysham and Cumberland Mountains, 1818

without dropping any. Beyond the village is a rocky hill, deep set with brushwood, a square crag or two of limestone emerging here and there, with pleasant turf on their brows, heaved in russet and mossy mounds against the sky, which, clear and calm, and as golden as the moss, stretches down behind it towards the sea. A single cottage just shows its roof over the edge of the hill, looking seawards: perhaps one of the village shepherds is a sea captain now, and may have built it there, that his mother may first see the sails of his ship whenever it runs into the bay. Then under the hill, and beyond the border tower, is the blue sea itself, the waves flowing in over the sand in long curved lines slowly; shadows of cloud, and gleams of shallow water on white sand alternating – miles away; but no sail is visible, not one fisher-boat on the beach, not one dark speck on the quiet horizon. Beyond all are the Cumberland mountains, clear in the sun, with rosy light on all their crags.

I should think the reader cannot but feel the kind of harmony there is in this composition; the entire purpose of the painter is to give us the impression of wild, yet gentle, country life, monotonous as the succession of the noiseless waves, patient and enduring as the rocks; but peaceful, and full of health and quiet hope, and and sanctified by the pure mountain air and baptismal dew of heaven, falling softly between days of toil and nights of innocence.

All noble composition of this kind can be reached only by instinct; you cannot set yourself to arrange such a subject; you may see it, and seize it, at all times, but never laboriously invent it. And your power of discerning what is best in expression, among natural subjects, depends wholly on the temper in which you keep your own mind; above all, on your living so much alone as to allow it to become acutely sensitive in its own stillness. The noisy life of modern days is wholly incompatible with any true perception of natural beauty. If you go down into Cumberland by the railroad, live in some frequented hotel, and explore the hills with merry companions, however much you may enjoy your tour or their conversation, depend upon it you will never choose so much as one pictorial subject rightly; you will not see into the depth of any. But take knapsack and stick, walk towards the hills by short day's journeys – ten or twelve miles a day – taking a week from some starting-place sixty or seventy miles away: sleep at the pretty little wayside inns, or the rough village ones; then take the hills as they tempt you, following glen or shore as your eye glances or your heart guides, wholly scornful of local fame or fashion, and of everything which it is the ordinary traveller's duty to see, or pride to do. Never force yourself to admire anything when you are not in the humour; but never force yourself away from what you feel

to be lovely, in search of anything better; and gradually the deeper scenes of the natural world will unfold themselves to you in still increasing fulness of passionate power; and your difficulty will be no more to seek or to compose subjects, but only to choose one from among the multitude of melodious thoughts with which you will be haunted, thoughts which will of course be noble or original in proportion to your own depth of character and general power of mind; for it is not so much by the consideration you give to any single drawing, as by the previous discipline of your powers of thought, that the character of your composition will be determined. Simplicity of life will make you sensitive to the refinement and modesty of scenery, just as inordinate excitement and pomp of daily life will make you enjoy coarse colours and affected forms. Habits of patient comparison and accurate judgment will make your art precious, as they will make your actions wise; and every increase of noble enthusiasm in your living spirit will be measured by the reflection of its light upon the works of your hands.

Figures

It is so natural to suppose that the main interest of landscape is essentially in rocks and water and sky; and that figures are to be put, like the salt and mustard to a dish, only to give it flavour.

Put all that out of your heads at once. The interest of a landscape consists wholly in its relation either to figures present – or to figures past – or to human powers conceived. The most splendid drawing of the chain of the Alps, irrespective of their relation to humanity, is no more true landscape than a painting of this bit of stone. For, as natural philosophers, there is no bigness or littleness to you. This stone is just as interesting to you, or ought to be, as if it was a million times as big. There is no more sublimity – *per se* – in ground sloped at an angle of forty-five, than in ground level; nor in a perpendicular fracture of a rock, than in a horizontal one. The only thing that makes the one more interesting to you in a landscape than the other, is that you could tumble over the perpendicular fracture – and couldn't tumble over the other. A cloud, looked at as a cloud only, is no more a subject for painting than so much feculence in dirty water. It is merely dirty air, or at best a chemical solution ill made. That it is worthy of being painted at all depends upon its being the means of nourishment or chastisement to men, or the dwelling-place of imaginary gods. There's a bit of blue sky and cloud by Turner – one of the loveliest ever painted by human hand. But, as a mere pattern of blue and white, he had better have painted a jay's wing: this was only

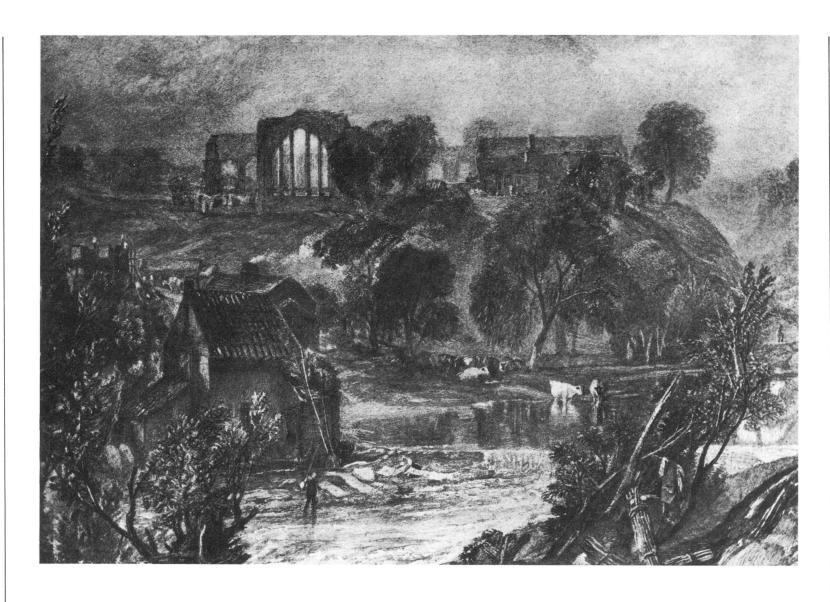

Eggleston Abbey, c.1818

painted by him – and is, in reality, only pleasant to you – because it signifies the coming of a gleam of sweet sunshine in windy weather; and the wind is worth thinking of only because it fills the sails of ships, and the sun because it warms the sailors.

Now, it is most important that you should convince yourselves of and fully enter into this truth, because all the difficulty in choosing subject arises from mistakes about it. I daresay some of you who are fond of sketching have gone out often in the most beautiful country, and yet with the feeling that there was no good subject to be found in it. That always arises from your not having sympathy enough with its vital character, and looking for physical picturesqueness instead. On the contrary, there are crude efforts at landscape-painting, made continually upon the most splendid physical phenomena, in America, and other countries without any history. It is not of the slightest use. Niagara, or the North Pole and the Aurora Borealis, won't make a landscape; but a ditch at Iffley will, if you have humanity enough in you to interpret the feelings of hedgers and ditchers, and frogs.

Next, here is one of the most beautiful landscapes ever painted, the best I have next to the Greta and Tees. Its subject physically is a mere bank of grass above a stream with some wych-elms and willows. A level-topped bank: the water has cut its way down through the soft alluvion of an elevated plain to the limestone rock at the bottom.

Had this scene been in America, no mortal could have made a landscape of it. It is nothing but a grass bank with some not very pretty trees scattered over it, wholly without grouping. The stream at the bottom is rocky indeed, but its rocks are mean, flat, and of a dull yellow colour. The sky is grey and shapeless. There's absolutely nothing to paint anywhere of essential landscape subject, as commonly understood.

Now see what the landscape consists in, which I have told you is one of the most beautiful ever painted by man. There's first a little bit of it left nearly wild, not quite wild; there's a cart and a rider's track through it among the copse; and then, standing simply on the wild moss-troopers' ground, the scattered ruins of a great abbey, seen so dimly, that they seem to be fading out of sight, in colour as in time.

These two things together, the wild copse wood and the ruin, take you back into the life of the fourteenth century. The one is the border-riders' kingdom; the other that of peace which has striven against border-riding – how vainly! Both these are remains of the past. But the outhouses and refectory of the abbey have been turned into a farmhouse, and that is inhabited, and in front of it the Mistress is feeding her chickens. You see the country is perfectly quiet and innocent, for there is no trace of a fence anywhere; the cattle have strayed down to the riverside, it being a hot day; and some rest in the shade and two in the water.

They could not have done so at their ease had the river not been humanised. Only a little bit of its stony bed is left; a mill weir, thrown across, stays the water in a perfectly clear and delicious pool; to show how clear it is, Turner has put the only piece of playing colour in all the picture into the reflections in this. One cow is white, another white and red, evidently as clean as morning dew can wash their sides. They could not have been so in a country where there was the least coal smoke; so Turner has put a wreath of perfectly white smoke through the trees; and lest that should not be enough to show you they burnt wood, he has made his foreground of a piece of copse just lopped, with the new faggots standing up against it; and this still not being enough to give you the idea of perfect cleanliness, he has covered the stones of the river-bed with white clothes laid out to dry; and that not being enough yet, for the river-bed might be clean though nothing else was, he has put a quantity more hanging over the abbey walls.

Only *natural phenomena in their direct relation to humanity* – these are to be your subjects in landscape. Rocks and water and air may no more be painted for their own sakes, than the armour carved without the warrior.

Turner Abroad

Ruskin claimed Turner as the foremost English painter of his or any other age. But Turner was a product of European Romanticism, and Ruskin knew that he was far more than a national phenomenon. Turner's European affinities were partly decided by his need to learn from great painters who had preceded him. Claude, Titian, Rembrandt were teachers who necessarily expanded Turner's education beyond English horizons. Books continued the process, for Turner was a wide and discriminating reader. He also made frequent working tours throughout his life, first within Britain, then through France, Switzerland, Germany, Italy. Years later, Ruskin was to follow in his footsteps – sometimes literally, as he tried to capture the exact viewpoints from which Turner had made his sketches and drawings. Ruskin saw Europe through Turner's eyes.

But the Europe that Ruskin encountered was inevitably different from the stirring prospects which had occupied Turner's imagination. Its people were beginning to live in a new way. Ruskin saw and lamented the effects of the steady growth of industrialisation throughout his lifetime: spectacular in England, but by no means confined to British shores. In his later years, he also witnessed great expansion in travel of a kind that Turner never experienced. As railways were extended, roads improved, and hotels built, Ruskin saw the first manifestations of mass tourism in the places that he and Turner had seen as travellers of a different kind. Ruskin was constantly inclined to look backwards when travelling, comparing his experiences with a lost golden country which could only be recaptured in Turner's pictures.

It is not always in this nostalgic spirit that Ruskin writes most shrewdly of Turner's response to Europe. He had a sensitive understanding of the liberation that European travel had brought to the artist, and of the technical developments that it had made possible. It was in terms of Turner's perception of a European city – Venice – that Ruskin was to mount his first public defence of Turner's work. Venice became a place that had an enduring importance in the work of both Turner and Ruskin. In 1836, when Ruskin wrote about *Juliet and her Nurse*, it had become the scene of some of the boldest of Turner's innovative work. For Ruskin, however, Venice was still a fresh discovery, and his pride in knowing the city is touchingly apparent in this early sample of his writing. It leads him, in fact, to defend Turner on dubious grounds, for the confident claim that the 'view is accurate in every particular' can hardly (as Turner must have known) be maintained in the face of the evidence. What he has to say about Turner in this engagingly indignant diatribe is very different from the views he was later to develop ('No one can deny that the faults of Turner are numerous . . . '). But the overall sense of enthusiastic revelation, in which the excitement of exploring Turner's art is inseparable from the excitement of discovering Europe, is characteristic of much of Ruskin's first work on Turner abroad.

These early passages often focus on the brilliant fidelity

with which Turner seizes specific and particular effects of light and colour at a given moment in a given place. If Turner could paint a mountain or a tree more truly than any other artist, so too could he capture the character of a Venetian boat or building. Ruskin patiently draws our attention to the means by which this is done. His act of critical service provides us with some of the most astute of his accounts of Turner's painting. Still more revealing are Ruskin's later meditations on where, and why, Turner's art might seem to depart from nature.

Ruskin's most extended analysis of this issue comes in the fourth volume of *Modern Painters*, published in 1856. Thinking about the way in which 'the artist who has real invention' puts a picture together, Ruskin insists that he does not simply paint what he sees. Though his image is based on a 'true impression from the place itself', his work is directed towards reproducing that impression on the mind of whoever should look at his picture. To this end he is entitled to use whatever means lie at his disposal. To demonstrate his point, Ruskin asks us to look at his own 'topographical outline' of an Alpine scene which Turner had painted. He tells us that there is 'nothing in this scene, taken by itself, particularly interesting or impressive'. But the impression on the mind of the traveller approaching the place is modified by its context, for it is 'approached through one of the narrowest and most sublime ravines in the alps'. The landscape artist, attempting to express the sensation of awe experienced by the traveller, must aim 'to give the far higher and deeper truth of mental vision, rather than that of the physical facts'. To do this, he must do what Turner has done in his watercolour painting of the place, *The Pass of Faido*. Ruskin points out that the scale of the mountains is adjusted to reflect the effect the pass produces on the mind of the traveller. Other changes have been made to the same end: trees cleared away, a bridge moved, a bank made steeper. All this, Ruskin insists, must not be done as a matter of cool calculation.

The artist acts under the direction of his vision. 'If he thought, he would instantly go wrong; it is only the clumsy and uninventive artist who thinks.' The picture becomes a dream, imposing its own detail on Turner's complex sense of the significance of the Alpine place. Like all dreams, it includes memory. His intimate knowledge of the range of Turner's work enables Ruskin to suggest that the painting includes fragments of truth from other pictures, completed years previously. In this way Ruskin begins to speculate on what would preoccupy him throughout the later development of his work on Turner – the concept of Turner as the great painter of memory, his work 'universally an arrangement of remembrances, summoned just as they were wanted, and set each in its fittest place.'

Ruskin is right to suggest that Turner's work constantly remembers previous pictures, his own and those of others. Whether this was a matter of the dream-vision Ruskin describes here is more doubtful. Ruskin is, as so often, using Turner's art as a means of approaching his own sense of creative responsibility, which was growing both bolder and more elegiac when he wrote the fourth volume of *Modern Painters*. This enabled him to see aspects of Turner's audacity which he had not previously wanted to acknowledge: the 'force and fury' with which Turner expressed his vision. But he had now come to see this vision in terms of a very much more subdued key of feeling than we find in his first delighted response to the richness of Turner's painting.

Nice cool green that lettuce, isn't it? and the beetroot pretty red – not quite strong enough; and the mixture, delicate tint of yellow that. Add some mustard, and you have one of my pictures.
J. M. W. Turner, discussing a salad

First responses

IF HE HAD expressed himself grammatically, I believe he would have affirmed that the 'Venice of Juliet and her Nurse' was a composition from models of different parts of the city, thrown, as he elegantly expresses it, 'higgledy-piggledy together'. Now, it is no such thing; it is a view taken from the roofs of the houses at the south-west angle of St Mark's place, having the lagoon on the right, and the column and church of St Mark in front. The view is accurate in every particular, even to the number of divisions in the Gothic of the Doge's palace. It would, I think, be as well if your critic would take something more certain than his own vague ideas to bear witness to a fact which tends to the depreciation of a picture, and which was to be asserted by Maga.

He next proceeds to inform us that Turner is out of nature. Perhaps, since he has made this most singular discovery, he may have an idea that 'there's ne'er a villain dwelling in all Denmark, but he's an arrant knave'. He may even have supposed that there never actually existed such a thing as Ariel; may have suspected that Oberon and Titania never walked the turf of Athenian forests; nay, the far more singular idea may have entered his pericranium, that the super-imposition of an ass's head on his own shoulders would be 'out of nature'. Turner may be mad: I daresay he is, inasmuch as highest genius is allied to madness; but not so stark mad as to profess to paint nature. He paints *from* nature, and pretty far from it, too; and he would be sadly disappointed who looked in his pictures for a possible scene. Are we to quarrel with him for this? If we are, let us at once condemn to oblivion the finest works of the imagination of our poets: 'The Ancient Mariner' and 'Christabel' must be vile, 'Prometheus Unbound' absurd, much of Shakespeare detestable, Milton ridiculous, Spenser childish. Alas! the spirit of all poetry must come under the animadversions of this sweeping rule.

Your critic finds much fault with Turner's colour. I think he himself has a rather singular idea of colour when he remarks of a yellow petticoat, that it looks as if it had been dipped in treacle. I suppose, however, this is for the sake of the paltry pun which follows. He goes on to remark that his execution is 'childish'. Of all artists, Turner is perhaps the least deserving of such blame; he can produce instantaneous effect by a roll of his brush, and, with a few dashes of mingled colour, will express the most complicated subject: the means employed appear more astonishingly inadequate to the effect produced than in any other master. No one can deny that the faults of Turner are numerous, and perhaps more egregious than those of any other great existing artist; but if he has greater faults, he has also greater beauties.

The critic affirms that he has deprived the sun of his birthright to cast shadows. Now the manner in which Turner makes his visible sunbeams walk over his foregrounds towards the spectator, is one of his most peculiar beauties; and in this very picture of 'Mercury and Argus' it is inimitably fine, and is produced by the exquisite perspective of his shadows, and the singular lurid tints of his reflected lights.

The connoisseur remarks, a few pages further on, that 'even composition is *often* made out by light, shade, and colour'. Will he inform us what else it could be made out by? Form does a little; but nothing compared to light, shade, and colour; and this he proceeds to assure us the graver cannot give. A good engraver can express any variety of colour, for there is as much light and shade in pure colour as in neutral tints; and it is this power of giving light and shade by pure colour in which Turner so peculiarly excels, and by which his pictures become so wonderfully adapted for engraving; (for I presume that even this Zoïlus[1] of Turner will not venture to deny that engravings from Turner are inimitably fine, and unapproachable by those from the paintings of any other artist;) and this peculiarity in his manner is remarkably observable in 'Mercury and Argus', for though the shadows of the complicated foreground are beautifully true, they are all expressed by colour. That this is contrary to nature, and to the rules of Art, I do not deny; and therefore it is a great pity that the admiration of the genius of Turner, which is almost universal among artists, raises up so many imitators. He is a meteor, dashing on in a path of glory which all may admire, but in which none can follow: and his imitators must be, and always have been, moths fluttering about the lights, into which if they enter they are destroyed.

His imagination is Shakespearian in its mightiness. Had the scene of 'Juliet and her Nurse' risen up before the mind of a poet, and been described in 'words that burn', it had been the admiration of the world: but, placed before us on the canvass, it becomes – what critics of the brush and pallet may show their wit upon at the expense of their judgement; and what real artists and men of feeling and taste *must* admire, but dare not attempt to imitate. Many-coloured mists are floating above the distant city, but such mists as you might imagine to be aetherial spirits, souls of the mighty dead breathed out of the tombs of Italy into the blue of her bright heaven, and wandering in vague and infinite glory around the earth that they have loved. Instinct with the beauty of

1 Zoïlus was a Greek critic of notorious ferocity. D.B.

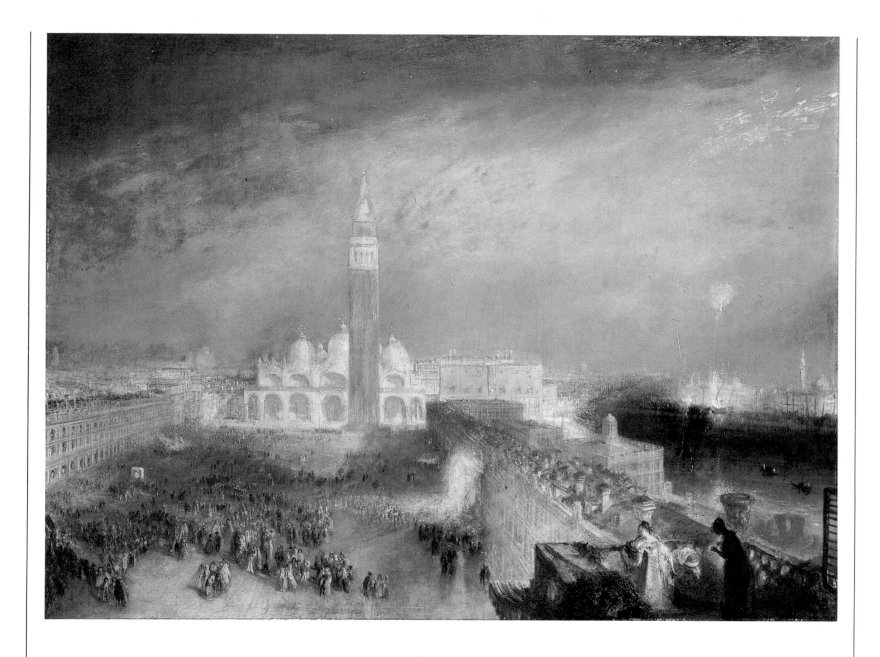

Juliet and her Nurse, 1836

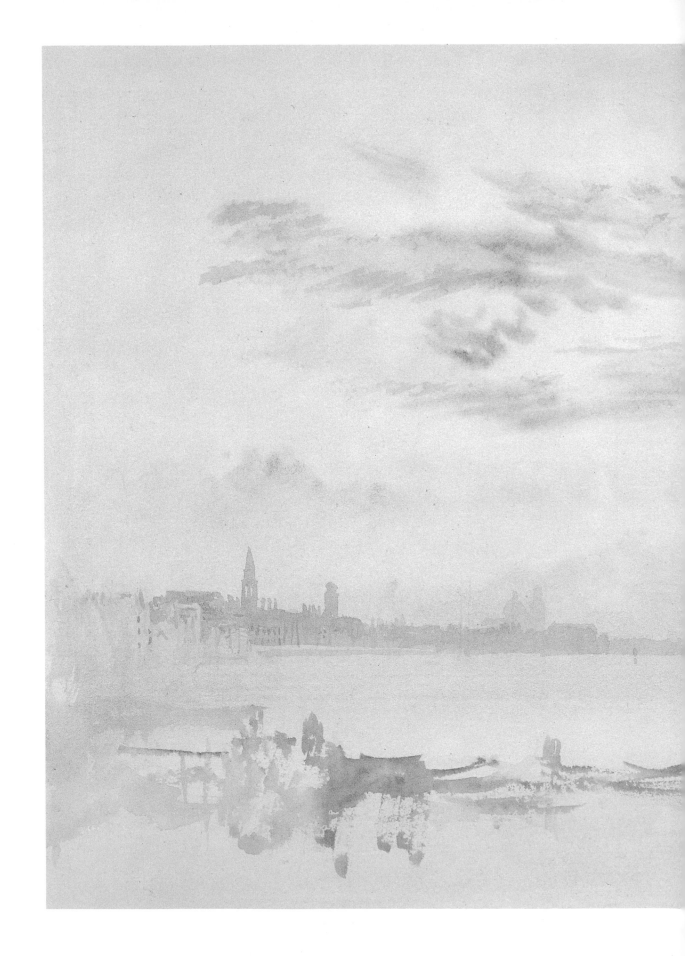

Looking East from Giudecca, 1819

uncertain light, they move and mingle among the pale stars, and rise up into the brightness of the illimitable heaven, whose soft, sad blue eye gazes down into the deep waters of the sea for ever – that sea whose motionless and silent transparency is beaming with phosphor light, that emanates out of its sapphire serenity like bright dreams breathed into the spirit of a deep sleep. And the spires of the glorious city rise indistinctly bright into those living mists, like pyramids of pale fire from some vast altar; and amidst the glory of the dream, there is as it were the voice of a multitude entering by the eye – arising from the stillness of the city like the summer wind passing over the leaves of the forest, when a murmur is heard amidst their multitude.

Turner's Venice

But let us take, with Turner, the last and greatest step of all. Thank heaven, we are in sunshine again – and what sunshine! Not the lurid, gloomy, plague-like oppression of Canaletti, but white, flashing fulness of dazzling light, which the waves drink and the clouds breathe, bounding and burning in intensity of joy. That sky – it is a very visible infinity – liquid, measureless, unfathomable, panting and melting through the chasms in the long fields of snow-white, flaked, slow-moving vapour, that guide the eye along their multitudinous waves down to the islanded rest of the Euganean hills. Do we dream, or does the white forked sail drift nearer, and nearer yet, diminishing the blue sea between us with the fulness of its wings? It pauses now; but the quivering of its bright reflection troubles the shadows of the sea, those azure, fathomless depths of crystal mystery, on which the swiftness of the poised gondola floats double, its black beak lifted like the crest of a dark ocean bird, its scarlet draperies flashed back from the kindling surface, and its bent oar breaking the radiant water into a dust of gold. Dreamlike and dim, but glorious, the unnumbered palaces lift their shafts out of the hollow sea, pale ranks of motionless flame, their mighty towers sent up to heaven like tongues of more eager fire, their grey domes looming vast and dark, like eclipsed worlds, their sculptured arabesques and purple marble fading farther and fainter, league beyond league, lost in the light of distance. Detail after detail, thought beyond thought, you find and feel them through the radiant mystery, inexhaustible as indistinct, beautiful, but never all revealed; secret in fulness, confused in symmetry, as nature herself is to the bewildered and foiled glance, giving out of that indistinctness, and through that confusion, the perpetual newness of the infinite, and the beautiful.

Yes, Mr Turner, we are in Venice now.

Local colour

After all, however, there is more in Turner's painting of water surface than any philosophy of reflection, or any peculiarity of means can account for or accomplish; there is a might and wonder about it which will not admit of our whys and hows. Take, for instance, the picture of the Sun of Venice going to Sea, of 1843; respecting which, however, there are one or two circumstances which may as well be noted besides its water-painting. The reader, if he has not been at Venice, ought to be made aware that the Venetian fishing-boats, almost without exception, carry canvas painted with bright colours; the favourite design for the centre being either a cross or a large sun with many rays, the favourite colours being red, orange, and black, blue occurring occasionally. The radiance of these sails and of the bright and grotesque vanes at the mast-heads under sunlight is beyond all painting; but it is strange that, of constant occurrence as these boats are on all lagoons, Turner alone should have availed himself of them. Nothing could be more faithful than the boat, which was the principal object in this picture, in the cut of the sail, the filling of it, the exact height of the boom above the deck, the quartering of it with colour; finally and especially, the hanging of the fish-baskets about the bows. All these, however, are comparatively minor merits (though not the blaze of colour which the artist elicited from the right use of these circumstances); but the peculiar power of the picture was the painting of the sea surface, where there were no reflections to assist it. A stream of splendid colour fell from the boat, but that occupied the centre only; in the distance the city and crowded boats threw down some playing lines, but these still left on each side of the boat a large space of water reflecting nothing but the morning sky. This was divided by an eddying swell, on whose continuous sides the local colour of the water was seen, pure aquamarine (a beautiful occurrence of closely observed truth); but still there remained a large blank space of pale water to be treated, the sky above had no distinct details, and was pure faint grey, with broken white vestiges of cloud; it gave no help therefore. But there the water lay, no dead grey flat paint, but downright clear, playing, palpable surface, full of indefinite hue, and retiring as regularly and visibly back and far away, as if there had been objects all over it to tell the story by perspective. Now it is the doing of this which tries the painter, and it is having done this which made me say above that 'no man had ever painted the surface of calm water but Turner.' The San Benedetto, looking towards Fusina, contained a similar passage, equally fine; in one of the Canale della Giudecca the specific green

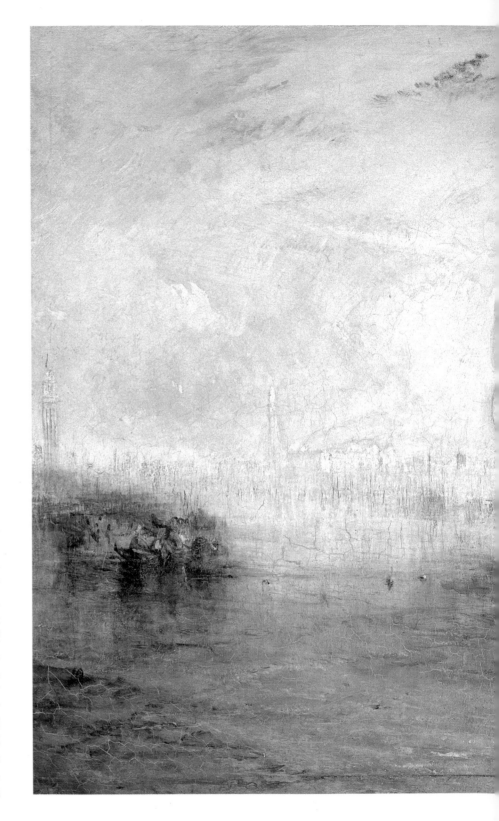

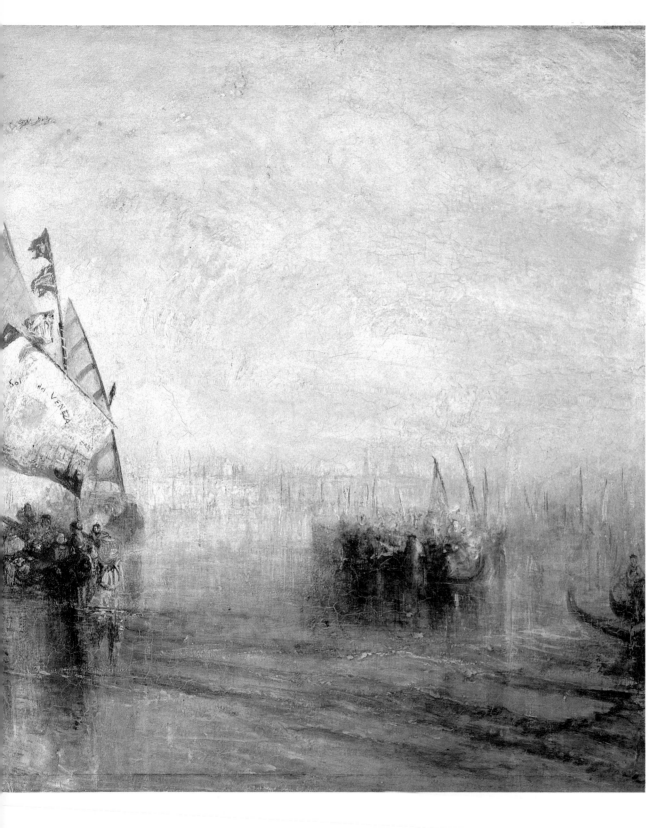

The Sun of Venice going to Sea, 1843

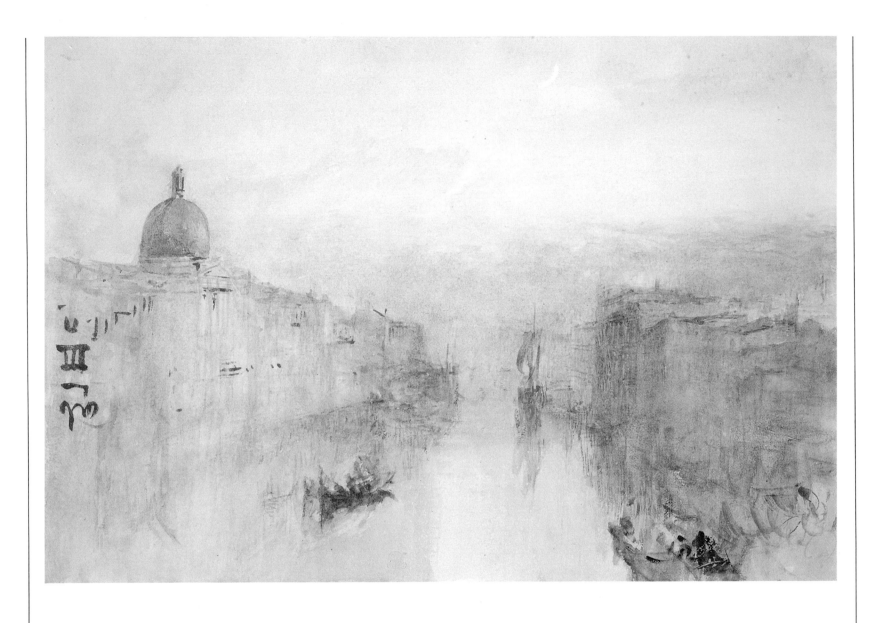

The Grand Canal: With S. Simeone Piccolo, dusk, 1840

colour of the water is seen in front, with the shadows of the boats thrown on it in purple; all, as it retires, passing into the pure reflective blue.

Detail

Go to the top of Highgate Hill on a clear summer morning at five o'clock, and look at Westminster Abbey. You will receive an impression of a building enriched with multitudinous vertical lines. Try to distinguish one of those lines all the way down from the one next to it: you cannot. Try to count them: you cannot. Try to make out the beginning or end of any one of them: you cannot. Look at it generally, and it is all symmetry and arrangement. Look at it in its parts, and it is all inextricable confusion. Am not I, at this moment, describing a piece of Turner's drawing, with the same words by which I describe nature? And what would one of the old masters have done with such a building as this in the distance? Either he would only have given the shadows of the buttresses, and the light and dark sides of the two towers, and two dots for the windows; or if, more ignorant and more ambitious, he had attempted to render some of the detail, it would have been done by distinct lines, would have been broad caricature of the delicate building, felt at once to be false, ridiculous, and offensive. His most successful effort would only have given us, through his carefully toned atmosphere, the effect of a colossal parish church, without one line of carving on its economic sides. Turner, and Turner only, would follow and render on the canvas that mystery of decided line, that distinct, sharp, visible, but unintelligible and inextricable richness, which, examined part by part, is to the eye nothing but confusion and defeat, which, taken as a whole, is all unity, symmetry, and truth.

Nor is this mode of representation true only with respect to distances. Every object, however near the eye, has something about it which you cannot see, and which brings the mystery of distance even into every part and portion of what we suppose ourselves to see most distinctly. Stand in the Piazza di San Marco, at Venice, as close to the church as you can, without losing sight of the top of it. Look at the capitals of the columns on the second story. You see that they are exquisitely rich, carved all over. Tell me their patterns: you cannot. Tell me the direction of a single line in them: you cannot. Yet you see a multitude of lines, and you have so much feeling of a certain tendency and arrangement in those lines, that you are quite sure the capitals are beautiful, and that they are all different from each other. But I defy you to make

out one single line in any one of them. Now go to Canaletto's painting of this church, in the Palazzo Manfrini, taken from the very spot on which you stood. How much has he represented of all this? A black dot under each capital for the shadow, and a yellow one above it for the light. There is not a vestige nor indication of carving or decoration of any sort or kind.

Very different from this, but erring on the other side, is the ordinary drawing of the architect, who gives the principal lines of the design with delicate clearness and precision, but with no uncertainty or mystery about them; which mystery being removed, all space and size are destroyed with it, and we have a drawing of a model, not of a building. But in the capital lying on the foreground in Turner's Daphne hunting with Leucippus, we have the perfect truth. Not one jag of the acanthus leaves is absolutely visible, the lines are all disorder, but you feel in an instant that all are there. And so it will invariably be found through every portion of detail in his late and most perfect works.

Turnerian topography

The way in which most artists proceed to 'invent', as they call it, a picture, is this: they choose their subject, for the most part well, with a sufficient quantity of towers, mountains, ruined cottages, and other materials, to be generally interesting; then they fix on some object for a principal light; behind this they put a dark cloud, or, in front of it, a dark piece of foreground; then they repeat this light somewhere else in a less degree, and connect the two lights together by some intermediate ones. If they find any part of the foreground uninteresting, they put a group of figures into it; if any part of the distance, they put something there from some other sketch; and proceed to inferior detail in the same manner, taking care always to put white stones near black ones, and purple colours near yellow ones, and angular forms near round ones – all this being, as simply a matter of recipe and practice as cookery; like that, not by any means a thing easily done well, but still having no reference whatever to 'impressions on the mind'.

But the artist who has real invention sets to work in a totally different way. First, he receives a true impression from the place itself, and takes care to keep hold of that as his chief good; indeed, he needs no care in the matter, for the distinction of his mind from that of others consists in his instantly receiving such sensations strongly, and being unable to lose them; and then he sets himself as far as possible to reproduce that impression on the mind of the spectator of his picture.

Now, observe, this impression on the mind never results from the mere piece of scenery which can be included within the limits of the picture. It depends on the temper into which the mind has been brought, both by all the landscape round, and by what has been seen previously in the course of the day; so that no particular spot upon which the painter's glance may at any moment fall, is then to him what, if seen by itself, it will be to the spectator far away; nor is it what it would be, even to that spectator, if he had come to the reality through the steps which Nature has appointed to be the preparation for it, instead of seeing it isolated on an exhibition wall. For instance, on the descent of the St Gothard, towards Italy, just after passing through the narrow gorge above Faido, the road emerges into a little breadth of valley, which is entirely filled by fallen stones and débris, partly disgorged by the Ticino as it leaps out of the narrower chasm, and partly brought down by winter avalanches from a loose and decomposing mass of mountain on the left. Beyond this first promontory is seen a

considerably higher range, but not an imposing one, which rises above the village of Faido. The etching [below] is a topographical outline of the scene, with the actual blocks of rock which happened to be lying in the bed of the Ticino at the spot from which I chose to draw it. The masses of loose débris (which, for any permanent purpose, I had no need to draw, as their arrangement changes at every flood) I have not drawn, but only those features of the landscape which happen to be of some continual importance. Of which note, first, that the little three-windowed building on the left is the remnant of a gallery built to protect the road which once went on that side, from the avalanches and stones that come down the 'couloir'[1] in the rock above. It is only a ruin, the greater part having been by said avalanches swept away, and the old road, of which a remnant is also seen on the extreme left, abandoned and carried now along the hill side on the right, partly

1 'Couloir' is a good untranslatable Savoyard word, for a place down which stones and water fall in storms; it is perhaps deserving of naturalization. J.R.

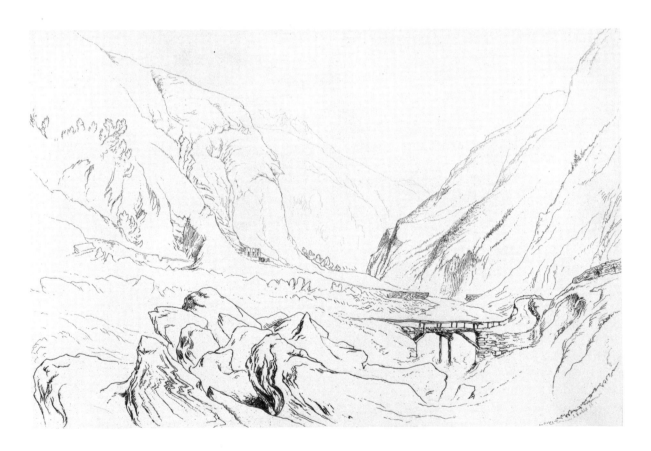

Pass of Faido, First Simple Topography. Modern Painters *IV, 1856*

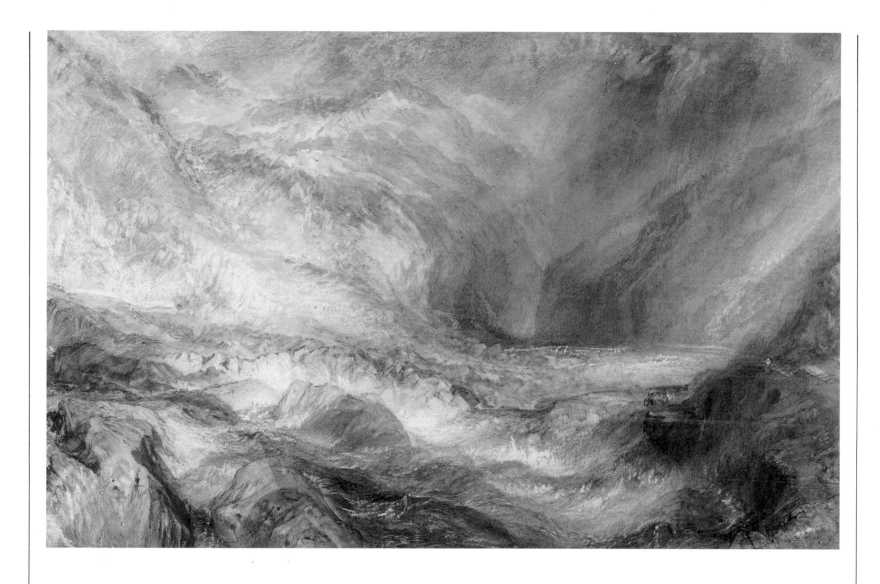

The Pass of Faido, St Gotthard, 1843

sustained on rough stone arches, and winding down, as seen in the sketch, to a weak wooden bridge, which enables it to recover its old track past the gallery. It seems formerly (but since the destruction of the gallery) to have gone about a mile farther down the river on the right bank, and then to have been carried across by a longer wooden bridge, of which only the two butments are seen in the sketch, the rest having been swept away by the Ticino, and the new bridge erected near the spectator.

There is nothing in this scene, taken by itself, particularly interesting or impressive. The mountains are not elevated, nor particularly fine in form, and the heaps of stones which encumber the Ticino present nothing notable to the ordinary eye. But, in reality, the place is approached through one of the narrowest and most sublime ravines in the Alps, and after the traveller during the early part of the day has been familiarized with the aspect of the highest peaks of the Mont St Gothard. Hence it speaks quite another language to him from that in which it would address itself to an unprepared spectator: the confused stones, which by themselves would be almost without any claim upon his thoughts, become exponents of the fury of the river by which he has journeyed all day long; the defile beyond, not in itself narrow or terrible, is regarded nevertheless with awe, because it is imagined to resemble the gorge that had just been traversed above; and, although no very elevated mountains immediately overhang it, the scene is felt to belong to, and arise in its essential characters out of, the strength of those mightier mountains in the unseen north.

Any topographical delineation of the facts, therefore, must be wholly incapable of arousing in the mind of the beholder those sensations which would be caused by the facts themselves, seen in their natural relations to others. And the aim of the great inventive landscape painter must be to give the far higher and deeper truth of mental vision, rather than that of the physical facts, and to reach a representation which, though it may be totally useless to engineers or geographers, and, when tried by rule and measure, totally unlike the place, shall yet be capable of producing on the far-away beholder's mind precisely the impression which the reality would have produced, and putting his heart into the same state in which it would have been, had he verily descended into the valley from the gorges of Airolo.

Now observe; if in his attempt to do this the artist does not understand the sacredness of the truth of *Impression*, and supposes that, once quitting hold of his first thought, he may by Philosophy compose something prettier than he saw or mightier than he felt, it is all over with him. Every such attempt at composition will be utterly abortive, and end in something that is neither true nor fanciful; something geographically useless, and intellectually absurd.

But if, holding fast his first thought, he finds other ideas insensibly gathering to it, and, whether he will or not, modifying it into something which is not so much the image of the place itself, as the spirit of the place, let him yield to such fancies, and follow them wherever they lead. For, though error on this side is very rare among us in these days, it *is* possible to check these finer thoughts by mathematical accuracies, so as materially to impair the imaginative faculty. I shall be able to explain this better after we have traced the actual operation of Turner's mind on the scene under discussion.

Turner was always from his youth fond of stones (we shall see presently why). Whether large or small, loose or embedded, hewn into cubes or worn into boulders, he loved them as much as William Hunt loves pineapples and plums. So that this great litter of fallen stones, which to any one else would have been simply disagreeable, was to Turner much the same as if the whole valley had been filled with plums and pineapples, and delighted him exceedingly, much more than even the gorge of Dazio Grande just above. But that gorge had its effect upon him also, and was still not well out of his head when the diligence stopped at the bottom of the hill, just at that turn of the road on the right of the bridge; which favourable opportunity Turner seized to make what he called a 'memorandum' of the place, composed of a few pencil scratches on a bit of thin paper, that would roll up with others of the sort and go into his pocket afterwards. These pencil scratches he put a few blots of colour upon (I suppose at Bellinzona the same evening, certainly *not* upon the spot), and showed me this blotted sketch when he came home. I asked him to make me a drawing of it, which he did, and casually told me afterwards (a rare thing for him to do) that he liked the drawing he had made. Of this drawing I have etched a reduced outline [opposite].

In which, primarily, observe that the whole place is altered in scale, and brought up to the general majesty of the higher forms of the Alps. It will be seen that, in my topographical sketch, there are a few trees rooted in the rock on this side of the gallery, showing, by comparison, that it is not above four or five hundred feet high. These trees Turner cuts away, and gives the rock a height of about a thousand feet, so as to imply more power and danger in the avalanche coming down the couloir.

Next, he raises, in a still greater degree, all the mountains beyond, putting three or four ranges instead of one, but uniting them into a single massy bank at their base, which he makes

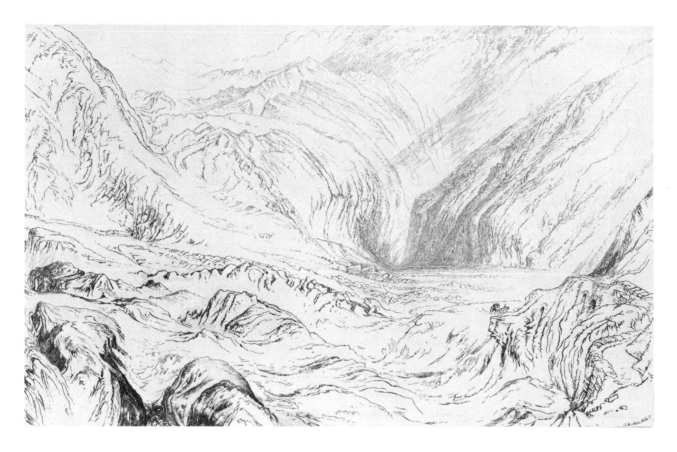

Pass of Faido, Second Turnerian Topography. Modern Painters *IV, 1856*

overhang the valley, and thus reduces it nearly to such a chasm as that which he had just passed through above, so as to unite the expression of this ravine with that of the stony valley. The few trees, in the hollow of the glen, he feels to be contrary in spirit to the stones, and fells them, as he did the others; so also he feels the bridge in the foreground, by its slenderness, to contradict the aspect of violence in the torrent; he thinks the torrent and avalanches should have it all their own way hereabouts; so he strikes down the nearer bridge, and restores the one farther off, where the force of the stream may be supposed less. Next, the bit of road on the right, above the bank, is not built on a wall, nor on arches high enough to give the idea of an Alpine road in general; so he makes the arches taller, and the bank steeper, introducing, as we shall see presently, a reminiscence from the upper part of the pass.

I say, he *'thinks'* this, and 'introduces' that. But, strictly speaking, he does not think at all. If he thought, he would instantly go

wrong; it is only the clumsy and uninventive artist who thinks. All these changes come into his head involuntarily; an entirely imperative dream, crying, 'Thus it must be', has taken possession of him; he can see, and do, no otherwise than as the dream directs.

This is especially to be remembered with respect to the next incident – the introduction of figures. Most persons to whom I have shown the drawing, and who feel its general character, regret that there is any living thing in it; they say it destroys the majesty of its desolation. But the dream said not so to Turner. The dream insisted particularly upon the great fact of its having come by the road. The torrent was wild, the storms were wonderful; but the most wonderful thing of all was how we ourselves, the dream and I, ever got here. By our feet we could not – by the clouds we could not – by any ivory gates[1] we could not – in no other wise could we have come than by the coach road. One of the great

1 Through which come false visions: see Homer, *Odyssey* xix. 562. C. & W.

elements of sensation, all the day long, has been that extraordinary road, and its goings on, and gettings about; here, under avalanches of stones, and among insanities of torrents, and overhangings of precipices, much tormented and driven to all manner of makeshifts and coils to this side and the other, still the marvellous road persists in going on, and that so smoothly and safely, that it is not merely great diligences, going in a caravannish manner, with whole teams of horses, that can traverse it, but little postchaises with small postboys, and a pair of ponies. And the dream declared that the full essence and soul of the scene, and consummation of all the wonderfulness of the torrents and Alps, lay in a postchaise with small ponies and post-boy, which accordingly it insisted upon Turner's inserting, whether he liked it or not, at the turn of the road.

Now, it will be observed by any one familiar with ordinary principles of arrangement of form (on which principles I shall insist at length in another place), that while the dream introduces these changes bearing on the expression of the scene, it is also introducing other changes, which appear to be made more or less in compliance with received rules of composition, rendering the masses broader, the lines more continuous, and the curves more graceful. But the curious part of the business is, that these changes seem not so much to be wrought by imagining an entirely new condition of any feature, as by *remembering* something which will fit better in that place. For instance, Turner felt the bank on the right ought to be made more solid and rocky, in order to suggest firmer resistance to the stream, and he turns it, as will be seen by comparing the etchings, into a kind of rock buttress to the wall, instead of a mere bank. Now the buttress into which he turns it is very nearly a facsimile of one which he had drawn on that very St Gothard road, far above, at the Devil's Bridge, at least thirty years before, and which he had himself etched and engraved for the Liber Studiorum, although the plate was never published. Fig. 1 is a copy of the bit of the etching in question. Note how the wall winds over it, and observe especially the peculiar depression in the middle of its surface, and compare it in those parts generally with the features introduced in the later composition. Of course, this might be set down as a mere chance coincidence, but for the frequency of the cases in which Turner can be shown to have done the same thing, and to have introduced, after a lapse of many years, memories of something which, however apparently small or unimportant, had struck him in his earlier studies. These instances, when I can detect them, I shall point out as I go on engraving his works; and I think they are numerous enough to induce a doubt whether Turner's composition was not universally

Fig. 1

an arrangement of remembrances, summoned just as they were wanted, and set each in its fittest place. It is this very character which appears to me to mark it so distinctly as an act of dream-vision; for in a dream there is just this kind of confused remembrance of the forms of things which we have seen long ago, associated by new and strange laws. That common dreams are grotesque and disorderly, and Turner's dream natural and orderly, does not, to my thinking, involve any necessary difference in the real species of act of mind. I think I shall be able to show in the course of the following pages, or elsewhere, that whenever Turner really tried to *compose*, and made modifications of his subjects on principle, he did wrong, and spoiled them; and that he only did right in a kind of passive obedience to his first vision, that vision being composed primarily of the strong memory of the place itself which he had to draw; and secondarily, of memories of other places (whether recognized as such by himself or not I cannot tell), associated, in a harmonious and helpful way, with the new central thought.

Drawing from nature

This example is entirely characteristic of his usual drawings from nature, which unite two characters, being *both* commemorative and determinant: commemorative, in so far as they note certain

facts about the place: determinant, in that they record an impression received from the place there and then, together with the principal arrangement of the composition in which it was afterwards to be recorded. In this mode of sketching, Turner differs from all other men whose work I have studied. He never draws accurately on the spot, with the intention of modifying or composing afterwards from the materials; but instantly modifies as he draws, placing his memoranda where they are to be ultimately used, and taking exactly what he wants, not a fragment or line more.

This sketch has been made in the afternoon. He had been impressed, as he walked up the hill, by the vanishing of the lake in the golden horizon, without end of waters, and by the opposition of the pinnacled castle and cathedral to its level breadth. That must be drawn! and from this spot, where all the buildings are set well together. But it lucklessly happens that, though the buildings come just where he wants them in situation, they don't in height. For the castle (the square mass on the right) is in reality higher than the cathedral, and would block out the end of the lake. Down it goes instantly a hundred feet, that we may see the lake over it; without the smallest regard for the military position of Lausanne.

Next: The last low spire on the left is in truth concealed behind the nearer bank, the town running far down the hill (and climbing another hill) in that direction. But the group of spires, without it, would not be rich enough to give a proper impression of Lausanne, as a spiry place. Turner quietly sends to fetch the church from round the corner, places it where he likes, and indicates its distance only by aerial perspective (much greater in the pencil drawing than in the woodcut).

But again: not only the spire of the lower church, but the peak of the Rochers d'Enfer (that highest in the distance) would in reality be out of sight; it is much farther round to the left. This would never do either; for without it, we should have no idea that Lausanne was opposite the mountains, nor should we have a nice sloping line to lead us into the distance.

With the same unblushing tranquillity of mind in which he had

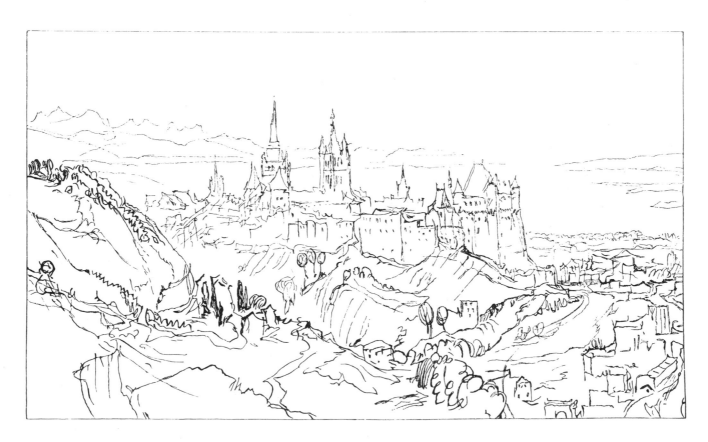

Lausanne. Ruskin's facsimile of Turner's memorandum, Modern Painters *V, 1860*

135

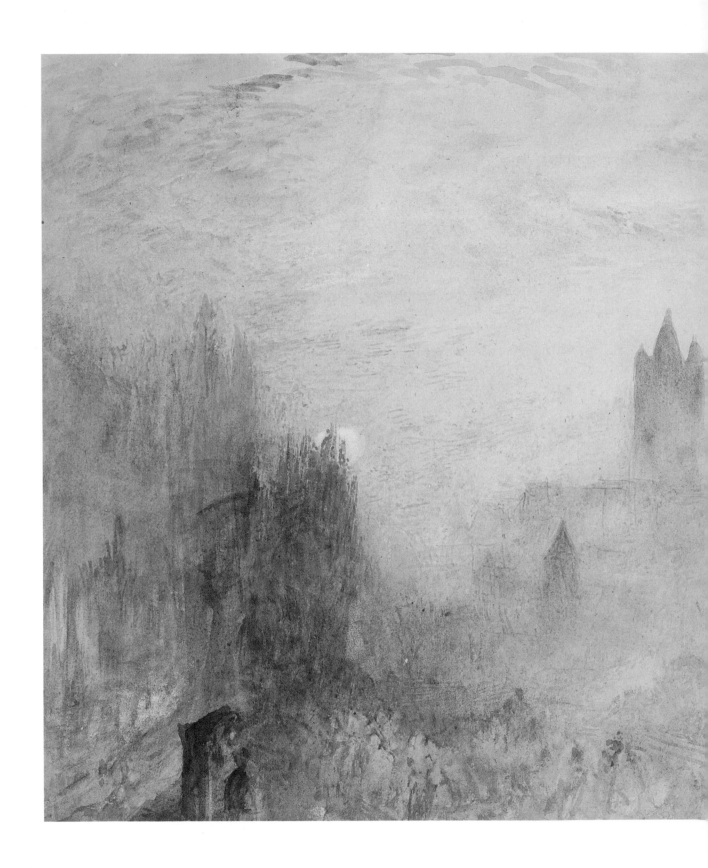

Lausanne: Sunset, 1841

ordered up the church, Turner sends also to fetch the Rochers d'Enfer; and puts *them* also where he chooses, to crown the slope of distant hill, which, as every traveller knows, in its decline to the west, is one of the most notable features of the view from Lausanne.

Melodies of colour

One of the most characteristic drawings of this period fortunately bears a date, 1818, and brings us within two years of another dated drawing, no less characteristic of what I shall henceforward call Turner's Second period. It is in the possession of Mr Hawkesworth Fawkes of Farnley, one of Turner's earliest and truest friends; and bears the inscription, unusually conspicuous, heaving itself up and down over the eminences of the foreground – '*Passage of Mont Cenis. J.M.W.Turner, January 15th, 1820.'*

The scene is on the summit of the pass close to the hospice, or what seems to have been a hospice at that time – I do not remember any such at present – a small square-built house, built as if partly for a fortress, with a detached flight of stone steps in front of it, and a kind of drawbridge to the door. This building, about 400 or 500 yards off, is seen in a dim, ashy grey against the light, which by help of a violent blast of mountain wind has broken through the depth of clouds which hangs upon the crags. There is no sky, properly so called, nothing but this roof of drifting cloud; but neither is there any weight of darkness – the high air is too thin for it – all savage, howling, and luminous with cold, the massy bases of the granite hills jutting out here and there grimly through the snow wreaths. There is a desolate-looking refuge on the left, with its number 16, marked on it in long ghastly figures, and the wind is drifting the snow off the roof and through its window in a frantic whirl; the near ground is all wan with half-thawed, half-trampled snow; a diligence in front, whose horses, unable to face the wind, have turned right round with fright, its passengers struggling to escape, jammed in the window; a little farther on is another carriage off the road, some figures pushing at its wheels, and its driver at the horses' heads, pulling and lashing with all his strength, his lifted arm stretched out against the light of the distance, though too far off for the whip to be seen.

Now I am perfectly certain that any one thoroughly accustomed to the earlier works of the painter, and shown this picture for the first time, would be struck by two altogether new characters in it.

The first, a seeming enjoyment of the excitement of the scene, totally different from the contemplative philosophy with which it

137

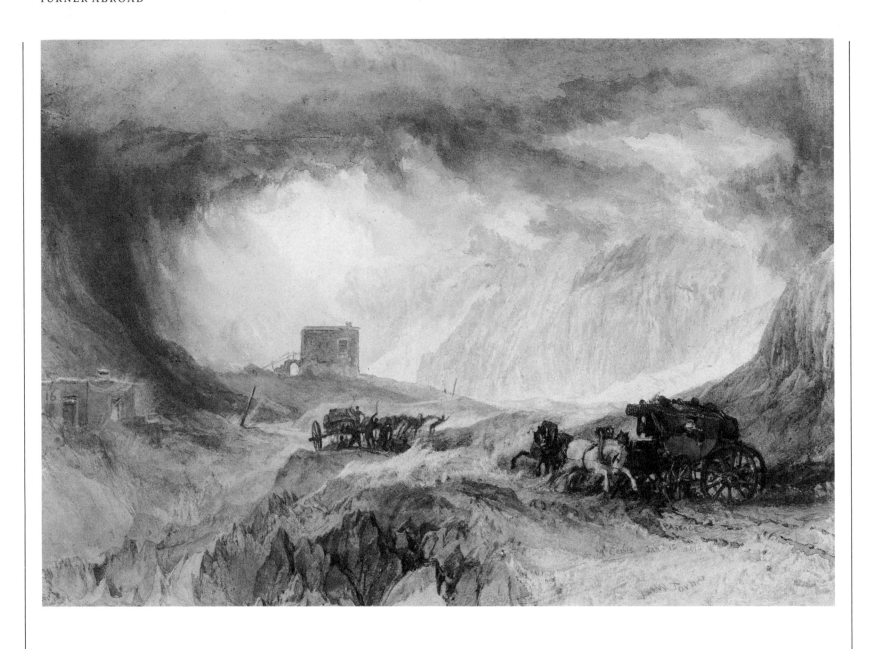

Passage of Mont Cenis, 1820

would formerly have been regarded. Every incident of motion and of energy is seized upon with indescribable delight, and every line of the composition animated with a force and fury which are now no longer the mere expression of a contemplated external truth, but have origin in some inherent feeling in the painter's mind.

The second, that although the subject is one in itself almost incapable of colour, and although, in order to increase the wildness of the impression, all brilliant local colour has been refused even where it might easily have been introduced, as in the figures; yet in the low minor key which has been chosen, the melodies of colour have been elaborated to the utmost possible pitch, so as to become a leading, instead of a subordinate, element in the composition; the subdued warm hues of the granite promontories, the dull stone colour of the walls of the buildings, clearly opposed, even in shade, to the grey of the snow wreaths heaped against them, and the faint greens and ghastly blues of the glacier ice, being all expressed with delicacies of transition utterly unexampled in any previous drawings.

The Great St. Bernard. Vignette from Rogers's Italy, *1836*

Conclusion

When the silence should be completed

MORNING BREAKS, AS I write, along those Coniston Fells, and the level mists, motionless, and grey beneath the rose of the moorlands, veil the lower woods, and the sleeping village, and the long lawns by the lake-shore.

Oh, that some one had but told me, in my youth, when all my heart seemed to be set on these colours and clouds, that appear for a little while and then vanish away, how little my love of them would serve me, when the silence of lawn and wood in the dews of morning should be completed; and all my thoughts should be of those whom, by neither, I was to meet more!

Opposite: *Morning Among the Coniston Fells, 1798*

Sources of Text

Volume and page numbers below refer to *The Works of John Ruskin*, eds. E.T. Cook and Alexander Wedderburn, 39 vols., London 1903-12, from which the text of this book has been derived.

RUSKIN'S TURNER
First Turners: *Praeterita* (1886-9), 35:253-6.
Meeting Turner: *Praeterita* (1886-9), 35:304-06.
Buying Turners: *Praeterita* (1886-9), 35:309-10.
Learning from Turner: *Modern Painters* I (1843), 3:475-6.
Ruin: *Modern Painters* V (1860), 7:431-3.

PAINTING THE AIR
The open sky: *Modern Painters* I (1843), 3:346-8.
Sunrise on the sea: *Modern Painters* I (1843), 3:364-6.
Perpetual form: *Modern Painters* I (1843), 3:403-05.
Infinity: *Modern Painters* I (1843), 3:386-9.
Mist: *Modern Painters* I (1843), 3:410-11.
Colour in the sky: *Modern Painters* I (1843), 3:285-9.
The cloud-balancings: *Modern Painters* V (1860), 7:133-5.
The roofs of Fribourg: *Catalogue of the Sketches and Drawings in Marlborough House* (1857), 13:315-6.
The storm-cloud: *The Storm-Cloud of the Nineteenth Century* (1884), 34:38-41.

THE MULTITUDINOUS SEA
The open sea: *Modern Painters* I (1843), 3:571-3.
Weight and power: *Modern Painters* I (1843), 3:564-6.
Boats: *The Harbours of England* (1856), 13:13-16.
Fishing: *The Harbours of England* (1856), 13:24-5.
Storms and wrecks: *The Harbours of England* (1856), 13:42-3.
The old Téméraire: *Notes on the Turner Gallery at Marlborough House* (1856), 13:169-72.
Calm: *The Harbours of England* (1856), 13:73-6.

TRUTH OF EARTH
Mountain truth: *Modern Painters* I (1843), 3:427-30.
Turner's geology: *Modern Painters* I (1843), 3:433.
Mount Lebanon: *Modern Painters* I (1843), 3:454.
Mountain form: *Modern Painters* I (1843), 3:464-6.
The surface of water: *Modern Painters* I (1843), 3:537-41.

The force of water: *Modern Painters* I (1843), 3:552-4.
Torrent-drawing: *Modern Painters* I (1843), 3:554-8.
River motion: *Modern Painters* I (1843), 3:547-8.
River colour: *Lectures on Landscapes* (1871), 22:55-6.
The task of the least: *Modern Painters* V (1860), 7:217-21.

TURNER'S MYTHS
The English Pegasus: *Modern Painters* V (1860), 7:185-8.
Messengers of fate: *Modern Painters* V (1860), 7:189-91.
The dragon: *Modern Painters* V (1860), 7:401-08.
The type of love: *Modern Painters* V (1860), 7:409-22.
The light of nature: *Notes on the Turner Gallery at Marlborough House* (1856), 13:136-9.
Greek hills: *Lectures on Landscape* (1871), 22:68-9.

TURNER IN ENGLAND
Boyhood: *Modern Painters* V (1860), 7:375-9.
The love of Yorkshire: *Modern Painters* IV (1856), 6:303-06.
The carelessness of nature: *Modern Painters* I (1843), 3:489-91.
Neatness in Deal: *The Harbours of England* (1856), 13:71-2.
Only the pigs: *The Ruskin Collection* (1878), 13:433-5.
Composing seascape: *Pre-Raphaelitism* (1851), 12:385-8.
Reflections: *Modern Painters* I (1843), 3:542-4.
Composing landscape: *The Elements of Drawing* (1857), 15:206-11.
Figures: *Lectures on Landscape* (1871), 22:14-17.

TURNER ABROAD
First responses: *Modern Painters* I (1843), 3:636-9.
Turner's Venice: *Modern Painters* I (1843), 3:257.
Local colour: *Modern Painters* I (1843), 3:545-6.
Detail: *Modern Painters* I (1843), 3:336-8.
Turnerian topography: *Modern Painters* IV (1856), 6:32-41.
Drawing from nature: *Modern Painters* V (1860), 7:241-2.
Melodies of colour: *Pre-Raphaelitism* (1851), 12:374-5.

Conclusion: *The Ruskin Collection* (1878), 13:409-10.

Sources of Illustrations

Further Reading and Acknowledgements

D. Birch, *Ruskin's Myths*, Oxford, 1988.

J. L. Bradley ed., *Ruskin's Letters from Venice*, New Haven, 1955.

V. A. Burd, ed., *The Ruskin Family Letters. The Correspondence of John James, his wife and their son John 1801-1843*, Ithaca and London, 1973.

V. A. Burd, ed., *The Winnington Letters*, Cambridge, Mass, 1969.

J. Clegg, *Ruskin and Venice*, London, 1981.

E. T. Cook and Alexander Wedderburn, eds., *The Works of John Ruskin*, 39 vols., London, 1903-12.

J. Gage, *J.M.W. Turner: A Wonderful Range of Mind*, London, 1987.

R. A. P. Hewison, *John Ruskin: the Argument of the Eye*, London, 1976.

T. Hilton, *John Ruskin: The Early Years*, London, 1985.

E. Shanes, *Turner's Picturesque Views in England and Wales 1825-1838*, London, 1979.

P. Walton, *The Drawings of John Ruskin*, Oxford, 1972.

G. Wilkinson, *Turner on Landscape: The Liber Studiorum*, London, 1982.

A. Wilton, *Life and Work of J.M.W. Turner*, London, 1979.

A. Wilton, *Turner in his Time*, London, 1987.

This book has taken shape with help from many sources. I am greatly indebted to the institutions and individuals with paintings and drawings by Turner in their care, who offered unfailingly courteous assistance in the preparation of the work. Andrew Wilton of the Tate Gallery gave invaluable aid; so too did Evelyn Joll of Thos. Agnew and Sons Ltd. The Open University generously supported the research that made the book possible. I am especially grateful for the encouragement and expertise of Neil Philip, Emma Bradford and Elizabeth Wilkes of the Albion Press, who kept me going. Finally, I would like to thank Sidney Birch, without whom this book would not have been written.